CONVERGENCES

Some other books by Octavio Paz

The Labyrinth of Solitude
The Other Mexico
Alternating Current
The Bow and the Lyre
Children of the Mire
Conjunctions and Disjunctions
Selected Poems
One Earth, Four or Five Worlds

OCTAVIO PAZ

CONVERGENCES

ESSAYS ON ART AND LITERATURE

Translated from the Spanish by
HELEN LANE

HARCOURT BRACE JOVANOVICH
San Diego New York London

Requests for permission to make copies of
any part of the work should be mailed to:
Permissions, Harcourt Brace Jovanovich, Publishers,
Orlando, Florida 32887.

In "Quevedo, Heraclitus, and a Handful of Sonnets" the quotations from
"Homage and Desecrations" © 1979 by Octavio Paz, English translation ©
1987 by Eliot Weinberger, are reprinted by permission of the author and the
translator. The lines from "A Garland for Thomas Eakins" by Charles
Tomlinson on page 290 are reprinted from Charles Tomlinson's *Collected
Poems* (1985) by permission of Oxford University Press.

Library of Congress-in-Publication Data

Paz, Octavio, 1914–
Convergences: essays on art and literature.

1. Arts. I. Title.
NX65.P388 1987 700 86–31836
ISBN 0–15–129055–5

Designed by Beth Tondreau
Printed in the United States of America
First edition
A B C D E

Contents

CONVERGENCES

Reading and Contemplation

To Helen Lane

Speaking in Tongues

Sooner or later all societies discover that there are other groups speaking a language different from their own. To realize that for other men the sounds designate one thing or another—bread, sky, demons, trees—name other objects or designate nothing at all and are simply noise, must have been an awesome experience. How can different sounds produce similar meanings? The diversity of languages breaks the link between sound and meaning and thereby constitutes an attack on the unity of the mind. It has always been believed that the relation between sound and meaning appertained not only to the natural order but also to the supernatural; they were inseparable and the tie that joined them, although unexplained, was indissoluble. This idea presents itself spontaneously to the understanding— Plato's astonishing etymological frenzy in the *Cratylus* is a

memorable example—and is extremely difficult to dislodge. I confess it is only with great antipathy that I accept (provisionally) the fact that the relation between sound and meaning, as Ferdinand de Saussure and his disciples maintain, is the result of an arbitrary convention. My misgivings are natural: poetry is born of the age-old magic belief in the identity of the word and what it names.

The story of Babel was the answer to the perplexity aroused, in all humans, by the multiplicity of languages: the Spirit is one and the soul is scatteredness, otherness. In the beginning "the whole earth was of one language, and of one speech," but humankind conceived a project that offended the Spirit: "Let us build us a city and a tower, whose top may reach unto heaven; and let us make us a name." Jehovah punishes human daring: "The people is one, and they have all one language; and this they begin to do: and now nothing will be restrained from them, which they have imagined to do. Go to, let us go down, and there confound their language, that they may not understand one another's speech." The people ceased to be one. The beginning of plurality was also the beginning of history: empires, wars, and the great piles of rubble that civilizations have left. Babel is the Hebrew version of Babylon, and the condemnation of that city, probably the first cosmopolitan city in history, is the condemnation of cosmopolitanism, of plural and pluralist society that acknowledges the existence of the other and of others.

In nearly all societies there is a story which, like that of Babel, explains the shattering of the original unity into a multitude of languages and dialects. Plurality is universally taken to be a curse and a condemnation: it is the consequence of a transgression against the Spirit. Hence in many

traditions there is also, in different forms, the story of an event that is its diametrical opposite. For Christians this event is the descent of the Holy Spirit upon the Apostles. Pentecost may be seen as the redemption of Babel: the reconciliation of languages, the reunion of the other and others in the unity of understanding. The greatest miracle is that unity is attained without impairing identity: each one, without ceasing to be himself, is the other. In the Acts of the Apostles we read: "And suddenly there came a sound from heaven as of a rushing mighty wind, and it filled all the house where they were sitting. And there appeared unto them cloven tongues like as of fire, and it say upon each of them. And they were all filled with the Holy Ghost, and began to speak with other tongues, as the Spirit gave them utterance." In that era many foreigners were living in Jerusalem: Parthians, Medes, Elamites, Mesopotamians, Cappadocians, Phrygians, Egyptians, Greeks, Romans, Cretans, Arabs. Thus the Gospel counters the diabolical cosmopolitanism of Babel with the spiritual cosmopolitanism of Jerusalem, and the confusion of languages with the wondrous gift of speaking other tongues. To speak a foreign tongue, understand it, and translate it into one's own is to restore the unity of the beginning.

The descent of the Holy Ghost upon the Apostles provoked not only wonder but disbelief among the witnesses of the miracle: "And they were all amazed, and were in doubt, saying one to another, What meaneth this? Others mocking said, These men are full of new wine." On hearing these utterances, Peter was indignant and reminded the skeptics of the words of the prophet Joel: "And it shall come to pass in the last days, saith God, I will pour out of my Spirit upon all flesh: and your sons and your daugh-

ters shall prophesy, and your young men shall see visions, and your old men shall dream dreams." This passage disconcerts us because Peter sees in the gift of tongues one of the signs of the end of time. Our puzzlement disappears once we remember that for Christians the Second Coming of Christ was imminent: if, in the beginning, language had been one, why should we find it surprising that, as the apparent end of the world approached, the gift of tongues should be granted so as to restore the unity of the beginning? What is more surprising is that those who heard the Apostles speak in tongues did not understand them and concluded that they were drunk. What were these languages? In 1 Corinthians, Saint Paul dispels the mystery: "For he that speaketh in an unknown tongue speaketh not unto men, but unto God: for no man understandeth him; howbeit in the spirit he speaketh mysteries."

An awesome enigma: the Spirit, on withdrawing from men, produces the plurality and confusion of tongues; later, on descending upon them and possessing them, it speaks in a language that by its very nature is unknown and untranslatable. What is no less astonishing is that all those possessed speak at one and the same time, thereby destroying language in its best and most immediate expression: conversation, the interchange of words and discourse. Saint Paul rebukes the Corinthians, exhorts them to speak one after the other in turn, and instructs them that one of them is then to interpret what has been said: "If any man speak in an unknown tongue, let it be by two, or at the most by three, and that by course; and let one interpret." Despite Saint Paul's admonitions, and later those of the bishops, Christian communities during the first centuries fell into trances in which the devout suddenly burst into mysterious and incoherent speech. The Church fought consistently

against these practices, but they continued to occur spontaneously. It is probable that the popularity of Montanism in the second and third centuries was due, among other causes, to the frequency with which its adepts, women in particular, would suddenly begin speaking in tongues. Even Tertullian succumbed to this heresy.

The "gift of tongues" was not exclusive to the early Christian communities. It antedates them and appears in a great many Oriental and Mediterranean cults going back to earliest antiquity. It also reappears in other religious movements contemporary with primitive Christianity. The Gnostics interjected meaningless words and syllables into their hymns and discourses. In his treatise against the Gnostics,[1] Plotinus accuses them of trying to *cast a spell* over superior intelligences by emitting cries, ejaculations, and whistles. Among the texts discovered at Nag Hammadi are several that include these syllables and interjections to which Plotinus refers. In "The Discourse of the Eight and the Nine," we read: "The Perfect One, the invisible God to whom one speaks in silence . . . is the best of the best, Zozthazo ōō ee ōōō ēēē ōōōō ēē ōōōōōō oooooo uuuuu ōōōōōōōōōōō ōōō Zozazoth." And further on: "I say your name, which is hidden within me: ao ee o eee uuuu ōōōōō."[2] An extraordinary statement: by pronouncing these incoherent sounds, the worshiper *says* the name of God *hidden* within him. God reveals himself in a name, but this name is unintelligible: it is merely a succession of syllables.

Speaking in tongues has been regarded as a sign of divine or, alternatively, demonic possession. The modern age has

1. Enneads, II, 9.
2. James M. Robinson, ed., *The Nag Hammadi Library in English*, 1977.

baptized the phenomenon with a scientific name—glossolalia—and has tried to identify it as a physiological and psychic disorder: self-hypnosis, epilepsy, neurosis. Naming and classifying are not the same as explaining, much less understanding. In this case, as in so many others, psychiatry substitutes scientific terms for the old religious ones, though this does not mean that the mystery has been solved: the phenomenon remains impenetrable. Nor does sociology explain it. Although it is a psychic manifestation as old as the most ancient religions—in other words, as old as humanity itself—it is not a vestige of past ages or a holdover, as those who argue in favor of a successive, linear view of history would have us believe. It appears in every century and in the most widely separated communities: the Montanist heretics of the second century in Asia Minor and the French Jansenists of the seventeenth; the Church of the Pentecostals in the United States in the twentieth century and the Gnostics of the Mediterranean in the third and fourth centuries.

An American anthropologist, Felicitas D. Goodman, has studied two groups belonging to the Mexican branch of the Church of the Pentecostals. Both practice glossolalia; one is located in a district of Mexico City and the other in a town in Yucatán.[3] Although the faithful are in one case Spanish speakers and in the other Mayan, their verbal behavior—the trance that causes them to speak in tongues—is essentially identical. The presence of glossolalia in Mexico, moreover, is not new, nor is it limited to Christian communities. The pre-Columbian Indians doubtless were familiar with it and practiced it. In the mountains of Puebla in our own day, during ceremonies of divination and cure

3. *Speaking in Tongues: A Crosscultural Study of Glossolalia*, 1962.

through the ingestion of hallucinogenic mushrooms, at the beginning and end of the rite the shamans chant and hum syllables and sounds that phonetically resemble a language. The universality of the phenomenon, and its persistence amid historical changes and the extreme diversity of cultures, languages, and societies, incline me to think that we are once more in the presence of a human constant.

Ms. Goodman defines glossolalia as one of the manifestations of certain "altered states of consciousness" characterized by an excitation of various psychic and physical functions (in this case verbal activity). At the opposite pole would be certain experiences—Yoga meditation, for example—that tend toward silence and immobility. The terms are new, though not the contradictory relation that unites them: excitation or passivity, an outward impulse or a withdrawal into the self. Antiquity was familiar with both types: *fury* and *contemplation*, ecstasy and introversion. I emphasize that for the modern anthropologist the expression *altered consciousness* does not mean a pathological abnormality or psychic disturbance: the dissociation of consciousness is a *trance*, a veritable *transit*, temporary by nature and in no way affecting the subject's daily conduct and activities.

Saying Without Saying

Although the experience manifests itself primarily in ritual and liturgical acts, it is not exclusively religious. In the history of poetry glossolalia and similar phenomena appear with a certain regularity. The frequency with which poets

yield to the frenzy of the dance of syllables and rhythmic sounds irreducible to concepts reveals, once more, the profound affinity, never wholly explained, between poetic and religious experience. Speaking in tongues obeys unconscious laws of rhythm not essentially different from those governing the elaboration of poems: meters, accents, pauses, coupling of syllables, explosion of phonemes—in a word, all the variations of verbal rhythm. The discourse of someone who speaks in tongues is unintelligible, yet it does not lack form. The contrary might be said: it offers itself to our perception as a pure verbal form. It is an architecture of sounds built of the rhythmic language of the poem.

In poetry in the Spanish language glossolalia is a recurrent phenomenon. The most radical experiment in the modern era was the one undertaken by Vicente Huidobro. I have spoken on another occasion of this poet and his poem *Altazor* (1931).[4] I must dwell once again, if only briefly, on the experiment of this Chilean poet: his endeavor sheds light on the surprising relations between the modern movement in poetry and the speaking in tongues of religious sects. In his first "creationist" poems, Huidobro set out to substitute the reality of the verbal image for real reality. In a second phase, that of *Altazor*, the poet gradually divests language of its burden of meanings; in the final cantos words aspire not to mean but to be: syllables that are rattles that are seeds. Why? To what purpose?

The story of Altazor—Huidobro's mythical double: *alto azor*, lofty goshawk—is that of a journey through celestial spaces by *parachute*. We are confronted by a paradox—was Huidobro aware of it?—that has led critics to see in the poem not the story of an ascent, but of a fall much like

4. Lecture at the Colegio Nacional, Mexico City, 1975.

those of Icarus and Phaëthon. I do not believe that such an interpretation is faithful to Huidobro's intentions. The first canto of the poem is admittedly the account of a fall, but later on, beginning with the third canto in particular, the Chilean poet recounts the episodes of a dizzying ascent that culminates, in the seventh and last canto, in a kind of ecstasy. I must add that the poem relates the journey of Altazor not through the celestial spheres, but rather through the subheavens and heavens of language. His adventures are a series of scuttles with words, at times a hand-to-hand combat and at others an intimate embrace. There is fidelity to the heroic model—war and love—but it is transposed to language; the creatures with whom Altazor does battle, or whom he embraces, are not human: they are words. Throughout the seven cantos we see Altazor subject language to violent or erotic acts: mutilations and divisions, copulations and juxtapositions. In the sixth canto the poet plays with words still charged with meaning, coupling them in a simplistic frenzy: *eterfinetre, unipacio, espaverso*. In the final canto he prefers simpler words such as "mountain," "moon," "star," telescoped into *monlutrella*. Thereafter the bird of poetry, which is that of language and whose name is *tratalí*, "sings in the branches" of Altazor's brain. Does it really *sing*? It *says*, rather. And what does it say? A few syllables that appear to be words, but words stripped of all meaning. Altazor's long discourse (even Huidobro did not manage to escape Spanish prolixity) ends in a series of blocks of syllables at once crystalline and impenetrable. Critics have seen in this "insignification" a proof of the *insignificance* of the poem. I doubt this.

Altazor's failure resembles Phaëthon's not because he tried to scale heaven but because he tried to be like a god. Phaëthon undertook to drive the steeds of Apollo; Altazor,

to make speech and creation one. This critical observation is correct, but certain subtle distinctions must be made. We humans speak words that designate one thing or another; we don't say things but names of things. Hence words have a sense, a direction: they are bridges between us and the things and beings of this world. Each word points toward an object or a reality outside itself. Language relates us to the world, its things, and its beings. The gods, on the other hand, as cosmogonies tell us, voice stars, rivers, mountains, horses, insects, dragons. For them, to speak is to create; their speech is productive. In our day Marxist—or rather, pseudo-Marxist—criticism attributes a quality to literary creation that in a strict sense is applicable only to divine languages: productivity. When the gods speak, they produce; when human beings speak, they relate.

Huidobro's "production," like that of all writers, consists of combining linguistic signs that form a discourse. But what distinguishes Huidobro's endeavor is that, at the end of his journey, Altazor voices not a discourse but a few dancing syllables. Criticism has categorically concluded: his adventure ends in the abolition of meanings and hence of language—a defeat. Nonetheless, for the Chilean poet each of the words or pseudowords that Altazor (or the *tralalí* bird) says is a living object and, as such, has ceased to signify. The language of the last canto of *Altazor* has attained the supreme dignity: fullness of being. Since Plato, the superiority of being as compared to meaning is radical: meaning is dependent upon being. For Huidobro the adventure of Altazor, which is his own, ends in triumph. And here we must make a subtle distinction. Huidobro is mistaken: although they have indeed ceased to be signs, the single syllables with which he ends his poem are not

living objects. Furthermore, they do not *exist*, but remain halfway between meaning and being. They have ceased to be words and aspire to the plenitude of being but fail to attain it: they are illusions and allusions to the reality beyond meaning and unsayable.

In short, we may criticize Huidobro and laugh at his vainglorious credulity: a petty god who creates nothing but a handful of syllables! But we cannot do what many critics have done: change the sense (the direction) of Altazor's flight and see a defeat in what, for its author, was a victory. Huidobro's journey through *unipacio* and *espaverso* is the story of the ascension of meaning to being. At the end the *tralalí* bird utters a few syllables, not music but a language beyond meaning and nonmeaning:

> *Lalalí*
> > *Io ía*
> *Iii o*
> *Ai a i ai ui a ía*

Huidobro's favorite procedure in the final cantos of *Altazor* is no different from Lewis Carroll's. The method, in fact, is as old as language and has been independently invented many times, in a number of different languages and eras. Yet there is an essential difference between Huidobro and the English poet. I am not referring to the humor, very nearly absent in the South American, nor to the criticism of reality distilled in Carroll's pages, but to his way of operating on language. Lewis Carroll's aim was to multiply the meanings of a word to the maximum: his portmanteau words are traveling bags roomy enough to accommodate a plurality of meanings. In Carroll, the compression of words is directly related to the number and

complexity of the meanings contained in each of them. The result is a greater richness of meanings, not a canceling out of meaning. James Joyce carried the method to extremes and increased the compression of words (ten or fifteen in one) in order to multiply the meanings. Against the world of words, he set the word-that-means-worlds. Huidobro takes precisely the opposite tack: in the last cantos of *Altazor*, his translanguage tends to become an idiom made up of words and certain consonants, such as *l*, in which each verbal form has ceased to have a meaning. Not an accumulation of meanings, but a progressive decline of meanings. The final verses of *Altazor*, strictly speaking, say nothing. They are reminiscent of the invocations of the Gnostics that so irritated Plotinus. The other face of being is nothing.

In a more narrowly aesthetic domain, the *jitanjáforas* of the Cuban poet Mariano Brull were also famous in their day: brief poems in the short meters of our traditional poetry, made up of phrases and words that are purely rhythmic and allude only vaguely to sensible realities:

> *Filiflama alaba cundre*
> *ala olalúnea alífera*
> *alveola jitanjáfora*
> *liris salumbra salífera*

Alfonso Reyes devoted a lively and penetrating essay to the subject; confronting us here, he declared, is one of the extremes of poetry, its magical and irrational side. For Reyes, an eclectic aesthete, speaking in tongues was a verbal game, that and nothing more. He forgot that game playing always borders on the sacred and, very often, on one of its most extreme and awesome forms: sacrifice. In

ancient Mexico the game of pelota was associated with a rite that culminated in the immolation of one of the players. It is one example among many of the intimate relation between game playing and divine creation: the gods do not work, they play; their games are the creation and destruction of worlds. Human game playing, with a hard rubber ball or with syllables and phonemes, is a reproduction of the divine game. Brull's *jitanjáforas* represented the aesthetic view of the phenomenon: something like contemplating, from a balcony, a landscape dizzyingly suspended over an abyss.

The history of modern poetry records even more daring, more complete explorations. They have to do with moments akin to that oceanic feeling which for Freud was characteristic of the religious experience, the feeling of being rocked to and fro in the primordial waters of existence— in this case, in the rhythmic surge of a language that no longer signifies and that says without saying. Around 1913 the Russian Cubo-Futurists, Velemir Khlebnikov and Alexei Kruchenykh in particular, set out to create a transrational universal language: *Zaum*. In an essay dating from that year, Kruchenykh pointed out a forerunner of *Zaum*: the speaking in tongues (glossolalia) of Russian religious sects. According to the faithful, the Holy Ghost descended upon them and moved them to speak in strange tongues. This declaration was not only the first theoretical formulation of modern poetics, but also the first to emphasize the similarity of the two verbal experiences, religious and poetic. In France, albeit much later, there were also attempts to create a language beyond language. There were notable experiments by Fargue, Michaux, and Artaud, but unfortunately they were isolated and sporadic. After World War II the *lettristes* came out in favor of a purely phonetic poetry;

they proved to be more systematic than inspired. But the most significant episode, soon after the experiments of the Russian Futurists, goes back to the birth of the Dada movement. One of its founders, the German poet Hugo Ball, tells how, on June 23, 1916, in the Cabaret Voltaire in Zurich, hiding his face behind a mask by Hans Arp, he recited, to the astonishment, indignation, and fascination of the audience, a phonetic poem consisting entirely of nonsense syllables and meaningless words. Ball's experience, as he himself recounts it, lucidly and with feeling, bordered on religious trance; it was a regression to the magic spell, or more precisely, to a language preceding language: "With those poems made up of mere sounds, we totally rejected the language corrupted and rendered unusable by journalism. We returned to the profound alchemy of the Word, beyond words, thus preserving poetry within its last sacred domain."

Ball's phonetic poetry reveals the religious nostalgia for a primal language preceding all languages. His experiment is the last and most extreme instance of one of the tendencies of poetry since the Romantic movement: the conjunction of Platonic furor and religious ecstasy. There thus reappears in the history of modern poetry the same obsession that drove Gnostics and primitive Christians, Montanists and the shamans of Asia and America: the search for a language prior to all languages that would reestablish the unity of the spirit. Although untranslatable into this or that signification, such language does not lack meaning. More exactly, what it expresses is not *before* meaning but *after*. It is not a presignificative babbling: it is a reality at once physical and spiritual, audible and mental, that has traversed the realm of meanings and set them afire. It is not more than, but *beyond*, meaning. *Saying* ceases to sig-

nify: it reveals realities that are unintelligible and untranslatable but not incomprehensible. It does not signify, yet at the same time it is impregnated with meaning.

Bridges and Abysses

The search for a language transcending all languages is one of the ways of resolving the opposition between unity and multiplicity that has never ceased to intrigue the human spirit. Another way of resolving the conflict is translation. From this perspective, translation is that "third term" to which antiquity was so deeply attached: the Spirit is One, languages are Many, and the bridge between the two is Translation. But the twentieth century does not recognize mediations, therefore translation does not seem like a bridge but like a plunge into a logical abyss; as the number of translations increases, the skepticism of philosophical, literary, and linguistic criticism grows: translation is an illusion, a fraud, or a caricature. The critics are even more severe toward translations of poetry. Their condemnation is almost always categorical and irrevocable; if it is extremely difficult to translate a sentence in prose—to provide an equivalent of its meaning is all we may aspire to at best—it is altogether impossible to translate a poetic phrase. The argument of the adversaries of poetic translation may be summarized as follows: the relation between sound and meaning is precisely what constitutes poetry, and this relation is untranslatable. In other of my writings I have tried to answer this argument. I will not repeat here what I have said elsewhere; I shall merely point out that linguistic solipsism is simply a variant of philosophical solipsism: the

translator is imprisoned inside his language just as the subject is trapped inside his ideas and sensations. This criticism, however, applies not only to poetic translation but to all forms of communication. Need I remind my readers that poets have never sought to avoid the difficulties of communication but to transcend them? Hence it has sometimes been said that poetry is not communication but communion. Yet it is not necessary, as we shall see, to resort to this quasi-religious analogy in order to maintain that poetic translation is possible.

In the poet's experience itself—in this respect, like that of all other humans—the interpenetration of what is felt, thought, and said is a constant feature. Our everyday experience is not made up of ideas or sensations but of idea-sensations which, in turn, are inseparable from the verbal utterance (albeit embryonic and silent) that corresponds to them. Sensations and idea-sensations manifest themselves within each individual and are evanescent by their very nature; in a first phase, language fixes them, and the moment it does so it changes them, transfigures them. The poet repeats this very same operation, though in an infinitely more complex and refined way. By naming what he has felt and thought, the poet does not transmit his or her original ideas and sensations, but presents forms and figures that are rhythmic combinations in which sound is inseparable from sense. These forms and figures, these poems, are artificial objects, cubes or spheres of echoes and resonances, that produce sensations and idea-sensations similar but not identical to those of the original experience. The poem is the metaphor of what the poet felt and thought. This metaphor is the resurrection of the experience and its transmutation. The reading of the poem reproduces this twofold movement of change and resurrection. The poetic

translation in turn repeats the same operation, but in an even more radical way: its aim is not an impossible identity but a similarity very difficult to achieve. Valéry said it all, with a simplicity that cannot be improved upon: the translator seeks to produce similar effects through different means.

The translation of poetry is an extreme case. Nonetheless, within the limits described, it seeems to me that it is not impossible. These limits, however, are variable and depend on a great many circumstances. It is not a superhuman task, for instance, to translate works dating from the same period into language belonging to the same family. This is the case when contemporary works are translated from one Romance language into another. It all depends, naturally, on the work being translated: translating an ideologist like Sartre is not the same as translating a poet like Mallarmé. If it is a question of translating a contemporary work written in English or German into Spanish or Italian, the difficulties increase; if we set out to translate a Joyce, they become superhuman. Translations of works from one era into the language of another constitute a special category. Within it, a relatively easy subcategory is translation within the same language, as for instance medieval Spanish texts into modern Castilian. At the other extreme are translations of texts both dating from an ancient period and belonging to another civilization: Chinese or Japanese poetry, the sacred books of the Mayas, the poems of the Mexicas, *kāvya* poetry.

How does one translate Dante? Into medieval or twentieth-century Spanish? There is a recent translation of the *Commedia* into French by a great specialist, André Pézard, using a language full of archaisms and medievalisms. This language is, in part, French as we know it to have been spoken in the thirteenth and fourteenth centuries, and in

part, an idiom invented by Pézard. The translator's avowed aim is to "communicate to the French reader the same impression that the reading of this old masterpiece may produce in the Italian reader." Pézard's undertaking fails in one essential regard: to translate Dante's hendecasyllabic tercets, he chose the ten-syllable verse of the medieval French epic. Since the French verse of ten syllables is the equivalent of the Italian hendecasyllable, Pézard can proudly claim that his translation of the *Commedia* "does not have a single syllable more than Dante's original." This is true, but the rhythm is altogether different: there is no equivalent in French for the combination of tonic accents in Dante's hendecasyllable. There is one in Spanish, however, and thus, despite the fact that our hendecasyllable is a Renaissance and modern verse form, Ángel Crespo was able to use this meter in his translation of the *Inferno* and the *Purgatorio*. The cantos of the *Paradiso* rendered into Portuguese by Haroldo de Campos are a notable example of a translation that is at the same time a resurrection in another language and another era. In a word, neither different historical periods nor different languages are ever exact equivalents, therefore translation is a leap not only between idioms but also between centuries. Yet the differences within a given historical period are no less profound than those separating one era from another: what year in New York, Teheran, or Peking is the equivalent of the year 1980 in Mexico City?

In the past, faith in translation predominated. This belief had a religious basis: if there was only one God—or only one truth—translation was possible, since all meanings were grounded in the meaning of the divine. The great examples of faith in the universality of the spirit, and therefore in the possibility of translation, are not exclusive to the West

or to Christian monotheism. Without the Arabs and their translations and interpretations of Greek philosophical thought, what would have become of medieval thought? The influence of Averroës was not limited to philosophy and medicine; it also influenced our ideas concerning the psychology of love, as received and reworked by Cavalcanti and the other poets of the *dolce stil nuovo*, ardent Averroists all. Less well known is the history of the translation into Chinese of Buddhist scriptures and treatises. When the Chinese discovered Buddhism, they immediately undertook to translate the texts, despite the enormous differences between Chinese and Sanskrit. Their concern for fidelity went beyond inviting Indian monks and scholars to their country and establishing schools for translators in monasteries. Very soon, beginning in the third century under the Han dynasty, Chinese pilgrims traveled to India to obtain manuscripts and books. The journey was long and arduous. They had to make their way first of all to one of the most distant outposts of the empire, Tun-huang, which from the second century on served as the point of arrival and departure of caravans. It is worth our while to linger a bit, as the pilgrims did, in this remote spot.

Tun-huang is celebrated for its temples in hillside caves and for the frescoes and statues of Buddhas and bodhisattvas that decorate its sanctuaries. And for the syncretistic nature of its culture as well; although Tun-huang was a Chinese military outpost, it was overrun at times by Tibetans and at other times by Mongols. It was in turn Buddhist, Manichaean, Buddhist again, then Taoist. The decadence of the empire and the disappearance of the trade routes brought its eventual ruin. In 1900 a Taoist monk, Wang Yuan-lu, who earned his living by selling magic formulas, discovered by chance an entire library in one of

the grottoes, the Cave of the Thousand Buddhas. Most of the manuscripts fell within a period of six centuries, from the fifth century to the tenth. Almost all the texts were Buddhist, although there were also literary works and, in lesser numbers, Taoist, Manichaean, and Christian writings. (Manichaeism reached as far as Central Asia,, and the Nestorian church had a certain importance in China.) In 1907 an English archaeologist, Aurel Stein, acting for the British Museum and the Viceroyalty of India, bought from Wang, the Taoist charlatan, a great number of manuscripts and many silk paintings, all for a ridiculously small sum. Paul Pelliot bought another lot of manuscripts and paintings from Wang. In 1910 the Chinese government finally managed to acquire a small part of his treasure. What was left of it was purchased by a Japanese mission in 1911. Thus scattered, various parts of the Tun-huang library ended up in London, Paris, Peking, and Tokyo.

From this Tun-huang sacked in the twentieth century, Chinese pilgrims once set out across Central Asia, where mountains, rivers, deserts, alien peoples, and perilous trails overrun with warring hordes and bandits awaited them. On arriving at the Oxus River, the pilgrims entered what is today Afghanistan, crossed the Hindu-Kush Mountains and the Indus, and reached the plains of the Ganges via the Punjab. The journey took several years and not all the pilgrims came back alive. In India, at Peshawar and Kashmir as well as the celebrated university of Nalanda, the Chinese studied and copied texts, bought books and, after long years, freighted with learning and a load of manuscripts, set out on the journey home. Traveling and translating were parallel activities that occupied an entire lifetime. The school of translators was a school of travelers and explorers.

The Japanese sent pilgrims and monks abroad on similar missions. From the seventh century on, they journeyed forth to learn the languages of China and Korea, study in the monasteries, and collect manuscripts and works of art. The Tibetans too sent out pilgrim-scholars. Thanks to them, many sutras and shastras have been preserved that were later lost in India, victims not only of the monsoons, insects, and calamities that destroy manuscripts and books, but of human barbarity as well. On two occasions the great Buddhist monasteries of India were sacked and their monks put to death: at the beginning of the sixth century by the Epthalites, a branch of the Huns, and in the twelfth century by Muhammadan Turks. The fanaticism of the Brahmans completed the work of destruction begun by Huns and Moslems. The Tibetans, like the Benedictines and other religious orders in Europe, saved what they could of the Buddhist heritage. The texts are gathered together in two collections: the canon proper, the *Kanjur* (the translated word) and the commentaries, the *Tanjur* (the translated treatises). One of the most venerated saints of Tibet, the famous Marpa, teacher of the even more famous Mila raspa, bears a significant title: Translator. Marpa the Translator! Could any of our philosophers and poets endure being referred to thus: Sartre the Translator, Beckett the Translator, Neruda the Translator?

In all the cases I have cited, translation had as its aim the preservation and transmission of truths considered universal and eternal. Because they were universal, these truths belonged to all humanity and could be translated into all languages; because they were eternal, they belonged to every period. Translation was grounded in a sacred legitimacy. The classic works of the past—Virgil and Ovid for the Middle Ages and the Renaissance, Li Po and Tu Fu for

the Chinese after the T'ang dynasty—also possessed the two attributes of sacred works. Universality and timelessness were manifestations of the Spirit, which was ever one and identical to itself, or, like the Buddhist Emptiness or the Tao of Chuang-tzu, was that which absorbed all changes and thus encompassed both rest and motion. The attitude of the ancients toward translation was the diametrical opposite of ours: for us a text, even a sacred text, is above all a work that has a date. History and geography relativize all texts: therein lies, essentially, the theoretical difficulty of translation for the modern age. It was not easy for the ancients to translate the Divine Word either, but for reasons precisely the contrary of ours. For us, the text is relative: it has a date and belongs to this or that society; for them, it was not the text but the translator who was a relative, ephemeral being. Hence the translator had to be worthy of what he translated. The Chinese and Tibetan pilgrims traveled for years and suffered great hardships: by so doing, they accumulated merit. Their hardships were yet another proof of their capability as translators. More specifically, this capability was at once an intellectual ability and a moral worth.

Edith Piaf and the Pygmies

The problems involved in translating the Eternal Word into a human language were many and disconcerted theologians. I shall cite an example of such difficulties. Both the Old and New Testaments continually allude to vineyards. This is not surprising: they reflect a religion born

in the Mediterranean world. The central metaphor of Christianity is linked to viniculture and its product, grape wine. The mystery of the Eucharist, transubstantiation, consists of the change of wine into divine blood and of wheat into the flesh of God. Missionaries had tremendous difficulties explaining this mystery to peoples who were completely unfamiliar with wine and with wheat bread. For these peoples the religious concepts of metamorphosis and mutation were not new—they are the axes on which the mythologies of all societies turn—but it was not easy for them to accept the Christian Word when they had no notion of its concrete terms: wine and wheat. In Mexico there were realities that bore a resemblance to those in Castile—pulque was similar to wine and maize cakes to wheat bread—but their functions were different. Although there were rites based on the union of maize and blood, the similarity with the ritual use of the Host was remote. As for pulque, unlike wine, it was not the magic agent of a transubstantiation.

The Mexican Indians had religious mysteries analogous to those of the Eucharist and communion, but the rites in which these mysteries found expression scandalized and horrified the missionaries. The agents of the miraculous change were neither wheat nor wine but, in the one case, the flesh and blood of humans sacrificed in the temples, and in the other, the mushrooms that we refer to today as hallucinogenic. There is a *loa* by Sor Juana Inés de la Cruz in which—following the usual interpretation of her day—she sees in the human sacrifices and the ritual cannibalism of the Mexicas (who ate a small portion of the victim's thigh, without salt) a sort of foreshadowing of the Eucharist. The missionaries were no less horrified by the ceremony involving the ingestion of mushrooms,

especially when they discovered that one of the names for them was "flesh of God." Translation became a theological problem, and Sahagún unhesitatingly ascribed the similarities between the Christian Eucharist and the communion ceremony based on the partaking of mushrooms to a trick of the Devil; the problems of translating from Spanish to Nahuatl were thus seen from the perspective of Satan's intervening in the affairs of this world. For us the difficulties are no less grave, although not of a religious nature: confronted with a literary or philosophical text in another language—Latin or Chinese, Greek or Arabic—we find ourselves face to face with a different society and a different civilization. In each case the unity of the spirit and of the species is threatened by plurality. The age-old duality, the One and the Many, reappears, and all the bridges to join them are fragile and precarious.

Sahagún's horror at the Aztec version of communion was commingled with feelings of admiration for the principles, customs, and institutions of the Mexican Indians. Sahagún was quite aware that the indigenous world was what we call *a civilization* today. His case was not the only one, nor was this realization limited to New World civilizations. In the seventeenth and eighteenth centuries the Jesuits established contact with China and soon discovered that that society, though ignorant of the truths of Christianity, was wiser and more harmonious than the nations of the West. Shortly thereafter, the Enlightenment extolled the traditions, morality, and learning of the Chinese. As the Europeans discovered that the versions of reality of other civilizations were not to be scorned, the truths of Christianity paled. Were they really universal? Were they really truths? But the waning of Christian universalism did not weaken the faith in translation. If the human spirit was

universal, meanings were also universal; consequently, translation was legitimate and possible. The common denominators of the multiplicity of languages were reason and its products, meanings. This idea went back to ancient times. Aristotle had said: "Though writing and the spoken work are not the same for all men, the states of soul and the things that these signs designate are the same." The plurality of languages and the diversity of the written signs that represent them were resolved in the universality of that which they designate: human beings, their states of mind, and the universe surrounding them.

The relation between language and reality was transparent. On the one hand, the universe: things and beings. On the other hand, meanings identical for all, despite the diversity of idioms. All languages obeyed the same laws of reason and thus, from Port-Royal in the seventeenth century to Noam Chomsky in the twentieth, one of the dreams of linguists has been the construction of a universal grammar. Languages were catalogues, nomenclatures, that is to say, names of beings, persons, processes, qualities, and properties: nouns, pronouns, verbs, adjectives. In the different languages human beings always named the same things, the same concepts, the same ideas. House, cold, woman, principle of identity—these were different words designating the same thing in French, Persian, Guaraní. The universality of meanings guaranteed that translation was possible.

Despite its faith in the universality of reason, the eighteenth century introduced the principle of relativism, first in ethics and later in the other realms of culture, from philosophy to aesthetics. Humanity becomes human beings, each one of whom is distinct, unique. A change of direction:

the search for universal identity gives way to a curiosity bent on discovering no less universal differences. A familiar example of these differences is that of colors: not all societies or periods see the same colors. If the Greek perception of color was different from ours, this fact is taken as an argument against the supposed universality of the human mind. A different distinction between colors points to a different sensibility and a different aesthetic. And to a different vision of reality and the world as well: another philosophy and another ethics. We are even more puzzled when we discover that, from the physiological point of view, the experience of colors is the same for all races: the cells of the retina and the optic nerve are the same in all humans; nonetheless, differences in color perception and the different attitudes resulting from this fact are a well-known, incontrovertible phenomenon. Homer's translators confront awesome obstacles as they try to find precise equivalents in our language of terms such as *xanthos, glaukos, ōchros*. *Ōchros* is sometimes yellow-green, sometimes gray. Certain translators have rendered these words as bright or dark, presuming that the Greeks, like the Hebrews, paid less attention to hue than to intensity, luminosity, and brightness. This is a false solution, since Greek possesses many words to designate luminosity and brightness. Others have maintained that the Greeks were a people with very little sensitivity to color, a blind people. In the excellent book he has devoted to these questions, Georges Mounin traces the linguistic differences back to differences in the conception of the world: "If the observed contradictions can be attributed neither to the nature of phenomena nor to the structure of the human eye, they must be based on what lies between the reality of the world and linguistic expression: the different ways humans have

of seeing and conceiving of the world."[5] It is hard to decide whether Mounin is right; for other writers, differences in the conception of the world are the consequences of linguistic differences.

A few years ago in Cambridge, I had impressive confirmation of the barriers between different civilizations. A Dutch documentary on New Guinea appeared on television. The film relates the adventures of a group of ethnologists, the first to cross the mountain range that divides the immense island. One episode shows the arrival of the expedition at a little settlement of pygmies, isolated in a narrow valley of the tropical mountains. The explorers camp at a certain distance from the huts of the aborigines because the latter, fearing magic contamination, ask them to keep their distance. But since curiosity proves more powerful than ritual prohibitions, a few moments later the savages are seen gathered round a radio set. The Dutch expedition coincided with the first Soviet journeys to outer space, so that the television viewer is offered a most surprising image: in a remote jungle ravine, a group of Stone Age pygmies hears a news report from the Age of Technology. The savages did not understand the words that came out of the radio set, but if an interpreter had translated what the speaker was saying, they would have immediately translated the scientific language into mythical and magical terms. The spacecraft and its crew would have been translated into a manifestation of supernatural powers. Even if the language of the aborigines had been able to express the ideas and concepts implicit in the notion of *space travel*, the translation would have transformed this fact into a myth, a miracle, or an act of magic. The question as to the

5. Georges Mounin, *Les Problèmes théoriques de la traduction*, 1963.

pygmies' capacity to understand, that is to say, the question as to their gifts as translators, could also be asked of the Dutch explorers. They in turn lacked an understanding of Papuan concepts; or to put it more precisely, in order to understand them, they translated them in terms of modern anthropology. They were thus repeating the story of the relations between different civilizations: for Sahagún, the Aztec religion was an invention of the Devil; for Lévy-Bruhl, primitive beliefs obeyed the laws of what he called the "prelogical mentality"; for Frazer, magic was an erroneous application of the principle of causality.

At another point in the film the viewer sees the pygmies gathered round a phonograph. Suddenly all of them take to their heels. What had made them flee? The intolerable, unbearable voice of Edith Piaf! The explorers listen, enthralled, to the song; the pygmies cover their ears and run off in terror. Piaf's song was one of love and violent jealousy, a theme that in the Western world goes back to the twelfth century and Provençal poetry. If someone had translated the lyrics for the pygmies, their fear would most probably have turned into revulsion. Their reaction might well have been no different from that of the Spaniards confronted with the human sacrifices of the Aztecs. Once again, a conclusion that I am reluctant to accept suggests itself: neither moral and aesthetic meanings nor scientific and magical ones are wholly translatable from one society to another. For the Papuans to understand modern science, they must abandon their beliefs; for us really to understand the Papuan world, we too must change. In both cases this change ought not to imply the abandonment of our former personality and the culture into which we were born. The understanding of others is a contradictory ideal: it asks that

we change without changing, that we be other without ceasing to be ourselves.

The change demanded of us by the passage from one civilization to another is tantamount to a genuine conversion. The most illustrious of the Chinese pilgrims, the sage Hsüan Tsang, better known as Tripitaka,[6] was the protagonist of a doubly miraculous incident, remarkable both in the history of religious conversions and in the chronicles of translation. In 645 Hsüan Tsang returned to China, and under the protection of the emperor T'ai Tsung carried on for more than twenty years a remarkable and perhaps unique project. He founded an academy of translators, made up of twelve experts in Buddhist literature and nine style editors (*chuiwen,* connectors of sentences); they translated eighty books and treatises and a guidebook to India, and for good measure translated the *Tao Tê Ching* into Sanskrit for the edification of Indian scholars and philosophers. And at the end of his life, while residing in the Monastery of Eternal Love as abbot and head of the school of translators, Tripitaka was invited by the new emperor, Kao Tsung, to stay for a time at the palace. The empress was with child and about to give birth. At this point there occurred the incident I mentioned earlier. But it is best reproduce the letter that Tripitaka wrote to the empress, as Arthur Waley transcribes it in his biography of the holy pilgrim:

6. Hsüan Tsang took this name from the texts that he translated: *Tripitaka* designates the "three baskets," in other words the three sections *(San Tsang)* containing the canonical scriptures of Mahayana Buddhism in their Chinese version: in Sanskrit, Sutta, Vinaya, and Abhidhamma (The baskets of discourses, discipline, and metaphysics).

Today, after the hour of the Snake and before the hour of the Cock, I saw a little bird fly between the curtains of one of the windows looking out on to the courtyard of the Hsien-ch'ing Hall. Its wings and back were pink; the feathers on its belly and legs were bright red. It flew into the curtain from a southerly direction and perched on your own chair. Here it hopped to and fro, entirely at its ease. Certain that it was not an ordinary bird I engaged it in conversation, saying, "Her Majesty the Empress is just going to have a baby. Naturally I am very much worried about it and have been fervently praying that everything will go well. If my prayers have been answered, please signify this by some happy sign." The bird at once performed a pirouette and then beat on the ground with its feet, which is the figure used [by dancers] to signify peace and happiness. It was evident that it had completely understood what I said to it. You can imagine my delight. I motioned to it to come to me and it came slowly towards me, not showing the slightest fear even when it was quite close. It even let me stroke it, as those who were with me can testify. I then administered the Triple Form of Refuge [*Budam saranam gakchi; Darman saranam gakchi; Sangam saranam gakchi.* (I take refuge in the Buddha; I take refuge in the Dharma—the Holy Doctrine; I take refuge in the Sangha—the Order of Monks)]. In view of its obliging conduct towards me I did not attempt to catch it, and after hopping about for a while it flew away.

Tripitaka never explained what language he and the bird talked in.

Meaning Is the Child of Sound

At an opposite extreme from those who think that linguistic differences result from differences in civilization and culture, are those who maintain that each language embodies a vision of the world different from that of all other languages. Each is an interpretation of the universe, a prism through which we see the nonlinguistic universe. Ernst Cassirer has put the matter clearly and succinctly: "Man not only thinks of the world by means of language. His vision of the world is predetermined by his language." In the modern age these ideas probably go back to Vico and Herder, the first two thinkers to offer a coherent pluralist vision of history. In the book that Isaiah Berlin has devoted to these two historians,[7] he cites a dictum of Vico's: "Geniuses are formed by the character of a language, rather than language being formed by the genius of those who speak it." A century later Joseph de Maistre said the same thing, though less clearly: "Thoughts and words are synonymous." André Breton held somewhat similar views; for him, the perfect equivalence between sound and meaning manifested itself in poetry; hence, he insisted, it is absurd to ask what Rimbaud meant when he said this or that. Poems are not to be explained or interpreted; in them the sign ceases to signify: it *is*. For Herder, each language was not so much a system of signs as a physiognomy, by which he meant that language is a destiny, a way not only of speaking but of being. According to Herder, those languages that had preserved gender contained a vision of

7. *Vico and Herder: Two Studies in the History of Ideas*, 1979.

the world essentially different from that of the "asexual" languages. Thus logic itself was simply the abstract ex ression of a language: there are as many logics as languages.

The first linguist to reject the view of language as a passive expression of the speaker was Wilhelm von Humboldt. The intuitions and hypotheses of Humboldt and his followers were rediscovered independently, around 1930, by an American linguist, Benjamin Lee Whorf. Whorf's importance resides not just in his reformulation of these ideas but in the fact that he was the first to support his argument by concrete examples and an extraordinarily penetrating analysis. Almost all Whorf's examples were taken from Amerindian languages: Hopi, Mayan, and Nahuatl. Whorf was not a professional linguist but a chemical engineer. He had studied at M.I.T., and his chosen profession led him to work for a fire insurance company. He was apparently a good employee, and out of gratitude for his services the company granted him paid leaves of absence to enable him to pursue his research. Whorf was born in 1897, but it was not until 1924 that linguistics attracted his interest. Since his scientific work was closely linked to his fascination for the world of Amerindians, it should be pointed out that his sympathy for them was first aroused by his boyhood reading of Prescott's history, *The Conquest of Mexico*. Robert Frost once told me that he wrote his first poem after reading the episode of Cortez's Noche Triste in this same book of Prescott's. From an early age Whorf loved riddles and charades; it is not surprising that in his adult years he had a try at deciphering the Mayan hieroglyphs. Other traits may give us an idea of the sort of person he was: throughout his life he kept a diary, and

a diary of his dreams as well. Unfortunately, neither has survived. He had a passion for botany; we are indebted to him for valuable information concerning Mexican flora.[8]

Whorf was a religious man who at the same time possessed a solid scientific background. He believed that profound study of the hidden meaning of the Bible could resolve the contradictions between science and religion. Whorf's attitude in this regard was not markedly different from that of Einstein and other physicists and mathematicians of his day. While pursuing his biblical studies, Whorf stumbled upon the writings of Antoine Fabre d'Olivet, a dramatist, linguist, and occult philosopher who had penned a curious book at the dawn of the nineteenth century: *La Langue hébraïque restituée* (The Hebraic tongue restored). The way readings and destinies cross is amazing. André Breton was also greatly impressed by Fabre d'Olivet, in particular by his linguistic and poetic theories. From his study of the Cabala, Fabre d'Olivet was persuaded that the Hebrew language contained certain universal roots. The age-old dream of a primal, universal language endowed with extraordinary properties such as the perfect correspondence between sound and meaning—a dream handed down by way of Neoplatonic hermeticism and the Cabala—was taken up again at the beginning of the nineteenth century by writers such as Court de Gebelin and Fabre d'Olivet. Both of them influenced Nerval. The sonnet "Vers Dorés" (Golden verses), in which the poet *reads* nature as if it were a text at once indelible and ever-changing, was

8. See John B. Carroll's preface to *Language, Thought and Reality*, a selection of writings by Whorf, 1956.

directly inspired by a work of Fabre d'Olivet's on Pythagoras's verses[9]:

> *Respecte dans la bête un esprit agissant,*
> *chaque fleur est une âme à la Nature éclose,*
> *un mystère d'amour dans le métal repose,*
> *tout est sensible! Et tout sur ton être est puissant.*[10]

In French Symbolist poetry—in Baudelaire's famous sonnet of the correspondences, for instance—echoes and resonances of these ideas can be heard. They can also be heard in Hispano-American poetry of the symbolist period: in the initial sonnet of Rubén Darío's *Las ánforas de Epicuro*, for instance:

> *Mira el signo sutil que los dedos del viento*
> *hacen al agitar el tallo que se inclina . . .*[11]

It is not likely that Whorf had come across all this or even read Nerval. It hardly matters: the reading of Fabre d'Olivet inspired some of his most daring speculations. His studies of the Indian languages of America were an equally decisive factor in the evolution of his thought.

9. *Les Vers dorés de Pythagore, expliqués et traduits pour la première fois en vers eumalpiques français, précédés d'un discours sur l'essence et la forme de la poésie chez les principaux peuples de la terre*, 1813.
10. Respect in the beast an acting spirit,/each flower is a soul full blown and open to nature,/within metal lies a mystery of love,/everything has feelings! And everything has an effect on your being. (My translation.—TRANS.)
11. Look at the subtle sign the fingers of the wind/make as they shake the stem that bends . . . (My translation.—TRANS.)

Around 1926 he learned Nahuatl without a teacher, then went on to learn Mayan and Hopi. The year 1930 found him in Mexico, studying with Don Mariano Rojas, and most important, living in the indigenous community of Milpa Alta, where until just a few years ago Nahuatl was still spoken. Whorf was one of the first—if not the very first—to call attention to the Mayan influence among the Nahuas. In 1931 he published a study entitled "A Central Mexican Inscription Combining Mexican and Maya Day Signs." (This essay—never mentioned or acknowledged by Mexican scholars—is of even greater interest today: the admirable recently discovered frescoes of Cacaxtla, as earlier the reliefs of Xochicalco, are further corroboration of the Mayan presence in central Mexico.)

Back in the United States again, Whorf established contact with one of the great modern linguists, Edward Sapir. Whorf dreamed of writing a book—a project that his early death in 1941, at the age of forty-four, kept him from completing—which was to be called *Language, Thought, and Reality*. He had planned to dedicate the book to Fabre d'Olivet and Sapir: the visionary and the scientist.

Whorf's contribution lies in having provided a truly linguistic foundation for what had previously been a philosophical hypothesis. He called his theory the "principle of linguistic relativity"—a clear allusion to Einstein's physics. In scientific circles it is also known as the "Whorf-Sapir hypothesis." In point of fact, Whorf might not have been able to formulate the whole of his theory without Sapir. I am of the belief that, as will be seen, the hypothesis might also be called "linguistic determinism," and from another point of view, "pluralist nominalism." In one of his very last essays ("Science and Linguistics"), Whorf indicates that "the background linguistic system (in other

words, the grammar) of each language is not merely a reproducing instrument for voicing ideas but rather is itself the shape of ideas. . . . Formulation of ideas is not an independent process, strictly rational in the old sense, but is part of a particular grammar. . . . We dissect nature along lines laid down by our native languages." Whorf counters rationalism by way of a relativism founded not on subjectivity, on the differences between civilizations, or on historical temporality, but on language. As a second step in his reasoning, Whorf introduces a new concept: "We cut nature up, organize it into concepts, and ascribe significances as we do, largely because we are parties to an agreement to organize it in this way—an agreement that holds throughout our speech community and is codified in the patterns of our language. The agreement is, of course, an implicit and unstated one, *but its terms are absolutely obligatory*; we cannot talk at all except by subscribing to the organization and classification of data which the agreement decrees." Relativism breaks down into a determinism.

In Whorf's hypothesis determinism appears as the result of an *agreement* among the members of a given linguistic community. This idea immediately calls to mind Rousseau, the first to assert, as he pondered the origin of language, that in the beginning there was a sort of verbal pact among humans. This pact—the child of necessity and passions, not of reason or freedom—was the antecedent and necessary cause of the social pact. Language founds society and in turn is a society. I confess to a certain vertigo when confronting the ideas of Rousseau and Whorf. Since this agreement or verbal pact is not only implicit but also involuntary—no one is asked for his consent as to how the language he speaks is constituted—neither term is very

accurate. If the relation between the signifier and the signified depends on a convention, how could such a convention come home without the consent of the speakers? Who is the author of this convention—language itself? In that case, what was there *before* language and where did it come from? In a word, if the origin of the so-called linguistic pact does not lie in human will, how does one explain the dual relation between language and society? Language is society's foundation and at the same time is founded on it. Without language, there is no society; without society, there is no language. To me this is one of the great enigmas of human history. Or rather, *the* enigma.

Unlike Rousseau's pact, Whorf's *agreement* is not universal, or rather it is a universal phenomenon that in each case manifests itself in a particular way and establishes a set of rules for speaking and thinking that are different for each group. This idea is very close to Wittgenstein's later philosophy and what he called "language games." The idea of language as a game, or more exactly as a set of games, is not far removed from the idea of language as an agreement: in both instances each language is governed by its own rules, which are inescapable and inapplicable either to other games or to other linguistic communities. It seems to me that Wittgenstein's and Whorf's ideas are very similar to the old nominalism, except that their version is pluralist and relativist. On the one hand, names have ceased to be universal and eternal; on the other hand, meanings are valid only within a given community and last only as long as it does. When I write that reality is not the name but rather names and their combinations, I am puzzled once again: are these combinations infinite? If that is the case, doesn't the linguistic relativism disappear? But who except God could find the point at which all these

combinations intersect and thereby produce the ultimate (and original) meaning that encompasses all others?

Whorf's hypothesis is a simultaneous attack on two basic terms of traditional philosophy, the object and the subject, objectivism and subjectivism. His argument against the former is that our language determines our logic and our vision of reality; his argument against the latter is that "no one is free to describe nature with absolute impartiality but is constrained to certain modes of interpretation even while he thinks himself most free." Language is more powerful than the individual self. Whorf concludes: "We are thus introduced to a new principle of relativity, which holds that all observers are not led by the same physical evidence to the same picture of the universe, unless their linguistic backgrounds are similar, or can in some way be calibrated." Whorf was not unaware of the influence of history and of nonlinguistic elements on the differences between languages. Nor did these differences appear to him to be irreducible. It is possible to pass from one language to another, but this leap implies a grave loss: the fact that "modern Chinese or Turkish scientists describe the world in the same terms as Western scientists means, of course, only that they have taken over bodily the entire Western system of rationalization, *not that they have corroborated that system from their native posts of observation*." I have emphasized the last phrase because it seems to me to be of major importance: by adopting the Western point of view the Chinese or Arabs lose the particular perspective of their own cultures, and as a result they impoverish themselves and impoverish the human species.

The great pride of the West is physics, in which certain concepts such as time, velocity, and matter are basic. Whorf did not reject modern physics—he imbibed it at the source

in one of its great centers: M.I.T. in Cambridge—but he maintained that the concepts underlying it "are not essential to the construction of a consistent image of the universe." Time is axiomatic in our physics, whereas "Hopi may be called a timeless language." Although Hopi has a psychological time—reminiscent of Bergson's *durée*—it in no way resembles the mathematical time (T) used by our physicists. The Hopi does not say, "I stayed in such and such a place for five days," but rather, "I left such and such a place on the fifth day." The omission of time does not preclude Hopi grammar from readily distinguishing between momentary, continued, and repeated occurrences and events, indicating sequences and specifying other pertinent characteristics. Thus "the universe can be described without recourse to a concept of dimensional time: How would a physics constructed along these lines work, with no T (time) in its equations? Perfectly, as far as I can see, though of course it would require different ideology and perhaps a different mathematics as well. . . . We may have to introduce a new term I, intensity." Someone will surely ask: Why, then, haven't the Hopis—or the Chinese or the Hindus—created a physics that, although different, would be comparable to the physics of the West? Isn't it more sensible to attribute cultural differences to the historical diversity of the various societies rather than to the plurality of languages? I confess that this argument, though reasonable, does not tempt me: I prefer to think of a physics in which T (time) has been replaced by I (intensity), and V (velocity) by R (rhythm).

Whorf's critics—even his most intelligent interpreters, such as Georges Mounin—have said that he saw language as a prison of concepts. It would be more exact to say that for him languages were *points of view*. True enough, we

cannot get outside of our language, but this language that imprisons us is also a window, a lookout post on the world, on our fellows, and on other languages. Whorf sees Hopi and Nahuatl from the viewpoint of his English, as I see his theories from the viewpoint of my Spanish. John B. Carroll rightly says: "Surely, at any rate, it would have been farthest from Whorf's wishes to condone any easy appeal to linguistic relativity as a rationalization for a failure of communication between cultures or between nations. Rather, he would hope that a full awareness of linguistic relativity might lead to humbler attitudes about the supposed superiority of standard average European languages." I for my part will add that Whorf's linguistic relativism is a paradoxical pluralism, since it is founded on a (possibly illusory) belief in an original common language. Even if science disproves this hypothesis—which he never dared maintain openly—this would not invalidate his idea of language as a window that allows us to see others and, within certain limits, to communicate with them. Whorf's linguistic relativism is a corrective for our ethnocentrism: "We are one constellation in one galaxy."

In my necessarily brief description of Whorf's linguistic philosophy, I have barely mentioned its contradictions and weaknesses. Its major shortcoming is the circular and tautological nature of his theory: linguistic differences become one with cultural differences, which in turn become linguistic differences. Perhaps the answer to this criticism is to recognize once and for all that each culture—that totality of material, intellectual, and emotional structures: the things, institutions, and persons that go to make up a society—is predominantly a symbolic system. Thus both the contradiction between language and society and the culture/language tautology disappear: every act of human beings—

even their crimes—*says* something. We are condemned to voice meaning endlessly. We *are* language.

Reading, Understanding, Contemplating

There is one aspect of Whorf's thought that linguists generally avoid discussing, out of a sort of modesty. I am referring to the notion of "phonetic symbolism," which one of his disciples (Carroll) defines as "inherent relations (over and above the arbitrary relations established in any given language) between sounds and meanings." This is a return to Plato's *Cratylus* with, however, a new basis. In one of his essays—the one on the Mayan language, "Stem Series in Maya"—Whorf writes: "Ideas obey phonetics." This statement is, to a certain degree, a consequence of the necessary verbal "agreement," independent of the will of its speakers, that Whorf takes to be the foundation of a given language. At the same time he goes beyond this idea, supposing that in language—that is to say, in its constitutive particles: phonemes and morphemes—there are manifested affinities and antipathies, conjunctions and oppositions, governed by forces that can only be called attraction and repulsion. What we are dealing with here are phenomena that we have not as yet succeeded in isolating or completely understanding. I must admit that Whorf never elaborated upon this idea, least of all in the terms I have used. It appears in his earliest writings, in a rather embryonic form; in truth, I have dared to draw from his brief, sometimes not at all clear, allusions to "phonetic symbolism" conclusions that may well be too categorical.

The image of language that Whorf puts before us offers a surprising analogy with the universe of modern physics. I am thinking not only of the physics that concerns itself with celestial bodies, from galaxies to planets, but of the physics that studies the infinitely small: the atom, electrons and neutrons, elementary particles. In both cases we find worlds in motion, governed by various forces that result in the creation of states in dynamic equilibrium between two extremes or tendencies: concentration and dispersion, the centifugal and the centripetal. Whorf's linguistics is a physics. Without contradiction, it is an erotic as well: a universe, ruled by attraction and repulsion, that in the alliances and antagonisms of its elements engenders figures that are endless variations on a single pattern. Stars and atoms, sexes and syllables—all are under the sway of the double rhythm of conjunctions and disjunctions. The analogy does not hold, however, at one angle of the triad: language. There is a difference, ignored by Whorf and many modern linguists: the junctions and separations between phonemes and syllables invariably secrete a unique, impalpable element—meaning. Neither the stellar universe nor the sexual one is a system of meaning: language, on the other hand, when amputated from meanings, ceases to be language. The atom, the galaxy, and the erotic cluster are faithless mirrors: they reproduce the bodies of language, its movements and embraces, but not its meaning. They rob it of its shadow, the reflection that signs cast on human awareness.

The criticism I have just briefly outlined points to the limits of the analogy between language and the physical universe. This criticism, it seems to me, holds good for many of the modern conceptions of language; however they may differ from each other, all of them have in com-

mon the elimination or the bracketing of meaning. But the difficulties and stumbling blocks encountered by contemporary semiotics at the other extreme also warn against the mirages of meaning. It goes without saying that everything human beings touch is impregnated with meaning; the trouble is that the moment we perceive it, meaning scatters and disappears. There is no meaning but meanings. Each one of them is instantaneous and lasts no longer than its appearance. Ashes of meaning: ashes without meaning. The question that meaning has traditionally put to things and to human beings—what does the universe, with its suns and planets, mean? what meaning is there to what we call life, death, history, humanity, atom, planet?—can also be put to language. We may also ask it: what does meaning mean? Language does not answer, and its silence seems to tell us that meanings have no final meaning or that such a meaning is unutterable and, properly speaking, ineffable and unthinkable. Meanings cancel each other out; on the ruins of meaning there appears a reality that cannot be named or perhaps even thought.

To question language is to question ourselves. Whorf no doubt asked himself the same question I have just asked myself. His last essays, written shortly before his death at an early age, were an attempt to overcome the linguistic relativism with which his name is associated. To overcome it, not deny it. At no time did Whorf have doubts about his thesis that each language—or rather each family of languages—constitutes a complete system that encompasses and determines the culture of its speakers. Despite the fact that each language is a world, all of them are constituted in the same way. Whorf conceived of them as a series of planes or levels: the physical-phonetic, the phonemic and the morphophonemic, the morphological and the

syntactical. The last plane, barely perceptible to conscious awareness, is situated beyond meanings and referents. This level is essentially characterized by the relations between the different linguistic elements and by the patterns and configurations that these relations create. On this plane the "combinatory system" that every language essentially constitutes appears with total clarity. Like Chomsky, though following a different course and pursuing different objectives, Whorf finds a common element in all languages. The diversity of idioms resolves into identity: each and every one is a system of relations, not static but dynamic. The analogy appears once again: languages are animated by something like a universal rhythm which is no different from that of music and likewise reflects mathematics.

Whorf was persuaded that, despite their increasing specialization, the sciences were little by little discovering "a noumenal world" whose first aspect is that of "a realm of PATTERNED RELATIONS." This assertion, I need scarcely add, calls to mind Pythagoras, as well as the Platonic vision of ideas and archetypes, although Whorf's ideas are not located in heaven and do not move in circles: his universe is that of contemporary physics. It is a world in perpetual motion that shows "a recognizable affinity to the rich and systematic organization of LANGUAGE, and also of mathematics and music." The archetypal configurations of language (the forms that bind and group the different elements together so as to construct words and sentences) "are basic in a really cosmic sense" and "form wholes, akin to the Gestalten of psychology, which are embraced in larger wholes in continual progression." Language is a fabric made of the patterns, from the simplest to the most complex, formed by the different linguistic elements. Although this fabric is continually changing and moving, the patterns

that appear, disappear, and reappear are variations of a few archetypes or models, inscribed, so to speak, in the laws of motion that produce the different combinations. The verbal patterns reproduce in some way the forms of perception (*Gestalt*), the map of the cosmos, the musical score, the page of equations, and the forms of geometry. The idea that the fabric of the universe appears in language was one already familiar to other civilizations, as Whorf himself points out. I imagine that his hypothesis would be accepted today by a number of philosophers of science, such as the topologist René Thom. I must add, finally, that this idea is the basis of modern poetics: it is the age-old vision of universal correspondence, already present among the Neo-platonists and reelaborated by the Romantics, the Symbolists, and certain contemporary poets. Nature and language correspond to each other, reflect each other; both can be seen as systems or configurations in rotation that in turn engender other moving patterns.

In our day the expression *to read* has become popular. We no longer say the *theory* but the *reading* of the universe of physicist X; likewise, we do not say the *interpretation* but the *reading* of Shakespeare's theater by critic Z: an affectation that would be harmless enough, if it did not reveal a certain spiritual myopia. I grant that to read means to understand, but does it mean to contemplate? Contemplation is the highest form of understanding because it embraces seeing and understanding. Contrary to the moderns, Whorf does not suggest that we read a text hidden beneath the linguistic text or get to the bottom of the relations between the different elements of nature—atoms, cells, stars—as if we were dealing with a discourse. The American linguist does not attempt to translate the forms and configurations of nature into linguistic signs, but rather

proposes precisely the opposite: *that we see linguistic signs as forms and archetypes.* In the same essay he says: "To 'see,' for instance, how all the English elementary sounds ('phonemes') and their groupings are coordinated by an intricate yet systematic law into all possible forms of English monosyllabic words, meaningful or nonsensical, existent or still unthought-of, excluding all other forms as inevitably as the chemical formula of a solution precludes all but certain shapes of crystals—this might be a distinct experience." A rare one, "yet many mathematicians and scientific linguists must have had the experience of 'seeing,' in one fugitive flash, a whole system of relationships never before suspected of forming a unity." It is not an exaggeration to compare this vision of language, bathed in a current of aesthetic delight, to the contemplation of the philosophers of antiquity.

At their highest level—which is also the deepest: at the base and at the apex—"the 'patternment' aspect of language always overrides and controls the 'lexation' . . . the higher mind deals in symbols that have no fixed reference to anything, but are like blank checks, to be filled in as required, that stand for 'any value' of a given variable." Thus "reference is the lesser part of meaning, patternment the greater." Language leads to a language beyond dictionaries, references, and meanings. Meaning does not evaporate but is irreducible to signification: it is a form. Whorf's linguistics, in its final phase, is a farewell to meaning, not in order to plunge into meaninglessness, as frequently occurs with nihilist criticism, but into a state not far removed from the emptiness (*śūnyatā*) of Buddhism. His conception also comes close to the vision of Plotinus: in their ultimate reality, forms do not mean; they are. The One does not even think, since thinking is already duality. But it does not matter

what our interpretation is: don't contemplation of being and contemplation of emptiness correspond?

Whorf's thought appears to be yet another disenchantment with faith in the sign that the West has professed throughout the modern age. There is a moment at which meanings, the subordinates of relations, evaporate; only forms remain. It is revealing that this disillusionment is the work not of philosophy but of linguistics, the last great intellectual undertaking of our civilization. For Whorf, the illusion of meaning "has been sealed in western Indo-European language, and the road out of illusion for the West lies through a wider understanding of language than western Indo-European alone can give." The criticism of meaning—which is the criticism of the modern West since the Renaissance—takes place through the criticism of language. But this criticism has been made—can be made—only from the viewpoint of the languages of the West. It is self-criticism. And a return to origins: Whorf's thought proceeds from the most radical linguistic relativism to a conception not far removed from the belief on which the speaking in tongues of the early Christians and the Gnostics was founded. It is not meanings but the combinations among linguistic elements that produce a meaning beyond meaning—a meaning we may see and hear but not translate, save through the medium of poetry and art, which in turn are untranslatable.

The quarrel between the One and the Many, between the spirit and the letter, has been resolved in different ways. The search for an original, primal language becomes, inevitably, the question as to the meaning of meaning. But meaning breaks down into a plurality of contrary meanings that ultimately cancel each other out: there is no meaning. The dissolution of signs culminates in the appearance of a

presence or an emptiness, both of them unutterable and unthinkable. Being trickles away into its attributes and manifestations; emptiness negates itself in its nothingness. Both presence and absence are eaten away by contradiction. We can say nothing about them and nothing names them, not even the word *nothing*. Nor does silence designate them. Silence does not *say*, or rather, it says only as the reverse of saying. Silence depends on words; it is an ultimate dimension of saying. If everything we touch and name becomes full of meaning, and if all these meanings—provisional, disparate, contradictory—instantly lose their meaning, what is left to us? To begin all over again. Between meaning and meaninglessness, between saying and silence, a spark is struck: a knowing without knowing, a comprehending without understanding, a speaking while remaining silent. We can still hear, in what we say, the meanings we do not voice. We can still contemplate.

Two hundred years before us and before our quarrels and questions, in the Tibet of the eighteenth century, under the Fifth Dalai Lama, a notable event took place. One day His Holiness saw, from a window of the Potala, his palace-temple-monastery, an extraordinary sight: in accordance with Buddhist ritual, the goddess Tara was circling the wall surrounding the building. The next day at the same hour the same thing happened, and again on the days that followed. After a week of watching, the Dalai Lama and his monks discovered that every day, just when the goddess appeared, a poor old man also walked around the wall, reciting his prayers. The old man was questioned: he was reciting a prayer in verse to Tara, which in turn was a translation of a Sanskrit text in praise of Prajñā Pāramitā. These two words mean Perfect Wisdom, an expression that designates emptiness. It is a concept that Mahayana

Buddhism has personalized in a female divinity of inexpressible beauty. The theologians had the old man recite the text. They at once discovered that the poor man was repeating a faulty translation, so they made him learn the correct one. From that day forth, Tara was never seen again.

Seeing and Using:
Art and Craftsmanship

In its rightful place. Not fallen from above, but emerged from below. Ocher, the color of burnt honey. Sun color buried a thousand years ago and dug up yesterday. Fresh green and orange stripes cross its still-warm body. Circles, frets: remains of a scattered alphabet? Pregnant woman's belly, bird's neck. If the palm of your hand covers and uncovers its mouth, it answers you in a low murmur, a bubble of gushing water; if you rap its haunch with your knuckles, it gives a laugh of little silver coins falling on stones. It can speak in many tongues, the language of clay and matter, that of air flowing down between the walls of the ravine, that of washerwomen as they do their laundry, that of the sky when it grows angry, that of rain. A baked clay vessel. Don't put it in the glass display case full of rare objects. It would show up badly. Its beauty is allied

with the liquid it contains and the thirst it quenches. Its beauty is corporeal: I see it, touch it, smell it, hear it. If it is empty, it must be filled; if it is full, it must be emptied. I take it by the turned handle as I would take a woman by the arm, I lift it up, I tilt it over a pitcher into which I pour milk or pulque—lunar liquids that open and close the doors of dawn and dark, of waking and sleeping. It is not an object to contemplate, but one for pouring something to drink.

A glass pitcher, a wicker basket, a *huipil* of coarse cotton cloth, a wooden bowl—handsome objects not in spite of but because of their usefulness. Their beauty is an added quality, like the scent and color of flowers. Their beauty is inseparable from their function: they are handsome because they are useful. Handicrafts belong to a world existing before the separation of the useful and the beautiful. This distinction is more recent than is generally believed: many of the objects gathered together in our museums and private collections belonged to that world in which beauty was not an isolated and self-sufficient value. Society was divided into two great realms, the profane and the sacred. In both, beauty was subordinate, in the one case to usefulness and in the other to magic. Utensil, talisman, symbol: beauty was the aura surrounding the object, the consequence—nearly always involuntary—of the secret relation between its making and its meaning. Making: how a thing is made; meaning: what it is made for. Today all these objects, torn from their historical context, their specific function, and their original significance, take on in our eyes the appearance of enigmatic divinities and command our adoration. The transition from the cathedral, the palace, the nomad's tent, the boudoir of the courtesan, and the witch's cave to the museum was a magico-religious

transmutation: objects turned into icons. This idolatry be-
gan in the Renaissance and, from the eighteenth century
on, has been one of the religions of the West (the other
being politics). We find Sor Juana Inés de la Cruz, at the
height of the Baroque era, already poking gentle fun at the
aesthetic superstition: "A woman's hand," she says, "is
white and beautiful because it is a thing of flesh and bone,
not ivory or silver; I esteem it not because it gleams but
because it grasps."

The religion of art, like the religion of politics, was born
of the ruins of Christianity. Art inherited from the old
religion the power of consecrating things and endowing
them with a sort of eternity; museums are our temples,
and the objects displayed in them are beyond history. Pol-
itics—or more precisely, Revolution—co-opted the other
function of religion: changing human beings and society.
Art was an asceticism, a spiritual heroism; Revolution was
the construction of a universal church. The mission of the
artist was to transmute the object; that of the revolutionary
leader, to transform human nature. Picasso and Stalin. The
process has been twofold: in the realm of politics, ideas
have been turned into ideologies, and ideologies into idol-
atries; objects of art, in turn, have become idols, and idols
have been transformed into ideas. We view works of art
with the same absorption as the sage of antiquity contem-
plated the starry sky (though with less profit): like heavenly
bodies, these paintings and sculptures are pure ideas. The
religion of art is a Neoplatonism that dares not speak its
name—except when it is a holy war against heretics and
infidels. The history of modern art may be divided into
two currents: the contemplative and the combative. Ten-
dencies such as Cubism and Abstractionism belong to the

former current; movements such as Futurism, Dadaism, and Surrealism, to the latter. Mysticism; crusade.

For the ancients, the movement of the stars and planets was the image of perfection: to see the celestial harmony was to hear it, and to hear it was to understand it. This religious and philosophical vision reappears in our conception of art. For us, paintings and sculptures are not beautiful or ugly objects but intellectual and sensible entities, spiritual realities, forms in which Ideas are made manifest. Before the aesthetic revolution, the value of works of art was related to another value: the link between beauty and meaning. Objects of art were things that were sensible forms that were signs. The meaning of a work was plural, but all its meanings were related to an ultimate signifier in which meaning and being were conjoined in an indissoluble knot: divinity. The modern transposition: for us the artistic object is an autonomous and self-sufficient reality; its ultimate meaning does not lie beyond the work but within it. This meaning lies beyond—or falls short of—meaning; it no longer possesses any referent whatsoever. Like the Christian divinity, Jackson Pollock's paintings do not mean: they are.

In modern works of art, meaning dissipates in the radiation of being. The act of seeing is transformed into an intellectual operation that is also a magical rite: to see is to understand and to understand is to commune. Side by side with divinity and its devotees are its theologians, the art critics. Their excogitations are no less abstruse than those of medieval Scholastics and Byzantine doctors of divinity, though their logic is less rigorous. The questions that aroused the passions of Origen, Albertus Magnus, Abelard, and Thomas Aquinas reappear in the quarrels of our art critics,

though in a disguised and trivialized form. Nor does the resemblance end there: to the divinities and the theologians who explain them we must add the martyrs. In the twentieth century we have seen the Soviet state persecute poets and artists with the same ferocity as that shown by the Dominicans in extirpating the Albigensian heresy.

It is only natural that the exaltation and sanctification of the work of art should have given rise to periodic rebellions and profanations: removing the fetish from its niche, painting it in garish colors, parading it through the streets with the ears and tail of a donkey, dragging it in the dirt, poking holes in it and showing that it is full of sawdust, that it is nothing and no one and means nothing—and then setting it back on its throne. "What art needs is a sound thrashing," the Dadaist Huelsenbeck once said in a moment of exasperation. He was right, except that the bruises left on the Dadaist object by the beating were like decorations on the chests of generals: they lent respectability. Our museums are full to overflowing with antiworks of art and works of antiart. More astute than Rome, the religion of art has absorbed all the schisms.

I don't deny that the contemplation of three sardines on a plate or of a triangle and a rectangle may enrich us spiritually; I merely affirm that the repetition of this act soon degenerates into a tedious ritual. That is why the Futurists, faced with the Neoplatonism of the Cubists, sought to reintroduce the subject into the work of art. It was a healthy reaction on their part, and at the same time a naive one. The Surrealists, possessed of greater perspicacity, insisted that the work of art should say something. Since reducing the work to its content or message would have been stupid, they eagerly embraced a notion that Freud had launched: *latent content*. What a work of art says is not its manifest

content but what it says without saying anything: that which lies behind forms, colors, words. This was a way of loosening, without undoing altogether, the theological knot between being and meaning in order to preserve, insofar as possible, the ambiguous relation between the two terms.

Marcel Duchamp was the most radical of all: the work passes by way of the senses but it does not linger in them. The work is not a thing; it is a fan of signs that, as it opens and closes, alternately reveals and conceals its meaning. The work of art is a secret sign exchanged between meaning and meaninglessness. This attitude has its danger—one that Duchamp (almost) always escaped: one may fall off on the other side and be left with the concept and without the art, with the *trouvaille* and without the thing itself. This is what has happened to his imitators. One might add that frequently they end up without either the art or the concept. It scarcely bears repeating that art is not concept: art is a thing of the senses. Speculating about a pseudoconcept is more boring than contemplating a still life. The modern religion of art turns round and round in circles without ever finding the road to salvation; it goes from the negation of meaning through the object, to the negation of the object through meaning.

The industrial revolution was the other side of the coin of the artistic revolution. The ever-increasing production of identical and more and more perfect utensils was the exact counterpart of the consecration of the work of art as a unique object. Like museums, our houses became filled to overflowing with clever gadgets. Precise, obedient, mute, anonymous instruments. In the beginning, aesthetic

concerns played almost no role at all in the production of use-
ful objects. Or rather, these concerns led to results quite
different from those their manufacturers had imagined. The
ugliness of many objects from the prehistory of industrial
design—an ugliness not without charm—stems from the
fact that the "artistic" element, generally borrowed from
the academic art of the period, was superimposed upon
the object itself. The result was not always unfortunate,
and many of these objects—those of the Victorian era and
also of the so-called modern style—belong to the same
family as the sirens and sphinxes of the Baroque period.
This family was ruled by what might be called the aes-
thetics of incongruity. In general, the evolution of the in-
dustrial object for daily use has followed that of artistic
styles. Almost invariably, industrial design has been a de-
rivation—sometimes a caricature, sometimes a felicitous
copy—of the artistic vogue of the moment. It has lagged
behind contemporary art and has imitated styles at a time
when they had already lost their initial novelty and were
becoming aesthetic clichés.

Contemporary design has endeavored in other ways—
its own—to find a compromise between usefulness and
aesthetics. At times it has managed to do so, but the result
has been paradoxical. The aesthetic ideal of functional art
is based on the principle that the usefulness of an object
increases in direct proportion to the paring down of its
materiality. The simplification of forms may be expressed
by the following equation: the minimum of presence equals
the maximum of efficiency. This aesthetic is borrowed
from the world of mathematics: the *elegance* of an equation
lies in the simplicity and necessity of its solution. The ideal
of design is invisibility: the less visible a functional object,
the more beautiful it is. A curious transposition of Arab

fairy tales and legends to a world ruled by science and the notions of utility and maximum efficiency: the designer dreams of objects that, like genies, are intangible servants. This is the contrary of the work of craftsmanship, a physical presence that enters us through our senses and in which the principle of usefulness is constantly violated in favor of tradition, imagination, and even sheer caprice. The beauty of industrial design is of a conceptual order; if it expresses anything at all, it is the accuracy of a formula. It is the sign of a function. Its rationality makes it fall within an either/or dichotomy: either it is good for something or it isn't. In the second case it goes into the trash bin. The handmade object does not charm us simply because of its usefulness. It lives in complicity with our senses, and that is why it is so hard to get rid of it—it is like throwing a friend out of the house.

There is a time when the industrial object at last becomes a presence with an aesthetic value: when it becomes useless. It then becomes a symbol or an emblem. The locomotive whose praises Whitman sings is a machine that has come to a halt and no longer transports in its cars either passengers or freight: it is a motionless monument to speed. Whitman's disciples—Valéry Larbaud and the Italian Futurists—extolled the beauty of locomotives and railroads at the very moment when other means of transportation—airplanes, automobiles—were beginning to take their place. The locomotives of these poets are the equivalent of the artificial ruins of the eighteenth century: they are a complement to the landscape. The cult of the machine is a naturalism *à rebours*: a usefulness that becomes a useless beauty, an organ without a function. By way of ruins, history turns back into nature, whether we stand before the crumbled stones of Nineveh or a locomotive graveyard

in Pennsylvania. Our fondness for machines and appara-
tuses fallen into disuse not only constitutes one more proof
of humanity's incurable nostalgia for the past, but also
reveals a rift in the modern sensibility: our inability to
associate beauty and usefulness. Here is a double damna-
tion: the religion of art forbids us to consider the useful
beautiful; the cult of utility leads us to conceive of beauty
not as a presence but as a function. This may explain why
technology has been such a poor source of myths: aviation
is the realization of an age-old dream that appears in all
societies, but it has not created figures comparable to Icarus
and Phaëthon.

The industrial object tends to disappear as a form and
become one with its function. Its being is its meaning, and
its meaning is to be useful. It lies at the other extreme from
the work of art. Craftsmanship is a mediation; its forms
are not governed by the economy of function but by plea-
sure, which is always wasteful expenditure and has no
rules. The industrial object forbids the superfluous; the
work of craftsmanship delights in embellishments. Its pre-
dilection for decoration violates the principle of usefulness.
The decoration of the craft object ordinarily has no func-
tion whatsoever, so the industrial designer, obeying his
implacable aesthetic, does away with it. The persistence
and proliferation of ornamentation in handicrafts reveal an
intermediate zone between utility and aesthetic contem-
plation. In craftsmanship there is a continuous movement
back and forth between usefulness and beauty; this back-
and-forth motion has a name: pleasure. Things are pleasing
because they are useful and beautiful. The copulative con-
junction *(and)* defines craftsmanship, just as the disjunctive
defines art and technology: utility *or* beauty. The hand-
made object satisfies a need no less imperative than hunger

and thirst: the need to take delight in the things we see and touch, whatever their everyday uses. This need is not reducible to the mathematical ideal that rules industrial design, nor is it reducible to the rigor of the religion of art. The pleasure that works of craftsmanship give us has its source in a double transgression: against the cult of utility and against the religion of art.

Made by hand, the craft object bears the fingerprints, real or metaphorical, of the person who fashioned it. These fingerprints are not the equivalent of the artist's *signature*, for they are not a name. Nor are they a mark or brand. They are a sign: the almost invisible scar commemorating our original brotherhood and sisterhood. Made *by* hand, the craft object is made *for* hands. Not only can we see it; we can also finger it, feel it. We see the work of art but we do not touch it. The religious taboo that forbids us to touch saints—"you'll burn your hands if you touch the Tabernacle," we were told as children—also applies to paintings and sculptures. Our relation to the industrial object is functional; our relation to the work of art is semireligious; our relation to the work of craftsmanship is corporeal. In reality, this last is not a relation but a contact. The transpersonal nature of craftsmanship finds direct and immediate expression in sensation: the body is participation. To feel is primarily to feel something or someone not ourselves. And above all, to feel with someone. Even to feel itself, the body seeks another body. We feel through others. The physical and bodily ties that bind us to others are no less powerful than the legal, economic, and religious ties that unite us. Craftsmanship is a sign that expresses society not as work (technique) or as symbol (art, religion) but as shared physical life.

The pitcher of water or wine in the middle of the table

is a point of convergence, a little sun that unites everyone present. But my wife can transform into a flower vase that pitcher pouring forth our drink at the table. Personal sensibility and imagination divert the object from its ordinary function and create a break in its meaning: it is no longer a recipient to contain liquid but one in which to display a carnation. This diversion and break link the object to another realm of sensibility: imagination. This imagination is social: the carnation in the pitcher is also a metaphorical sun shared with everyone. In its perpetual movement back and forth between beauty and utility, pleasure and service, the work of craftsmanship teaches us lessons in sociability. At fiestas and ceremonies its radiation is still more intense and total. At fiestas the collectivity communes with itself, and this communion takes place through ritual objects that almost always are handmade objects. If fiesta is participation in primordial time—the collectivity literally shares out among its members, like sacred bread, the date being commemorated—craftsmanship is a sort of fiesta of the object: it transforms a utensil into a sign of participation.

The artist of old wanted to be like his predecessors, to make himself worthy of them through imitation. The modern artist wants to be different; his homage to tradition is to deny it. When he seeks a tradition, he looks for it outside the West, in the art of primitives or other civilizations. Because they fall outside the tradition of the West, the archaism of the primitive and the antiquity of the Sumerian or Mayan object are paradoxical forms of novelty. The aesthetics of change requires that each work of art be new and different from those preceding it; novelty in turn implies the negation of immediate tradition. Tradition be-

comes a succession of abrupt breaks. The delirium of change also rules industrial production, though for different reasons: each new object, the result of a new process, ousts the object preceding it. The history of craftsmanship is not a succession of inventions or of unique (or supposedly unique) works. In reality, craftsmanship does not have a history, if we conceive of history as being an uninterrupted series of changes. There is not a break but a continuity between its past and its present. The modern artist has embarked upon the conquest of eternity, and the designer upon that of the future; the artisan allows himself to be vanquished by time. Traditional but not historical, linked to the past but bearing no date, the craft object teaches us to be wary of the mirages of history and the illusions of the future. The artisan seeks not to conquer time but to be one with its flow. Through repetitions that are imperceptible but real variations, his works endure—and hence survive the fashionable object.

Industrial design tends to be impersonal. It is subject to the tyranny of function, and its beauty is rooted in that subjection. Yet functional beauty is fully realized only in geometry, and only in geometry are truth and beauty one and the same; in the arts strictly speaking, beauty is born of a necessary infringement of the rules. Beauty—or rather art—is a violation of functionality. Taken together, these trespasses constitute what we call a style. The ideal of the designer, if he is consistent, ought to be the absence of style—forms reduced to their function—whereas the ideal of the artist should be a style that begins and ends in each of his works. (Perhaps this is what Mallarmé and Joyce were aiming at.) No work of art, however, begins and ends in itself; each is a language at once personal and collective: a style, a manner. Styles are communal. Every

work of art is at once a deviation from and a confirmation of the style of its time and place: by violating the canons of that style, it validates them. Again, craftsmanship lies at a midpoint: like design, it is anonymous; like the work of art, it is a style. In contradistinction to design, the craft object is anonymous yet not impersonal; in contradistinction to the work of art, it brings out the collective nature of style and shows us that the vainglorious *I* of the artist is a *we*.

Technology is international; its constructions, methods, and products are the same everywhere. By suppressing national and regional particularities and peculiarities, it impoverishes the world. By spreading all over the globe, technology has become the most powerful agent yet of historical entropy. The negative character of its action may be summed up in a phrase: it makes things uniform but does not unify. It levels the differences between cultures and national styles, but it does not do away with the rivalries and hatreds between peoples and states. After transforming rivals into identical twins, it arms both of them with the same weapons. The danger of technology does not lie solely in the death-dealing nature of many of its inventions, but in the fact that it threatens the very essence of the historical process. By putting an end to the diversity of societies and cultures, it puts an end to history itself. It is the amazing variety of societies that produces history: the clashes and encounters between different groups and cultures, between alien ideas and techniques. There is no doubt an analogy between the historical process and the twofold phenomenon that biologists call inbreeding and outbreeding, and that anthropologists call endogamy and exogamy. The great civilizations have been syntheses of different and contradictory cultures. Where a civilization

has not been forced to confront the threat and undergo the stimulation of another civilization—as was the case in pre-Columbian America up until the sixteenth century—its destiny is to mark time and go in circles. The experience of the *other* is the secret of change—and of life.

Modern technology has brought about a great many profound transformations, but all in the same direction and with the same import: the extirpation of the *other*. By leaving the aggressiveness of the human species intact and by making its members uniform, it has lent added strength to the causes tending toward its extinction. Craftsmanship, on the other hand, is not even national in scope: it is local. Heedless of boundaries and systems of government, it out-lives republics and empires: the pottery, basketwork, and musical instruments seen in the frescoes of Bonampak have survived Mayan priests, Aztec warriors, colonial friars, and Mexican presidents. They will also survive American tourists. Craftsmen have no country; they are from their village. What is more, they are from their neighborhood and their family. Craftsmen defend us from the unification of technology and its geometrical deserts. By preserving differences, they safeguard the fecundity of history.

The craftsman does not define himself in terms of either his nationality or his religion. He is not loyal to an idea or image but to a practice: his craft. A workshop is a social microcosm governed by laws of its own. The craftsman seldom works by himself, nor is his work exaggeratedly specialized as in industry. His workday is not ruled by a rigid time schedule but by a rhythm linked more to his body and sensibility than to the abstract necessities of production. As the craftsman works he may talk with others and sometimes sing. His boss is not an invisible bigwig but an old man who is his master and almost always a

relative of his, or at least a neighbor. It is revealing that, despite its markedly collectivist character, the craft workshop has not served as a model for any of the great utopias of the West. From Campanella's City of the Sun to Fourier's Phalanstery to Marx's Communist society, the prototypes of the perfect social man have not been craftsmen but priest-sages, philosopher-gardeners, and the worker of the world in whom praxis and science are conjoined. Of course I do not believe that the craft workshop is an image of perfection. Yet I think that its very lack of perfection points to how we might humanize our society: its imperfection is that of men and women, not of systems. Because of its size and the number of persons who compose it, a community of craftsmen favors a democratic way of life; its organization is hierarchical but not authoritarian, and its hierarchy is founded not on power but on skill: masters, journeymen, apprentices. Finally, craftwork is an occupation that involves both play and creation. After giving us a lesson in sensibility and imagination, craftsmanship gives us one in politics.

Until recently, it was commonly believed that crafts were doomed to disappear, industry having usurped their place. Precisely the opposite is happening today: for better or worse, handcrafted articles now play an appreciable role in world trade. The products of Afghanistan and the Sudan are sold in the same department stores as the newest creations straight from the Italian or Japanese industrial designer's board. This renaissance is most notable in the industrialized countries and affects both consumer and producer. In places where the concentration of industry is greatest—in Massachusetts, for example—we are witness

to the resurrection of the old trades of potter, carpenter, glassblower; many young people sick and tired of modern society have returned to craftwork. In those countries dominated (at the wrong time in their development) by the fanaticism of industrialization, there has been a revival of craftwork. Often, national governments encourage handicrafts. This phenomenon is disturbing, insofar as government subsidies are usually forthcoming for commercial reasons. The craftsmen who today are the object of the paternalism of official planners were only yesterday threatened by projects for their country's modernization drawn up by the very same bureaucrats, intoxicated by economic theories learned in Moscow, London, or New York. Bureaucracies are the natural enemies of the craftsman, and whenever they set out to "orient" him, they blunt his sensibility, mutilate his imagination, and degrade his handiwork.

The return of craftwork in the United States and Western Europe is one of the symptoms of the great change in contemporary sensibility. We find here yet another expression of the criticism of the abstract religion of progress and of the quantitative vision of humanity and nature. To experience the disillusionment of progress, it is necessary, to be sure, to have experienced progress. It is not likely that underdeveloped countries share this disillusionment, even if the ruinous nature of industrial superproductivity is increasingly evident. Nobody learns from someone else's experience. Yet how can we not see what the belief in infinite progress has led to? If every civilization ends in a pile of ruins—a heap of broken statues, fallen columns, texts ripped to shreds—those of industrial society are doubly impressive, because they are immense and premature. Our ruins are beginning to be more awesome than our

constructions and threaten to bury us alive. This is why the popularity of craftwork is a sign of health, as is the return to Thoreau and Blake or the rediscovery of Fourier. Our senses, our instinct, our imagination are always a step ahead of our reason. Criticism of our civilization began with the Romantic poets, at the very dawn of the industrial era. The poetry of the twentieth century took up the Romantic revolt and sank its roots even deeper, but only recently has this spiritual rebellion penetrated the minds and hearts of the majority. Modern society is beginning to doubt the very principles on which it was founded two centuries ago, and is trying to change course. Let us hope that it is not too late.

The fate awaiting the work of art is the air-conditioned eternity of the museum; that awaiting the industrial object is the trash bin. Craftwork escapes the museum, and when it does end up in its showcases, it acquits itself with honor: rather than a unique object, it is merely a sample. It is a captive example, not an idol. Craftsmanship does not go hand in hand with time, nor does it seek to conquer it. Experts periodically examine the inroads of death on art works: cracks in paintings, lines that have blurred, changes of color, the leprosy that eats away both the wall paintings of Ajanta and Leonardo's canvases. As a material thing, the work of art is not eternal. And as an idea? Ideas too grow old and die. But artists very often forget that their work holds the secret of true time: not empty eternity but the life of the instant. The work of art, moreover, has the power to fecundate human spirits and to be reborn, even as negation, in the works that are its descendants. For the industrial object there is no resurrection; it disappears as rapidly as it appears. If it left no trace whatsoever it would be truly perfect; unfortunately it has a body, and once it

has ceased to be useful, it becomes mere refuse difficult to dispose of. The indecency of trash is no less pathetic than the indecency of the false eternity of the museum. Craftsmanship does not aspire to last for millennia, but at the same time it seeks no early death. It follows the course of time from day to day, it flows along with us, it very slowly wastes away, it neither looks for death nor denies it. It accepts it. Between the time without time of the museum and the accelerated time of technology, the work of craftsmanship is the pulse of human time. It is a useful object but also a handsome one; an object that endures through time yet meets its end and resigns itself to so doing; an object that is not unique like the work of art, but replaceable by another object similar yet not identical. Craftwork teaches us to die, and by so doing teaches us to live.

Cambridge, Mass., December 7, 1973

At Table and in Bed

Civilization and Harmony

The comparisons that I propose to develop call for a justification. If I wish to examine the present situation in Mexico, I spontaneously compare it with our past and think of the times of Montezuma, the Viceroy Bucarelli, the dictator Santa Anna, or President Cárdenas. In the case of the United States, however, the comparison that suggests itself is between present reality and some utopian construction. Like most other countries, Mexico is the product more of historical circumstances than of the will of its citizens. In this respect too, the United States is an exception: will was a determining factor in the birth of that nation. The poet Luis Cernuda used to say to me: "I am doomed to be Spanish." And a character in Carlos Fuentes's novel *La región más transparente* (Where the air is clear) says: "This is where it was my fate to be born. What

can I do?" It will be said that there are Americans for whom it is a curse to be what they are, particularly after Vietnam. This hardly matters: in the beginning and all during its early development, the United States was a choice, not a fate. It is the product of a plan for a society rather than the offshoot of an already established society. The U.S. Constitution is a pact whose aim was to found a new society, and in this sense it is a society prior to history. Before history and beyond it: the society of the American republic overvalues changes and envisions itself as the will to annex the future. Hence it is not an absurdity to compare the present situation of the United States with other realities or ideas that lie outside history—primitive societies, for example, or those imagined by utopian schemes: Rousseau or Fourier, the Neolithic village or the phalanstery. The first antedates history, like the pact that founded the United States; the second lies beyond history in the future, the chosen realm of the United States.

The similarities between primitive and utopian society stem not only from the fact that both lie outside history. Primitive society (or our idea of it) is, to a certain degree, a projection of our desires and dreams and thus shares the exemplary nature of a utopian society; the constructs of utopians, in turn, are in large part inspired by the real or imagined features of archaic societies. Fourier says that the future world of Harmony will be closer to the simplicity and innocence of barbarians than to the corrupt manners and morals of civilized peoples. Our visions of what human society was (or might have been) and of what it will be (or might be) fulfill similar functions: apart from their greater or lesser reality, they are paradigms, patterns. Through them we see ourselves, examine ourselves, judge ourselves.

In recent years, perhaps as a part of the phenomenon that I have elsewhere called "the twilight of the future,"[1] there has been a tendency to prefer the patterns of archaic societies: the village and not the cosmopolis, the craftsman and not the technocrat, direct democracy and not bureaucracy. When we do not find the future terrifying, we find it disappointing. Nonetheless, if only to compare the hopes of yesterday to the realities of today, it occurs to me that it would be worthwhile to compare the social state described by Fourier with the changes that have taken place in the United States with regard to erotic *moeurs*. Or, more precisely, to compare that state with the changes in the ideas of Americans concerning love and the variety of sexual inclinations and practices. For it is evident that what is primarily involved here is a change in ideas and opinions; the mores themselves, naturally, have changed a great deal less than is commonly thought. The difference lies not so much in what people are doing as in their attitude toward what is being done.

Why Fourier? Because a few years ago a French researcher, Simone Debout, discovered and published, in an edition accompanied by an intelligent and scholarly yet not at all pedantic introduction, the manuscript of *Le Nouveau Monde amoureux*,[2] a major text of Fourier's that prudish disciples of his had claimed was lost. In the society described by Fourier—thanks to the cooperative organization of work and other social and moral reforms, foremost

1. *Corriente alterna*, 1967 (American ed., *Alternating Current*, 1973); *Conjunciones y disyunciones*, 1969 (American ed., *Conjunctions and Disjunctions*, 1972).
2. Charles Fourier, *Le Nouveau Monde amoureux*, notes and introduction by Simone Debout, 1967.

among them the absolute equality of men and women—
"abundance reigns, and for the sake of general harmony
it is necessary not only that there be an immense variety
of pleasures but that each person devote himself or herself
to pleasure." Although the United States is far from having
attained the state of justice and social harmony depicted
by Fourier, industry has created an abundance that, while
we must not close our eyes to its horrors, is unique in
history. This material abundance, and a tradition of crit-
icism and individualism that is still very much alive, are
the social and historical background against which the erotic
rebellion has unfolded. The analogies between the Amer-
ican world and that imagined by Fourier are no less re-
vealing than the differences. Among the similarities are
material abundance and erotic freedom, this latter total in
Fourier's Harmony but relative in the United States. The
major difference is that Fourier's society, as its name in-
dicates, has attained harmony—a social order which, like
that governing celestial bodies, is ruled by the attraction
that unites opposites without suppressing them—whereas
in the United States there prevail, either overtly or cov-
ertly, the profit motive, lying and cheating, violence, and
all the other ills of civilized society.

In Harmony, sovereignty is divided—as in all societies,
according to Fourier—into two spheres: Administration
and Religion. The first is concerned with production and
distribution, that is to say with work, if one can distinguish
between work and pleasure in the harmonious society. The
second is the realm of pleasures strictly speaking. In civ-
ilized society Religion legislates pleasures, notably those
having to do with bed and table—Religion is love and
communion—but it does so in order to repress them and
divert them into other channels. By opposing passions

71

and inclinations, it transforms them into fierce, delirious obsessions. There are no cruel passions: the repression brought about through morality and Religion inflames us and literally infuriates us. In Harmony, once the morality of civilization has been abolished, Religion no longer oppresses but liberates, exalts, and harmonizes the instincts, bar none. "My theory is limited to making use of the passions such as nature creates them, changing nothing in them." Except, it should be added, for the social context. In civilized society passions are pernicious, dividing people; in Harmony they unite people. Even though they develop to the limit without restraint, they do not destroy social cohesion or harm individuals. Precisely because Fourier's human being is entirely socialized, he or she is wholly free. Everything is permitted, but unlike what happens in Sade's world, destructive passions change sign, thanks to a radical reversal of values, and become creative. Sadism always acts upon an erotic *object*, while in masochism the subject tends to become an object; in the world of Harmony, ruled by passionate attraction, all are subjects.

The jurisdiction of Religion is twofold: love and taste, communion and conviviality, Erotics and Gastrosophy. Eroticism is the most intense passion and gastronomy the most extensive. Neither children nor the elderly are able to practice the first; the second, on the other hand, encompasses both childhood and old age. Although these two passions consist of unions and combinations, in the one case of bodies and in the other of substances, in Erotics the number of combinations is limited and pleasure tends to culminate in a peak moment (orgasm), whereas in Gastrosophy the combinations are infinite, and pleasure, rather than being concentrated, tends to diffuse and communicate itself (tastes, flavors). For this reason, no doubt, Fourier

makes love an art, the supreme art, and gastronomy a science. The arts are the realm of Erotics, the sciences the domain of Gastrosophy. Erotics, which is surrender of self, corresponds to virtue, whereas Gastrosophy, which is sharing, corresponds to wisdom.

Harmony has its saints and heroes, very different from ours: the champions in the art of love are saints; scientists, poets, and artists are heroes. In civilized society, yielding to the fantasies of a pervert or making love with an old woman is an eccentricity or an act of prostitution; in Harmony these are virtuous actions. The exercise of virtue is not a sacrifice but the result of abundance. It is not difficult to be generous, when no one suffers from sexual privation (all have the right to an erotic minimum). Moreover, the saint of Harmony—man or woman—gains public recognition by satisfying the desires of others, and thus satisfies a passion no less violent than the sensual: ambition or the "Cabalist" passion, as Fourier calls it. Whether sexual or gustatory, pleasure ceases to be the satisfaction of a need and becomes an experience in which desire simultaneously reveals to us what we are and invites us to go beyond ourselves in order to be *other*. Imagination and knowledge, or as Fourier puts it, virtue and wisdom. We may now take a look at American society from the dual perspective of Erotics and Gastrosophy.

Hygiene and Repression

Traditional American cooking is a cuisine without mystery: simple, nourishing, scantily seasoned foods. No tricks: a carrot is a homely, honest carrot, a potato is not ashamed

of its humble condition, and a steak is a big, bloody hunk of meat. This is a transubstantiation of the democratic virtues of the Founding Fathers: a plain meal, one dish following another like the sensible, unaffected sentences of a virtuous discourse. Like the conversation among those at table, the relation between substances and flavors is direct: sauces that mask tastes, garnishes that entice the eye, condiments that confuse the taste buds are taboo. The separation of one food from another is analogous to the reserve that characterizes the relations between sexes, races, and classes. In our countries food is communion, not only between those together at table but between ingredients; Yankee food, impregnated with Puritanism, is based on exclusions. The maniacal preoccupation with the purity and origin of food products has its counterpart in racism and exclusivism. The American contradiction—a democratic universalism based on ethnic, cultural, religious, and sexual exclusions—is reflected in its cuisine. In this culinary tradition our fondness for dark, passionate stews such as moles, for thick and sumptuous red, green, and yellow sauces, would be scandalous, as would be the choice place at our table of *huitlacoche*, which not only is made from diseased young maize but is black in color. Likewise our love for hot peppers, ranging from parakeet green to ecclesiastical purple, and for ears of Indian corn, their grains varying from golden yellow to midnight blue. Colors as violent as their tastes. Americans adore fresh, delicate colors and flavors. Their cuisine is like watercolor painting or pastels.

American cooking shuns spices as it shuns the devil, but it wallows in slews of cream and butter. Orgies of sugar. Complementary opposites: the almost apostolic simplicity and soberness of lunch, in stark contrast to the suspiciously

innocent, pregenital pleasures of ice cream and milkshakes. Two poles: the glass of milk and the glass of whiskey. The first affirms the primacy of home and mother. The virtues of the glass of milk are twofold: it is a wholesome food and it takes us back to childhood. Fourier detested the family repast, the image of the family in civilized society, a tedious daily ceremony presided over by a tyrannical father and a phallic mother. What would he have said of the cult of the glass of milk? As for whiskey and gin, they are drinks for loners and introverts. For Fourier, Gastrosophy was the science of combining not only foods but guests at table: matching the variety of dishes is the variety of persons sharing the meal. Wines, spirits, and liqueurs are the complement of a meal, hence their object is to stimulate the relations and unions consolidated round a table. Unlike wine, pulque, champagne, beer, and vodka, neither whiskey nor gin accompanies meals. Nor are they apéritifs or digestifs. They are drinks that accentuate uncommunicativeness and unsociability. In a gastrosophic age they would not enjoy much of a reputation. The universal favor accorded them reveals the situation of our societies, ever wavering between promiscuous association and solitude.

Ambiguity and ambivalence are resources unknown to American cooking. Here, as in so many other things, it is the diametrical opposite of the extremely delicate French cuisine, based on nuances, variations, and modulations—transitions from one substance to another, from one flavor to another. In a sort of profane Eucharist, even a glass of water is transfigured into an erotic chalice:

> *Ta lèvre contre le cristal*
> *Gorgée à gorgée y compose*

Le souvenir pourpre et vital
De la moins éphémère rose.[3]

It is the contrary as well of Mexican and Hindu cuisine, whose secret is the shock of tastes: cool and piquant, salt and sweet, hot and tart, pungent and delicate. Desire is the active agent, the secret producer of changes, whether it be the transition from one flavor to another or the contrast between several. In gastronomy as in the erotic, it's desire that sets substances, bodies, and sensations in motion; this is the power that rules their conjunction, commingling, and transmutation. A reasonable cuisine, in which each substance is what it is and in which both variations and contrasts are avoided, is a cuisine that has excluded desire.

Pleasure is a notion (a sensation) absent from traditional Yankee cuisine. Not pleasure but health, not correspondence between savors but the satisfaction of a need—these are its two values. One is physical and the other moral; both are associated with the idea of the body as work. Work in turn is a concept at once economic and spiritual: production and redemption. We are condemned to labor, and food restores the body after the pain and punishment of work. It is a real *reparation*, in both the physical and the moral sense. Through work the body pays its debt; by earning its physical sustenance, it also earns its spiritual recompense. Work redeems us and the sign of this redemption is food. An active sign in the spiritual economy

3. Your lip against the crystal/Sip by sip forms therein/The vital deep crimson memory/Of the least ephemeral rose.—Stéphane Mallarmé, "Verre d'eau." (My translation—Trans.)

of humanity, food restores the health of body and soul. If what we eat gives us physical and spiritual health, the exclusion of spices for moral and hygienic reasons is justified: they are the signs of desire, and they are difficult to digest.

Health is the condition of two activities of the body, work and sports. In the first, the body is an agent that produces and at the same time redeems; in the second, the sign changes: sports are a wasteful expenditure of energy. This is a contradiction in appearance only, since what we have here in reality is a system of communicating vessels. Sports are a physical expenditure that is precisely the contrary of what happens in sexual pleasure, since sports in the end become productive—an expenditure that produces health. Work in turn is an expenditure of energy that produces goods and thereby transforms biological life into social, economic, and moral life. There is, moreover, another connection between work and sports: both take place within a context of rivalry; both are competition and emulation. The two of them are forms of Fourier's "Cabalist" passion. In this sense, sports possess the rigor and gravity of work, and work possesses the gratuity and levity of sports. The play element of work is one of the few features of American society that might have earned Fourier's praise, though doubtless he would have been horrified at the commercialization of sports. The preeminence of work and sports, activities necessarily excluding sexual pleasure, has the same significance as the exclusion of spices in cuisine. If gastronomy and eroticism are unions and conjunctions of substances and tastes or of bodies and sensations, it is evident that neither has been a central preoccupation of American society—as ideas and social values, I repeat, not

as more or less secret realities. In the American tradition the body is not a source of pleasure but of health and work, in the material and the moral sense.

The cult of health manifests itself as an "ethic of hygiene." I use the word ethic because its prescriptions are at once physiological and moral. A despotic ethic: sexuality, work, sports, and even cuisine are its domains. Again, there is a dual concept: hygiene governs both the corporeal and the moral life. Following the precepts of hygiene means obeying not only rules concerning physiology but also ethical principles: temperance, moderation, reserve. The morality of separation gives rise to the rules of hygiene, just as the aesthetics of fusion inspires the combinations of gastronomy and erotics. In India I frequently witnessed the obsession of Americans with hygiene. Their dread of contagion seemed to know no bounds; anything and everything might be laden with germs: food, drink, objects, people, the very air. These preoccupations are the precise counterpart of the ritual preoccupations of Brahmans fearing contact with certain foods and impure things, not to mention people belonging to a caste different from their own. Many will say that the concerns of the American are justified, whereas those of the Brahman are superstitions. Everything depends on the point of view: for the Brahman the bacteria that the American fears are illusory, while the moral stains produced by contact with alien people are real. These stains are stigmas that isolate him: no member of his caste would dare touch him until he had performed long and complicated rites of purification. The fear of social isolation is no less intense than that of illness. The hygienic taboo of the American and the ritual taboo of the Brahman have a common basis: the concern for purity. This basis

is religious even though, in the case of hygiene, it is masked by the authority of science.

In the last analysis, the cult of hygiene is merely another expression of the principle underlying attitudes toward sports, work, cuisine, sex, and races. The other name of purity is separation. Although hygiene is a social morality based explicitly on science, its unconscious root is religious. Nonetheless, the form in which it expresses itself, and the justifications for it, are rational. In American society, unlike in ours, science from the very beginning has occupied a privileged place in the system of beliefs and values. The quarrel between faith and reason never took on the intensity that it assumed among Hispanic peoples. Ever since their birth as a nation, Americans have been modern; for them it is natural to believe in science, whereas for us this belief implies a negation of our past. The prestige of science in American public opinion is such that even political disputes frequently take on the form of scientific polemics, just as in the Soviet Union they assume the guise of quarrels about Marxist orthodoxy. Two recent examples are the racial question and the feminist movement: are intellectual differences between races and sexes genetic in origin or a historico-cultural phenomenon?

The universality of science (or what passes for science) justifies the development and imposition of collective patterns of normality. Obviating the necessity for direct coercion, the overlapping of science and Puritan morality permits the imposition of rules that condemn peculiarities, exceptions, and deviations in a manner no less categorical and implacable than religious anathemas. Against the excommunications of science, the individual has neither the religious recourse of abjuration nor the legal one of *habeas*

corpus. Although they masquerade as hygiene and science, these patterns of normality have the same function in the realm of eroticism as "healthful" cuisine in the sphere of gastronomy: the extirpation or the separation of what is alien, different, ambiguous, impure. One and the same condemnation applies to blacks, Chicanos, sodomites, and spices.

The Spice Insurrection

The above observations create the image of a world whose distinctive trait is social conformity. This is not so: the very Puritanism that makes food taste insipid and turns work into a morality of salvation, is also the root of the movements of criticism and self-criticism that periodically stir American society to the depths and force it to examine itself and make acts of contrition. This characteristic is altogether modern. Baudelaire said that progress is measured not by the increase in the number of gas lamps for street lighting but by the decrease in the signs of original sin. As I see it, the index of progress is different: modernity is measured not by the onward march of industry but by the capacity for criticism and self-criticism. People keep saying that the Latin American nations are not modern because they have not yet reached the stage of industrialization; very few have said that throughout our history we have given proof of a singular incapacity for criticism and self-criticism. The same thing is true of the Russians: they have paid in blood, literally, for their industrialization, for in their case criticism continues to be an article imported from abroad, so that their modernity is incomplete, su-

perficial. We Russians and Hispanics, to be sure, are intimately acquainted with irony, satire, aesthetic criticism. We have a Cervantes and a Chekhov, but no Swift, Voltaire, Thoreau. We lack philosophical, social, and political criticism: neither of us, Russians or Hispanics, had an eighteenth century. This lack had been fatal for Latin American peoples: not only does criticism lay the groundwork for social changes; if it is absent, these latter turn into destinies imposed from outside. Thanks to criticism, we assume responsibility for changes, internalize them, change ourselves. In this respect Americans are admirable: their historic changes have at the same time been social crises and crises of conscience.

The United States has gone through a number of crises and is today experiencing what may be the gravest one in its entire history. In all of them dissent—even when dissension borders on schism, as is the case today—has restored this people's health. But the word *pleasure* has never before appeared in the vocabulary of dissidents. This is quite natural: it is not a word that belongs to the philosophical and moral tradition of the United States. The country was founded by other words, its opposites: duty, expiation, guilt, debt. All of them are the moral and religious foundation of Puritanism; all of them, by conceiving of human life as a fault and a debt for which reparation must be paid to the Creator, were the leaven of capitalism; all of them are translatable into economic and social terms: work, savings, accumulation. Pleasure is wasteful expenditure and therefore the negation of all these values and beliefs. The fact that this word is now on so many lips and uttered with such vehemence is a portent, as are "the twilight of the future" and other signs, that perhaps American society is changing course. But the prospects of a

revolutionary change are remote. The reason, as we all know, is the absence, both in the United States and in Western Europe, of an international revolutionary class; the proletariat has given no sign of either an international outlook or a revolutionary vocation. If no revolution is in sight, at least in the meaning that this term had up until recently in both the Marxist and the anarchist tradition, a tremendous mutation is nonetheless perceptible, more profound perhaps than a revolution, the consequences of which cannot yet be foreseen. A mutation: a shift of values and of direction.

American taste has changed. As a people, Americans have discovered the existence of other civilizations and are experiencing a sort of gastronomic cosmopolitanism. In the big cities, culinary traditions of the five continents coexist in the same street. In the perfection and encyclopedic variety of what they offer, restaurants rival the great museums and libraries. New York is not so much Babel as Alexandria. Not only are there countless restaurants that serve rare dishes, from African ants to Périgord truffles, but in supermarkets it is not unusual to find a department of spices and exotic condiments displaying on its shelves a range of products and substances that would have sent Brillat-Savarin himself (naturally enough—he was a cousin of Fourier's) into ecstasies. A profusion of cookbooks now exists, and countless institutes and schools of gastronomy. Televised programs on cuisine are more popular than religious broadcasts. The ethnic minorities have contributed to this universalism: in many families the culinary traditions of Odessa, Bilbao, Orvieto, or Madras are a living heritage. But eclecticism in the realm of cuisine is no less pernicious than in philosophy and ethics. This entire body of knowledge has perverted native cuisine.

Though modest, in the past it was forthright and honest; today it is ostentatious and fake. Worse still, eclecticism has inspired many cooks to invent hybrid dishes and other palate-pleasers. The "melting pot" is a social ideal that, when applied to culinary art, produces abominations. This failure is not surprising: it is more difficult to maintain a tradition of good cuisine than a tradition of great literature, as England teaches us.

The perverse fantasies of cooks lacking in genius are compounded by the industrialization of food products. This is the real evil. The food industry has been and is the principal agent of the degeneration of taste, and has now become a threat to public health. Poetic justice: the possibility of collective poisoning is punishment for the obsession concerning the purity of foodstuffs and their origin. Nobody knows what he or she is eating on opening a can or package of prefabricated food.

The subject of the industrialization of food is altogether too vast, going beyond the limits both of this article and of my competence. What I would like to emphasize is that culinary morality (since in this instance it is a question of morality, not of aesthetics) has broken down, owing to two factors: first, the industrialization of foods and its disastrous consequences; and second, the reigning cosmopolitanism and eclecticism that have undermined taboos concerning food. The acceptance of strange sauces, rare condiments, dressings, garnishes, and methods of preparing dishes reveals a change not only in taste but in values as well. Pleasure in its most immediate, direct, and instant form, smell and taste, displaces traditional values. It is the contrary of thrift and work. The change modifies the very vision of time: *now* is the time for pleasure, while the time for work is *tomorrow*.

The discovery of ambiguity and exception in eroticism has paralleled the discovery of spices and condiments in gastronomy. But it is an error to speak of discovery, as though eroticism and the body had been unknown realities. No, Americans have known full well the powers of the body, that source of marvels and horrors; precisely because they knew them, they feared them. The body is a constant presence in Whitman, Melville, and Hawthorne. The United States is a country poor in spices, rich in human beauty. It is likewise an error to conclude that the laxity of public morality has increased the number of perversions and deviations. (With greater objectivity, Fourier called them *manias*; deviation and perversion are words referring to arbitrary models of normality that vary in each century and each society.) The new morality has doubtless caused innumerable collective and individual masks to fall; many men and women who never before dared confess their homosexual preferences even to themselves are today confronting their own erotic truth more resolutely. Likewise, it would be obtuse to deny that people today are enjoying their bodies and those of others with greater freedom. Furthermore, and even more important: without the fear they once had. At the same time it is obvious that practices have not changed, nor has the erotic rebellion altered or modified the art of loving. I don't know if there are a greater number of erotic encounters nowadays; I am certain that there are no new and different ways of copulating. Perhaps people make love more (how can anyone know?), but the capacity to enjoy and suffer neither increases nor diminishes. The body and its passions are not historical categories. It is more difficult to invent a new position than to discover a new planet. In eroticism and the passions, as in the arts, the idea of progress is particularly ridiculous.

The eminently popular nature of the erotic rebellion was immediately perceived by the large corporations that control the communications media and by the entertainment and garment industries. It has not been the churches or political parties but the industrial and economic monopolies that have divided among themselves the powers of fascination that eroticism exercises over human beings. In this division of power it was neither show business—the movies, the theater, television—nor old-style literary pornography that received the lion's share; rather, it fell to publicity. The mouth and the teeth, the belly and the breasts, the penis and the vulva—the sacred or accursed signs of dreams, myths, and religions—have become slogans for one product or another. What began as a liberation has turned into a business. The same thing has happened in sexuality as in gastronomy: the erotic industry is the younger sister of the food industry. In the world of Harmony, erotic freedom coincides with social freedom and abundance; economic necessity has disappeared and the authority of the state is limited to the self-administration of each phalanstery. In the twentieth century, in the United States as in Western Europe, industry co-opts erotic rebellion and cripples it. It is the expropriation of utopia by private enterprise. When it was on the rise, capitalism humiliated and exploited the body; today it turns it into an advertisement.

Many critics have pointed out that Fourier was unable to foresee the development of industry and the changes that it would usher into the world. This shortsightedness would suffice to discredit him as a prophet. However, this supposed lack of vision may in reality have been a more accurate vision of the future. Fourier never hid his antipathy for manufacturing industry, the only kind that existed in his day. His attitude no doubt reflects his experiences

with the wretched textile workers in Lyons, whom he knew intimately. But the reasons for his animus against industry go deeper still. The axis of the system of Harmony is *attractive* work. In the phalansteries men and women will work with the same enthusiasm that they give to play and their favorite passions today. For this reason the tasks in Harmony are extremely varied. The "butterfly" passion, one of the three "distributive passions"—the alternating and contrasting passion—is one of the rulers of Fourier's system: what human beings have been condemned to is not work but doing the same things over and over again. The pleasure principle is almost impossible to apply to industrial work because, as Fourier never tires of repeating, such work is *intrinsically* monotonous and unattractive. Hence the principal activity of Harmony is agriculture. At the same time, Fourier realizes that it is impossible to do away with industry entirely. What can be done? His solution is ingenious: it applies his cardinal principle of absolute contradiction.

In civilized society the almost unlimited output of identical products is the rule. Mass production is based on maximum consumption and therefore on minimum durability of the product. In Harmony the rule is precisely the opposite: an immense variety of products of great durability and therefore minimum consumption. With all the imperturbable courage of his convictions, Fourier says that the products of Harmony will last practically forever. To avoid the danger of fatigue and to keep passionate attraction alive, these objects will be of great perfection and beauty. This is the application of craftsmanship to industry. The needs of this mode of production will be the opposite of those of our factories: not an army of laborers, but a small group of artist-workers producing a limited

number of objects of extraordinary variety, perfectly turned out. The horror and boredom of industrial work will be reduced to a minimum. The manufacture of goods, Fourier triumphantly concludes, will require only one fourth of a day's labor. In Harmony "true wealth will be based, first, on the *greatest* possible consumption of different sorts of foods and, second, on the *least* possible consumption of different sorts of clothing, furniture, objects." Exactly the contrary of contemporary society, where cuisine itself is now an industry and subject to mass production. We may smile at Fourier's solution, yet it is merely the exact, symmetrical reverse of the central contradiction of American society and the entire "developed" world: the opposition between industry and passionate attraction. Industry has created abundance but has turned Eros into one of its servants.

Eroticism, Love, Politics

The erotic revolts of the past affected, almost exclusively, the upper level of the population. The extraordinary erotic freedom of the eighteenth century was a phenomenon restricted to the nobility and the grande bourgeoisie. Libertine philosophy did not reach the people: neither Choderlos de Laclos nor even Restif de la Bretonne was a popular author. The same may be said of courtly love, which was an erotics and a poetics of aristocrats and the learned. So it is for the first time in the West that today the masses are directly participating in a rebellion of this sort. Movements permeated with erotic ideas have become truly popular in other civilizations as well: sexual Taoism

in China, Tantrism in India, Nepal, and Tibet. It will be objected that Taoism and Tantrism were essentially religious movements, whereas the contemporary erotic rebellion is taking place outside the churches and on occasion is violently anti-Christian. Let me make myself clear: it is anti-Christian, not areligious. Or rather, it is parareligious. Since, as Hume feared and as the history of the twentieth century appears to confirm, the religious instinct is congenital in humanity, I wonder whether the erotic frenzy of our day does not presage the rise of future orgiastic cults. Until recently, arguments in favor of erotic freedom were put forward in the name of the individual and his passions; but what is stressed today is the collective and public aspects. Another difference: what is extolled is not so much pleasure as spectacle and participation. The erosion of traditional morality and the decadence of Christian ritual (not to mention the discredit into which official ceremonies have fallen) have merely enhance the need for communions and collective liturgies. Our time hungers and thirsts for celebrations and rites.

The American erotic movement is steeped in morality, pedagogy, good social intentions, and progressive politics. All this, along with its popular, democratic character, distinguishes it both from other eroticizing movements of Western history and from the tradition of that intellectual lineage, descending from the Marquis de Sade to Georges Bataille, that has conceived of eroticism as violence and transgression. By contrast with the somber visions of Sade or the philosophical pessimism of Bataille, the optimism of the American rebels is striking. By breaking with Puritan morality, which condemned the lower half of our bodies to a clandestine existence, the erotic rebellion has brought about a change with odd but unquestionable moral

overtones. It is not a matter of *knowing* something that was hidden but of *recognizing* it, in the legal sense of the word. This recognition is a consecration of sex as nature. Recognition embraces all exceptions, deviations, and perversions: they are legitimate because they are natural inclinations. There are no exceptions: everything is natural. This represents a legitimation of the forbidden and secret aspects of eroticism, something that would have scandalized Bataille.

The erotic rebellion affirms that the passions we call antinatural, the traditional "sins against nature," are natural and hence legitimate. Its critics reply that the passions against nature and the other perversions are exceptions, violations of normality: disorders and illnesses to be brought under control by means of the psychoanalyst's couch, the straitjacket of the mental asylum, or prison bars. These critics must be reminded, once again, that "nature" and "normality" are conventions. But the rebels must be informed that eroticism is not natural but social sex. The idea of the dissidents is based on a confusion between the natural and the social, between sexuality and eroticism. Sexuality is animal; it is a natural function, whereas eroticism develops within society. The former belongs to the realm of biology, the latter to that of culture. Its essence is the imaginary: eroticism is a metaphor of sexuality. There is a dividing line between eroticism and sexuality—the word *like*. Eroticism is a representation, a ceremony of transfiguration: men and women make love *like* lions, eagles, doves, or praying mantises; neither lions nor praying mantises make love like human beings. We humans see ourselves in animals; animals do not see themselves in humans. By contemplating itself, humanity changes itself and changes sexuality. Eroticism is not brute sex but sex transfigured

by the imagination: rite, theater. For this reason, it is inseparable from perversion and deviation. Apart from being impossible, a natural eroticism would be a regression to animal sexuality. This would end Fourier's "manias" and Sade's "penchants," but also the most innocent caresses, the bouquet, and the kiss. It would end the entire range of sentiments and sensations that have enriched the sensibility and imagination of men and women since the Neolithic Age or perhaps before. The ultimate consequence of the erotic rebellion would be the disappearance of eroticism and of what has been its loftiest and most revolutionary expression: the idea of love. In the history of the West, love has been the secret subversive power: the great medieval heresy, the solvent of bourgeois morality, the winds of passion that (in several senses) moved the Romantics and passed on to the Surrealists as well.

Is a society without prohibitions and repressions possible, viable, even imaginable? Here Freud, Sade, and Bataille join hands with Augustine and the Buddha: there is no civilization without repression, therefore the essence of eroticism, unlike animal sexuality, is the violence that transgresses limits. Fourier would retort that there is transgression because there is prohibition: it's not instinct but repression that has made wild beasts of human beings. Although I cannot but sympathize with all those who fight against repression, whether sexual or political, it is my belief that it cannot be done away with entirely. Human passions are not solitary; even in so-called solitary pleasure the subject/object duality appears. Machado said that Onan knew many things that Don Juan had no notion of. In narcissistic and masochistic relations the subject/object pair also plays a role: the ego divides itself into the subject that contemplates and the object contemplated. The same in-

dividual is *la plaie et le couteau, le soufflet et la joue.*[4] Passions always manifest themselves in society; therefore, ever since the Paleolithic Age, the social powers that be have tried to regulate and channel them. Among the erotic passions, moreover, there is a whole range belonging to the variety that Sade called the "strong" or "cruel" inclinations—those that are destructive or self-destructive. The victim/torturer pair does not exist solely in the sphere of political domination; it also inhabits the ambiguous realm of erotic fascination. Sade imagined a society of "strong passions and mild laws," in which the only sacred right would be the right to *jouissance*, total enjoyment; in that world the death penalty would be abolished, but not sexual murder. Nothing could be more like a bullfight or a slaughterhouse than the society imagined by Sade.

If we grant that Freud is right and that sublimation and repression are the price we must pay to live in society, we are forced to grant that Bataille is right, too: the essence of eroticism is transgression. Fourier's society vanishes as a utopia: we are condemned, at one and the same time, to invent rules that define the normal in the domain of the sexual—and to transgress them. It is not easy to reject this pessimistic vision of human nature and our passions. Nor is it easy to accept it unblinkingly. I for my part have always been repelled by it. The idea of original sin never ceases to shock me. For this reason, perhaps, the libertinage of the Gnostics, the Tantrists, the Taoists, and other sects has always seemed to me a way out of the dilemma of eroticism. These tendencies and movements represented an attempt to transcend the dual condemnation that appears

[4] The wound and the knife, the blow and the cheek. Baudelaire, "L'Héautontimoroumenos."—TRANS.

to be the condition of eroticism: repression and transgression, taboo and violation. While the philosophies that inspired these groups were very different—Christianity, Hermeticism, Buddhism, Hinduism—in all of them a common element appears: the ritualization of transgression. Among the Christian and pagan Gnostics as among the Buddhist and Hindu Tantrists, the rite's purpose is to integrate the exception. More than a transformation, what takes place is a radical conversion, in the religious sense of *conversion*: the crime becomes a sacrament. The break with social morality appears as union with the absolute. Furthermore, as seen in Gnostic and Tantric rites, the process of symbolization admirably fulfills the function of sublimation that Freud assigned to culture and to art and poetry in particular.

By stressing and deepening the affinity between erotic and religious ritual, these movements simply revealed, yet again, the close relationship between eroticism, religion, and poetry (in the broadest sense of the latter). The bridge between the experience of the sacred and eroticism is imagination. The religious rite and the erotic ceremony are, first and foremost, *representations*. Because of all the foregoing, Bataille's idea strikes me as incomplete, unilateral: eroticism is not only transgression but also representation. Violence and ceremony: the opposite and complementary faces of eroticism. Once we conceive of sexual union as *ceremony*, we discover its intimate relation to religious ritual and to poetic and artistic representation. Eroticism does not have its roots in animal sexuality: it is something human beings have invented. More precisely, it is one of the forms in which desire manifests itself. It is closely related to religion and poetry through the cardinal, and subversive, function of the imagination. In these three experiences

real reality becomes image, and images in turn become embodiments. Imagination makes the phantoms of desire palpable. Through imagination, erotic desire always goes *beyond*—specificially, beyond animal sexuality.

One of the *strings* of eroticism—the metaphor of the body as a musical instrument goes far back in time—is transgression. But transgression is only one extreme of the movement that, with our body as the point of departure, leads us to imagine other bodies and at once seek the incarnation of these images in a real body. This is the origin of the erotic ceremony, a ceremony that, in its own way, consecrates the exception. Eroticism, then, because it is a going beyond, is a search. For what or for whom? For the other—and for ourselves. The other is our double, the phantom invented by our desire. Our double is other, and this other, because it is always and forever other, denies us. It is *beyond*, and we never succeed in possessing it completely; it is perpetually alien. In the face of the essential distance of the other, two possibilities present themselves: the destruction of this other who is myself (sadism and masochism), or going even further beyond. In this beyond lies the freedom of the other and my recognition of that freedom. The other extreme of eroticism is the contrary of sadomasochistic transgression: the acceptance of the other. The other extreme of eroticism is called *love*.

The originality of courtly love, in comparison with Gnosticism and Tantrism, was twofold. On the one hand, rather than turning eroticism into a ritual, it consecrated its autonomy as an intimate ceremony, totally apart from religious liturgies and from social and moral conventions as well; it was situated both outside the Church and outside of marriage. On the other hand, unlike the libertine Gnostic and Tantric sects, it was not an alternate "path of

perfection" running counter to asceticism, but a personal experience, an intimate liberation—again, outside of cults and theologies. Transgression and nonreligious consecration. In both ways, as ceremony and as experience, the erotic of the West leads to something that does not appear, except in an isolated and fragmentary way, in other eras and civilizations: love. This experience consists not of the religious vision of Otherness but of the passionate vision of the *other*: a human like ourselves, yet enigmatic. In the face of the numinous mystery of the divine presence, the worshiper apprehends himself as radical otherness; before the mystery of the beloved, the lover perceives himself as at once similarity and irreducible difference. Arising from the same psychic zone, the two experiences bifurcate; between the religious mystery and the mystery of love there is a boundary, and this boundary is of an ontological order: it is an uncrossable line that separates two modes of being, the divine and the human. In Provence, during the eleventh and twelfth centuries, human beings discovered—or more exactly, recognized—a type of relation that, although originally linked to eroticism and religion, is reducible to neither. I say *recognized* because the experience of love is as old as humanity, though only in Provence, through a conjunction of historical circumstances, did it stand out in all its sovereignty.

The history of love, as distinct from eroticism, has yet to be written. I don't know if it is an exclusive invention of the West, but it can safely be said that in the Arab world, classic India, China, and Japan versions of love appear that do not correspond exactly to the Western archetype. The Persian and Arabic erotic is, of course, very close to the Provençal; very likely, its influence was a decisive factor in the birth of courtly love. The differences are clearer and

more revealing if we think of India and the Far East: in these civilizations the concept of the person—a being endowed with a soul, which is the axis of the love relation in the West—becomes attenuated, and in Buddhist societies it collapses altogether. For Hinduism the soul, wandering from incarnation to incarnation, finally dissolves in the bosom of Brahma: with it there also disappears what we call the person. For Buddhism, more radical still, belief in the soul is a heresy. Bao-yu and Dai-yu, the lovers of *The Dream of the Red Chamber*, are incarnations of a magic Stone and of an equally magic Flower; their love is but a moment in the long, tortuous path that leads the Stone and the Flower "from the contemplation of Form (which is illusion) to Passion, which in turn consumes itself in Form so as to awaken in Emptiness (which is Truth)." Though the characters of Bao and Dai are unforgettable, their reality is fleeting: they are but two moments of a spiritual adventure. As a measure of how far removed we are from this conception, we need only think of Dante's Paolo and Francesca, condemned to be what they are for all eternity and burn forever in their ill-starred passion.

In the West, since Plato, love has been inseparable from the notion of the person. Each person is unique—and more than that, a *person*—because he is a composite of soul and body. To love does not mean to feel an attraction for a mortal body or for an immortal soul but for a person: an indefinable alloy of corporeal and spiritual elements. Love commingles not only matter and spirit, flesh and the soul, but the two forms of time: eternity and the present moment. Christianity perfected Platonism: the person is not only unique but unrepeatable. Shattering the circular time of classic paganism, Christianity affirms that we live only once on earth and that there is no return. A violent paradox:

the person we love "forever" we love only once. The Arabic heritage refined the tradition that had come down from Plato, and finally, Provence brought into being what we might call the autonomy of the love experience. It is not surprising that the paradoxical nature of love in the Western world—soul and body, the one immortal and the other mortal—has inspired a series of memorable images. The Renaissance and the Baroque era favored that of iron attracted by a magnet—a convincing metaphor, since the irreconcilable pairs that constitute love appear to become one by virtue of the magnetic stone. The magnet, a motionless stone, impels the movement of the iron; like the magnet, the beloved is an object that attracts us and moves us toward her; in other words, she is an object that becomes a subject, without ceasing to be an object.

The metaphor of the magnet illustrates the differences between love and eroticism: love makes of the erotic object a subject with free will; eroticism transforms the desired being into a sign that belongs to a set of signs. In the erotic ceremony each participant occupies a definite place and fulfills a specific function, just as words are joined together to compose a sentence. The erotic ceremony is a composition that is at the time a representation. In it, therefore, nakedness itself is a disguise, a mask; in other instances, as in Sade and Fourier, it is a philosophical exemplum, an allegory of nature and its manifestations, by turns terrifying and pleasurable. The naked couples and their various positions are merely figures in the countless combinations of the passional mathematics of the universe. For eroticoreligious sects as well, nakedness is an emblem. The young woman of low caste who couples with the adept in the Tantric rite is in reality a divinity, the *Shakti* or the *Dakini*, Emptiness and the vagina. And the yogi is simultaneously

the manifestation of the lightning bolt, the *vajra*, the penis, and the adamantine essence of the Buddha.

I have yet to point out other differences between love and eroticism. The former is historical: if we are to believe the testimony of the past, it appears only in certain groups and civilizations. The latter is a constant in all human societies; there is no society without erotic rites, just as there is no society without language or work. Furthermore and most important, love is individual: no one loves with amorous love a collectivity or a group, only a single person. Eroticism, on the other hand, is social; hence the oldest and most common form of eroticism is the collective ceremony, the orgy or bacchanalia. Eroticism tends to exalt not the uniqueness of the erotic object but its peculiarities and eccentricities, and always to enhance some power or generative principle, such as nature or the passions. Love is the recognition that each person is unique, hence its history in the modern era becomes intermingled with revolutionary aspirations that, since the eighteenth century, have proclaimed the freedom and sovereignty of each person. Eroticism, by contrast, affirms the primacy of cosmic or natural forces: we humans are the playthings of Eros and Thanatos, terrible divinities.

Romanticism and Surrealism exalted love and thus carried on the tradition of the West with great and violent originality. In modern erotic rebellion, on the other hand, love is not central. In an article such as this I cannot discuss in detail the causes of this omission, a veritable spiritual and passional lesion of our time. I shall only say that the decadence of love is directly related to the decline of the idea of a soul. By departing from the tradition of the West—or rather, from the successive images of love that our poets and philosophers have given us—erotic rebellion has

followed, unknowingly and in its own way, the path previously taken by such sects and tendencies as Gnosticism and Tantrism. But the modern movement has developed within an areligious context; hence, unlike the Gnostics and the Tantrists, it is not nourished by religious visions but feeds on ideologies. It thus manifests itself not as religious divergence but as political protest. In reality, it is as spurious as the political pseudoreligions of the twentieth century. This is the essential difference between the movements of the past and the modern one.

Tantrism was an eroticization of Buddhism and Hinduism. In the first centuries of our era the Gnostics set out to do something similar, to eroticize Christianity, and failed. Today we are witness to a contrary effort: the politicization of eroticism. A protest against Western morality in general and against Puritanism in particular, erotic rebellion has flourished above all in the United States and in other Protestant countries such as England, Germany and naturally Sweden and Denmark. Even if one sympathizes, as I do, with many of the political, moral, and social demands of these movements, I believe that a distinction must be made between their political and erotic aspects. It is true, for example, that women have been oppressed in all civilizations, but it is not true that the relation between men and women can be reduced to one of political, economic, or social domination. Such a reduction immediately engenders confusion. No, the essence of eroticism is not politics.

The rebellion against a morality based on repression is linked to two conditions that, if they do not determine it, at least explain it: economic abundance and political democracy. There is no erotic rebellion in Communist countries, and as we all know, the price for sexual deviation is imprisonment and internment in forced labor camps. In

the West, erotic rebellion is a symptom of a decisive event destined to alter the course of American history and, along with it, world history: the collapse of the system of values of Protestant capitalism. This collapse immediately assumes the form of moral criticism. Criticism turns into protest and protest into a political demand: the recognition of the exception. Thus, through a curious process, our era turns sexuality into ideology. On the one hand, the erotic exception disappears as an exception: it is merely a natural inclination; on the other hand, it reappears as dissent: eroticism turns into social and political criticism. The moralization of eroticism, its legalization, leads to its politicization. Sex becomes critical, draws up manifestoes, delivers noisy speeches, and parades through the streets and public squares. It is no longer the inferior half of the body, the sacred and accursed region of passions, convulsions, emissions, death rattles. In Sade the sex organ philosophizes and its syllogisms are a lava flow: the logic of eruption and destruction. Sex has now become a public preacher and its discourse is a call to battle: it makes pleasure a duty. A Puritanism in reverse. Industry turns eroticism into a business; politics turns it into an opinion.

Cambridge, Mass. October 1971

Iniquitous Symmetries

Gabriel Caballero—You have written: "Dissidents are the honor of our era." What is the relationship between dissident and the work of the writer?

Octavio Paz—As a young man I adopted a maxim of André Gide's as my own: "The writer must know how to swim against the tide." The maxim is valid for everyone.

G.C.—There is a historical reference for what we know today as dissidence: I am referring to the work of Albert Camus and the famous controversy with Jean-Paul Sartre that it led to. Could you tell us something about your

Interview with Gabriel Caballero, 1979.

relationship with Camus? Do you think *The Rebel* still applies to the situation today?

O.P.—I met Camus at the time he was writing *L'Homme révolté*. To translate *l'homme révolté* as "the rebel" is not entirely accurate, of course. There are overtones and meanings in *revolt* that *rebellion* does not have. In *Corriente Alterna* (1967)[1] I tried to point out the different meanings of *rebellion*, *revolt*, and *revolution*. *Rebellion* is a term of military origin and has an individualistic shading; *revolution* and *revolt* are related words, but *revolution* is more intellectual; it is a philosophical term, whereas *revolt* is older and more spontaneous. *Revolution* is revolt that has been turned into a theory and a system. A *révolté* is an insurgent, one who refuses to obey, who rises up spontaneously against injustice. The uprising of the peasants of Fuente Ovejuna against the Comendador or the razing of the Viceroy's palace by Mexican rioters in 1692 are examples of revolts. The French Revolution began as a revolt—the storming of the Bastille—and the same can be said of the beginning of almost all modern revolutions, before they are co-opted by terrorist ideologues. The Mexican Revolution was really a revolt, and at no point did it become a revolution in the modern sense of the word. The revolutionary is the philosopher—or rather, the ideologue—who turns revolt into doctrine. Revolutionary ideology borders on philosophy on the one hand and on religion on the other. Like the former, it derives its authority from the (supposed) authority of reason; like the latter, it presents itself as a total and universal explanation of the world and of existence. Camus's book would have gained a great deal, had he made

1. American ed.: *Alternating Current*, 1974.

a more precise distinction between age-old, healthy revolt and modern revolution.

It was not the rebel but the revolutionary who, from the eighteenth century on, turned revolt into a system, and the system into a despotism. I for my part still admire rebellion, even if at times I don't approve of certain of its contemporary manifestations. Lucifer, the angel of rebellion, the spirit of negation, has fascinated many generations of poets and artists. It is not hard to guess why: negation, in its own way, is creative. Negation creates through doubt and criticism, that is, by eliminating and omitting. Among the architectonic works that have most impressed me is one that corresponds exactly to this idea of creation by ellipsis: the colossal temple of Ellora, in India. It is carved from a mountain. This is architecture through removal of material, creative omission. Romanticism was the great modern movement of rebellion. It was an explosion of isolated personalities and minorities in opposition to the mainstream: the contrary of a revolution. We owe to Romantic rebellion nearly all the ideas and experiences that have changed the literature, arts, morality, and even politics of the modern age, from free love to the vision of poetry as a spiritual way of knowledge. As for revolt, it continues to be the great recourse of peoples for restoring to political health a society disfigured by tyranny, privilege, and injustice. Revolt is as old as classes and states; it was born with them and will die with them.

What is new in the West is the idea of revolution. The idea, in the modern sense, was born in the seventeenth century. In it, two quite different traditions are interwoven. One is intellectual and originates with a minority group: utopia. The other is popular and free of philosophical speculation, although it is related to millenari-

anism, messianism, and other religious manifestations: revolt. Modern philosophy grafted the rational geometry of utopia onto the age-old sense of revolt and thus converted it into an ideological system. The revolutionary is, above all else, an ideologue, a man who systematizes; at the same time, faithful to the religious tradition of revolt—millenarianism, the Great Change—he is a believer. The fusion of belief and system produces the militant, a warrior fighting for an idea. In the militant, two figures are conjoined: the cleric and the soldier. The archetype of the revolutionary party is dual: the Church and the Army. The party is ruled by a committee, which in turn is dominated by a leader who is a double incarnation—of historic necessity: reason; and of justice: redemption. The marriage of philosophy and religion. The archetype of the revolutionary is on the one hand the philosopher and on the other, the ascetic: Saint-Just, Robespierre—at the same time martyrs and priest-murderers of sacrificial victims. All this explains the mistrust with which revolutionaries look upon popular revolts—the same suspicion with which theologians look upon mystics. Yet it has not been conservative tyrannies alone, but revolutionary ones as well, that have put down popular uprisings and persecuted intellectuals and rebel artists.

The first time I saw Camus was at a ceremony in Paris honoring Antonio Machado. The speakers were Jean Cassou and myself; María Casares recited several of Machado's poems. As we were leaving after the ceremony, a stranger in a gabardine trenchcoat came up to me to express his warm approval of what I had said. That's Albert Camus, María Casares told me. He was at the peak of his fame in those days and I was an unknown Mexican poet lost in postwar Paris, so his welcoming gesture was generous.

We saw each other several times after that and both of us took part, along with María Casares, in a celebration of the Eighteenth of July,[2] organized by a group of Spanish anarchists.[3] I read chapters of *L'Homme révolté* as they were published in periodicals, and Camus himself recounted to me, so to speak, the overall argument of the book. We argued a great deal about certain points—his critiques of Heidegger and Surrealism, for example—and I warned him that his chapter on Lautréamont would arouse Breton's wrath. And so it did. I think all of us, Breton included, regretted this run-in. Years later I heard him speak highly of Camus.

At the time, Sartre's *Le Diable et le Bon Dieu* had just opened. I attended one performance and was struck by the Jesuitical justification of the "rightness" of revolution contained in this work. It is the symmetrical reverse (or the caricature) of the theological image that inspired seventeenth-century Spanish drama: free will as the grace of God. A few days later I had lunch with Camus and said to him: "I've just seen Sartre's play" (he had not yet seen it), "and it's an indirect apology for Stalinism. Sartre is going to attack your book when it comes out." He looked at me incredulously and replied: "I have just three friends in the Paris literary world. One of them is Malraux. I've come to a parting of the ways with him because of his

2. See "Aniversario español" in my *El ogro filantrópico*, 1979.
3. The Eighteenth of July is the date of Franco's uprising against the Spanish Republican government. In many cities and towns it provoked a popular reaction; the people spontaneously created organizations, independent of the Republican government and established institutions, to defend themselves and to fight Franco's troops. The date is thus one commemorated in the liberal tradition. *(Author's note.)*

political position. My ties with the second, Sartre, are primarily intellectual. The third, with whom I share something more than ideas, is the poet René Char—a fraternal friend. None of the three will attack me." His answer took me aback and I said: "You're right, Malraux will never attack you. His heroic and theatrical aesthetic wouldn't allow him to; it would be a gesture unworthy of the lofty character he's playing. Char won't attack you either: he's a poet and at heart he feels exactly as you do—or you feel exactly as he does. But Sartre is an intellectual and, unlike Malraux, it's the life of ideas that is real to him (even though he maintains the contrary in his philosophy). What you say in *L'Homme révolté* must strike the author of *Le Diable et le Bon Dieu* as heresy, and he will condemn the heresy and the heretic in the Tribunal of Philosophy." Camus didn't believe me. A few days later Sartre unleashed his attack in his review. I telephoned María Casares: "How's Alberto?" "He's staggering about the house like a wounded bull," she answered.

G.C.—Time has passed and the characters in this drama appear in a different light today. Could you tell us a little about Breton's last years?

O.P.—Breton was not only incorruptible but clearsighted. But in those days his clearsightedness seemed to the Left to be typical bourgeois thinking, the confusion of the *bien-pensant* idealist. These were years of loneliness and isolation for him; people spoke of him with a pitying smile, a condescending gesture of compassion. Breton seemed like a poor deluded dreamer alongside Jean-Paul Sartre, the realist philosopher. Time has passed and we now see that the true realist, the one closest to reality and history, was

Breton, the delirious poet. The giants that Sartre attacked were not windmills but ideological chimeras. *Pièges*—pitfalls—of philosophy.

G.C.—Camus's criticisms of the Soviet regime are a contribution to those put forward earlier by various opposition movements in the U.S.S.R., ranging from the diverse opposition tendencies between 1917 and 1923 to the Kronstadt rebellion and finally to Trotskyism. What do you think of Trotsky's ideas in particular?

O.P.—Trotsky never said that the Soviet Union was a socialist state; he maintained that it was on the way to socialism. He saw it as a proletarian state that had degenerated. The sickness of the proletarian state was the Stalinist bureaucratic dictatorship. According to his analysis, the bureaucracy had usurped power through a palace counterrevolution. He thought that the Stalinist regime—which he compared to Bonapartism, a great error—was by nature transitory. He also maintained that the bureaucracy was not a new class but a caste. He believed that this caste was simply a political and administrative excrescence growing out of a deformed state. The entire Trotskyist reading of events is based on the transitional nature of bureaucratic regimes. That's all well and good, but this regime has lasted for more than fifty years now. A rather long transition period, don't you think? I think we're faced here with a new phenomenon that is causing the definitions of scholarly Marxism to totter. We must rethink modern history and look for other ways to interpret events. The analysis, for example, of those Asiatic states in which the bureaucracy was the dominant class can lead us out of the blind alley we have been led into by the idea of a transition *ad*

aeternam. A feudal society existed in China—during the so-called Chou dynasty—but unlike in Europe, the emergence from feudalism did not take place through the accumulation of capital. The feudal regime—a feudalism in many respects radically different from that in Europe—was replaced, in 221 B.C., by an alliance between the emperor, the bureaucracy, and the army. An unstable alliance, yet one that lasted two thousand years and survived both changes of dynasties and domination by a number of foreign powers. This example clearly demonstrates that bureaucratic despotism is not a transitory phenomenon.

G.C.—Marxism has fallen prey to the Hegelian myth. Marxists believe that they find in the so-called socialist countries an "inexorable end of history." From this there follows an uncritical acceptance of the monstrosities committed in the name of "real socialism." But if history in fact is open—if we exclude any sort of teleology—the postcapitalist societies take on the appearance of an enigma that must be deciphered. To do so, it is absolutely necessary to create new tools of analysis. What is your opinion as regards such new tools? Can they be forthcoming from Marxism, or has the Soviet tradition destroyed the revolutionary potential that this theory possessed in the nineteenth century?

O.P.—Your question is too vast in scope; I would rather break it down into smaller parts before answering. First of all, what I am about to say is not really a categorical opinion. Rather, it's certain impressions regarding various contemporary Marxisms. My answer should not be taken as a definite stand concerning historical materialism or dialectics, the hypothesis (since that's what it is—a hypothesis)

of surplus value, the relations between the modes of production and classes (which constitutes the real, much-debated, and highly debatable contribution of Marxism to the idea of the class struggle in history, an idea as old as Thucydides and the Roman historians), the Hegelian doctrine of alienation as modified by Marx, the question of the dictatorship of the proletariat, economic determinism, culture as superstructure, and so on. My impressions are of a historical, political, and moral nature.

G.C.—When you speak of Marxism, you use the plural.

O.P.—Despite their vast scope, Marx's writings remained open-ended and have come down to us as an imposing series of gigantic fragments. His thought never attained its definitive formulation; from the beginning, it was the object of successive interpretations. A number of them, such as those of Engels and Kautsky, were reductionist; others—Bernstein's, for example—constituted revisions and basic changes; still others, like those of Lenin and Mao, were amplifications and modifications no less substantial than Bernstein's, although along other lines. By emphasizing certain aspects and ignoring others, each of these versions was a different Marxism. And each of them proclaimed itself the one true Marxism. A mystery as tremendous as that of the Trinity. The Marxism of Rosa Luxemburg and Trotsky, of Gramsci and Stalin, have very little in common. Among all these Marxisms, which is the real one? A question that has no answer. Perhaps none is required: Marxism is not a theory; it's history. I remember how deeply impressed I was as a young man by the phrase uttered by one of the characters in Malraux's *Man's Fate*: "Marxism isn't a philosophy; it's a destiny." Yet one doesn't

argue with destiny or refute it: we either yield to its powers of fascination or rebel against it. The other side of the coin of destiny goes by the name of consciousness: freedom.

G.C.—But Marxism—or Marxisms—is also a thought that simultaneously seeks to explain the world and to transform it.

O.P.—That is so. Marxism is part of the intellectual and moral heritage of the West. Marx's contributions—and to a lesser degree those of Engels—have been of major importance, above all in history and economics. We cannot repudiate Marx, just as we cannot repudiate Adam Smith in economics or Tocqueville in history. Marxism, moreover, has been a powerful and profound body of critical and moral thought; it has had a decisive influence on the formation of the modern consciousness. In this sense, we are all Marxists in one way or another, just as sometimes, unwittingly, we are Neoplatonists, Stoics, Kantians, Darwinists. All these ideas and philosophies have been transformed, so to speak, into our intellectual blood, and circulate visibly in our modern minds, animating and irrigating our theories and hypotheses. As for myself, when I examine my intellectual and political life, I realize that a large part of it has been a dialogue—and often a polemic—with Marx and, above all, with Marxisms. Reading Marx is refreshing and invigorating; it is an exercise in intellectual fearlessness that enriches us. Each generation has two or three great conversational partners. For my generation, Marx is one of them. Recognizing this fact does not imply closing one's eyes to the exorbitant philosophical pretensions of this thought or its intolerant and dogmatic features.

G.C.—What has been the function of Marxist thought in the formation of the modern consciousness?

O.P.—Marxism has been, contradictorily, both a critical thought and an orthodoxy. In the second half of the twentieth century it has ceased to be critical and has turned into a pseudoreligious dogmatism. In the past it helped us to think freely, but today it's an obstacle to freedom of thought. It has lost its intellectual fecundity, as frequently happens in the history of ideas. Renaissance Neoplatonism was an extremely powerful current that in the sixteenth century paved the way for the modern era, but it disappeared when the thought that really inaugurated modern times appeared: Descartes, Newton. In like manner, ask today's physicists, chemists, geologists, or specialists in genetics and molecular biology what they think of dialectics as a scientific method. There is a difference, however: the discredit into which Neoplatonism fell was an intellectual phenomenon, whereas that of Marxism has been, and is, above all moral and political. Contemporary criticism of Marxism is similar to the criticism of bourgeois liberalism developed by Marxism; just as the latter set the terrible reality of capitalist society over against the principles and ideas that its law codes and constitutions proclaimed, so we have confronted the regimes that call themselves Marxist with the principles and ideas of Marxism. The contradiction could not be greater or more scandalous.

G.C.—In what sense does it seem to you not to be a modern philosophy?

O.P.—The shortcomings of Marxism are those of the philosophies of the nineteenth century. Marxism has historical

limitations; it is the prisoner of its origins. Marx thought through the problem of the Other within the framework of the European culture of the nineteenth century. Marx recognized the working class as this Other and thus grasped one of the contradictions on which present-day society is founded. We now know that this schema neglects—and, when it takes power, represses—other differences and oppositions: peasants, women, oppressed nationalities, submerged cultures, Dostoevski's underground man—the Other that each one of us constitutes, sexuality and its contradictory complement: the aspiration toward the divine, the beliefs that we call irrational, poetry—in a word, all the areas where exception and difference are the rule, the world of Others and the Other. The multiple other that Marx was unable to recognize.

G.C.—How effective is Marxism today?

O.P.—It's a truism that Marx left us not a closed system, but many foundation stones for building a new vision of history. In this sense, Marxism is still fertile. But by the will of its founders Marxism also tried to make itself the instrument of the universal class, the workers, for the great task: the revolutionary change of society. From this point of view, the doctrine has proved singularly inadequate. Marx's first successors, the German and Austrian Marxists in particular, always believed that the same relation obtained between the doctrine and the working class as between the hand and the hammer that it uses, both to destroy and to build. But the European working class did not want to use this hammer and chose other ways to fight. Lenin and the Bolsheviks wrested the hammer away from the working class and handed it over to its supposed

vanguard, the Communist Party. Since then, there have been countless deformations of Marxism. The most notable one came about in China: at first an international revolutionary philosophy of industrial society, Marxism came to be the ideology of a national movement of peasants led by a revolutionary militia. A strange trick of fate. Marxism, conceived and designed as a weapon of the proletariat of the industrial countries, is today the ideology of backward nations on the periphery, barely or insufficiently industrialized, dependent on the outside world, and with a small, recently formed working class. Marxism was a revolutionary internationalism that set out to erase national boundaries and do away with the State: today it is a nationalism and an idolatry of the State.

G.C.—And in Latin America?

O.P.—In Latin America it is not a doctrine but a belief; this accounts simultaneously for its intellectual vulgarity and its power of contagion. It is the ideology not of the working class and certainly not of the peasants, but of an exasperated and desperate middle class. Despite its vocabulary, it is basically a scientism with large admixtures of nationalism, populism, and worship of the State.

If the evolution of the industrial countries of Europe has belied the predictions of Marxism, what can be said of its value as a method of interpretation for non-Western societies or ones on the periphery of the West, such as those of Latin America? It was not Marx's intention to limit his studies to the advanced society of the West. Basing himself on European reality, he imposed his schemas and generalizations on foreign cultures. When I was in India, I realized how ethnocentric Marx was. (A limitation, more-

over, that was not only his but that of his time.) He believed, for example, that English rule—capitalism and its most revolutionary technological expression, the railroad—would put an end to the caste system. More than a hundred years later the castes and civilization of India are still resisting a modernity that is alien to them. Marx saw with admirable clarity that capitalist expansion would bring about, for the first time in history, the unification of countries and of humankind in a worldwide economic system, but the fascination that this major discovery exerted on his mind blinded him to the reverse phenomenon: the persistence of national cultures and their irreducible singularity. The time has now come to reintroduce into our vision of history that reality known by the ancients as "the genius of peoples."

G.C.—To do justice to Marx's thought, it must be granted that in his last years he began to revitalize the European model of development, as is evident in his letter to Vera Zassulich (1881). If we transcend its limits, what is left of Marxism that we can salvage?

O.P.—What must be salvaged in Marxism is its interest in the Other, its subversive nature. William Blake said that true poets are of the Devil's party. True Marxism is still of the Devil's party, that is to say, on the side of creative negation.

G.C.—What must be criticized in Marxism is its inability to recognize multiplicity, to take differences into account in its thinking.

O.P.—In Latin America, taking differences into account in our thinking means recognizing what distinguishes us, the ethnic and cultural heterogeneity and plurality of our peoples. The expression "Third World," which was meant to fill this vacuum, creates a new fictitious uniformity (what do Zaire and Argentina, Brazil and Burma have in common?). Latin America belongs to the West both by virtue of its languages—Spanish and Portuguese—and by virtue of its civilization. Our political and economic institutions are also Western. But within this "Westernness" the Other, the Others, lie hidden: Indians, pre-Columbian cultures or those brought from Africa by blacks, the peculiarity of our Hispano-Arabic heritage, the particularity of our history. All this makes of us a different, unique, eccentric world: we are and are not the West.

G.C.—A return of the repressed?

O.P.—A historical vengeance. Repressed cultures take vengeance on this artificial, imposed modernity. Iran has been the most recent example: the revolt that did away with the imperial regime was a reaction against an attempt to modernize imposed from above. Another example, less dramatic and closer to home, is that of Mexico. In different writings I have repeatedly pointed out the presence of traditional, premodern traits not only in the mores of Mexicans but also in their ideas and beliefs. The axis of Mexican traditionalism is religious: the peculiar form that Catholicism took in Mexico, the most notable expression of which is our worship, at once ingenuous and impassioned, of the Virgin of Guadalupe. Her figure is not only intimately associated with the public history of our country—her image appears on the banners of popular peasant uprisings—

but is also part of the intimate history of each Mexican. In their dreams and inner monologues, men and women speak with the Virgin. What would we think of a historian or sociologist who disdainfully dismissed the reality of the worship of the Great Goddess of India, Durga or Kali, on the grounds that this is a matter of superstitions thousands of years old, and that Marx and his disciples have already said everything there is to say about religion? This aberration, the product of self-conceit and ignorance, has been frequent among Mexican leftist intellectuals. My opinions on Mexican traditionalism and worship of the Virgin have been received with disdain and mocking scorn. In one case they were even cited as an example of my incurable idealism or what amounts to the same thing, my no less incurable reactionary obscurantism.

In the second half of the twentieth century we have witnessed a general collapse of ideas, philosophies, and systems. We have also seen the reappearance of realities buried prematurely by arrogant ideologues. Among the great survivals of the century—fortunately or unfortunately?—are religions and nationalisms. The persistence of national cultures and their traditional forms leads us to look at the central theme of the history of Latin America, modernization, with different eyes. It is evident that each culture and each country must find its own road to modernization. This has been the tragedy of Latin America: our modernization, which began with independence, has been a failure because it does not correspond to our tradition or to what we really are. Liberalism, positivism, and now Marxism-Leninism have been enthusiastically adopted by Latin American intellectuals as abstract formulas; none of these doctrines has been thoroughly reexamined by and for Latin Americans. Hence we live in a

state of permanent dualism: Latin America claims to be modern, but our social and political realities are premodern. We continue to be dominated by the myth (and the reality) of *caudillismo*.[4] *Caudillismo*—a Spanish and Arabic inheritance—has been reinforced by militarism and populism. In Latin America, authoritarian paternalism predominates, under different names and in various forms— some of them bloody and tyrannical, but others peaceful and institutional, as in Mexico. Cuba is no exception. Castro is a traditional *caudillo* in the Latin American style, although his regime is the gray dictatorship of the militarized bureaucrats of Eastern Europe.

G.C.—To conclude these reflections, what in your opinion can serve as the basis of a new critical thought?

O.P.—Two obstacles stand in the way of elaborating a new idea of society. The first is the identification of social progress with industrial development, an error shared by capitalists, Marxists, and the technocracies that rule us. One great precursor can help free us of this error: Fourier. With extraordinary foresight Fourier saw that industrial development is not something desirable in and of itself. Fourier repeatedly states that the factory worker is necessarily a person who is wretched, or as we would say today, alienated. So he put forth a plan for a society with a minimum of industries and assigned a fundamental role to agriculture.

G.C.—Might we then think of a postcapitalist development that can skirt the disasters of industrialism? Schu-

4. Rule by a *caudillo*, a strong man.—TRANS.

maker, with his proposal for intermediate technologies, and Ivan Illich, with his rethinking of the energy problem, could be said to be adapting these ideas to the needs of our day.

O.P.—I believe we are condemned to be modern. We cannot, and must not try to, get along without technology and science. As a solution to the impasse of industrial society, any "return to the past" is impossible and unthinkable. The problem lies in adapting technology to human needs rather than the reverse, as has been the case so far. In Mexico some of us have begun to think about such matters: Gabriel Zaid, Enrique Krauze, Enrique González Pedrero, myself. Zaid's book (*El progreso improductivo*) breaks a path: traditional societies must be defended, if we wish to preserve diversity. We all realize that this is extremely difficult, but the other possibility is grim: a general collapse of civilization, compared to which the end of the ancient world between the fifth and seventh centuries will prove to have been no more than a modest "dress rehearsal" of disaster. From this point of view, the preservation of plurality and differences between groups and individuals is a preventive defense. The extinction of each marginal society and each ethnic and cultural difference means the extinction of yet another possibility of survival for the entire species. With each society that disappears, destroyed or devoured by industrial civilization, a human possibility also disappears—not only a past and a present but a future. History has thus far been plural: different visions of humanity, each with a different vision of its past and future. To preserve this diversity is to preserve a plurality of futures, that is to say life itself.

The other great danger, closely linked to what I have

just described, lies in conceiving of the new society as a geometric construction: utopia. There is nothing more oppressive than life in the phalansteries imagined by Fourier. The temptation of geometry is the intellectual temptation par excellence. It is the temptation of philosophical Caesars. We must cultivate and defend particularity, individuality, and irregularity—life. Human beings do not have a future in the collectivism of bureaucratic states or in the mass society created by capitalism. Every system, by virtue as much of its abstract nature as of its pretension to totality, is the enemy of life. As a forgotten Spanish poet, José Moreno Villa, put it with melancholy wit: "I have discovered in symmetry the root of much iniquity."

The New Analogy:
Poetry and Technology

In 1964 I wrote some fifty pages that I called *Signs in Rotation*.[1] The publisher advertised the pamphlet as a "poetic manifesto." I don't know if it really was one. I do know, however, that it was an attempt to shed light on the *manifestation* of poetry in our century, its appearance as an errant sign in a time that is also errant: this time that is ending and the time, still without a name, that is now beginning. I saw poetry as a configuration of signs, and the pattern it traced was that of dispersion. A poem: an ideogram of a world seeking its meaning, its orientation,

Third Herbert Read Lecture, The Institute of Contemporary Arts, London, 1970.

1. They are now the final chapter of *El arco y la lira*. American ed.: *The Bow and the Lyre*, 1956.

not in a fixed point but in the rotation of points and in the mobility of signs. What follows is the continuation and critique of those reflections.

All societies possess what is commonly called an "image of the world." This image is rooted in the unconscious structure of society and sustained by a particular conception of time. The cardinal role of time in the formation of the image of the world is due to the following: we humans never see it as a mere succession but as an intentional process, possessing a direction and pointing to an end. The acts and words of human beings are made of time, they *are* time: they are a *toward* this or that, whatever the reality designated by this or that may be, not even excluding nothingness. Time is the repository of meaning. The poet says what time says, even when he contradicts it: he names the flow, gives voice to succession. The image of the world enfolds itself in the idea of time and this idea unfolds in the poem. Poetry is time unveiled: the enigma of the world transformed into an enigmatic transparency. Each civilization has had a different vision of time; some have thought of it as an eternal return, others as an immobile eternity, others as an emptiness without dates or a straight line or a spiral. There is the Platonic year, circular and perfect like the movement of the heavenly bodies, or the apocalyptic time, in a straight line, of Christians; the illusory time of the Hindu, a whirlwind of reincarnations; or the infinite time, the continuous progress of the nineteenth century. Each of these ideas has become incarnate in images we call poems—a name that designates a verbal object without a fixed form and perpetually changing, from the magic invocation of spirits by primitive peoples to contemporary

novels. But poetry today is confronted with the loss of the image of the world. And so it takes on the appearance of a configuration of scattered signs: the image of a world without an image.

The modern era began as a criticism of all mythologies, not excluding the Christian one. This latter fact is not surprising: Christianity shattered the circular time of Greco-Roman antiquity and postulated a rectilinear, finite time, with a beginning and an end: the Fall and the Last Judgment. Modern time is the offspring of Christian time. The offspring and the negation: it is an irreversible time that follows a straight line, but it lacks a beginning and will have no end; it has not been created, and it will not be destroyed. Its protagonist is not the fallen soul but the evolution of the human species, and its real name is history. Modernity is grounded in a twofold paradox. On the one hand, meaning resides neither in the past nor in eternity but in the future, so that history is also called progress. On the other hand, time does not have a foundation in any divine revelation or immutable principle; we conceive of it as a process that continually negates itself and thus transforms itself. Time is grounded in the criticism of itself, its constant division and separation; its form of manifestation is not the repetition of an eternal truth or of an archetype: its substance is change. Or rather, our time lacks substance; what's more, its action is the criticism of any and every substantialism. Thus Revolution takes the place of Redemption. A new time is a new mythology: the great creations of modernity, from Cervantes to Joyce and from Velázquez to Marcel Duchamp, are different versions of the myth of criticism.

Technology today makes criticism an even vaster enterprise, since it has undertaken to criticize criticism itself

and its idea of time. The heaven and earth that philosophy stripped of gods are gradually being covered over with the formidable constructions of technology. These works, however, represent nothing, and strictly speaking they say nothing. Romanesque churches, Buddhist stupas, and Mesoamerican pyramids had their firm foundation in an idea of time, and their forms were a representation of the world: architecture as a symbolic double of the cosmos. The Baroque palace was the monologue of the curved line that breaks and forms anew, the monologue of pleasure and death, of the presence that is absence. The Hindu temple was a sexual vegetation of stone, the copulation of the elements, the dialogue between *lingam* and *yoni*. What do our airplane hangars, railway stations, office buildings, factories, and public monuments express? They express nothing: they are functions, not meanings. They are centers of energy, monuments of will, signs that radiate power, not meaning. The works of antiquity were a representation of reality, the real and the imaginary; those of technology are an operation performed on reality. For technology the world is neither a perceptible image of the idea nor a cosmic model: it is an obstacle that must be overcome and modified. The world as image disappears, and in its place rise the realities of technology, fragile despite their solidity, being doomed to be negated by new realities.

The destruction of the image of the world is the first consequence of technology. The second is the acceleration of historical time. This acceleration culminates, in the final analysis, in a negation of change, if by change we understand an evolving process that implies progress and continued renewal. The time of technology speeds up entropy: in just one century the civilization of the industrial era has produced more refuse and dead matter than all other civ-

ilizations put together, from the revolution of the Neolithic Age on. It thus attacks the very center of the idea of time elaborated by the modern age; by exaggerating it, it reduces it to absurdity. Technology is not only a radical criticism of the idea of change as progress; it also sets a limit, a "thus far and no farther," to the correlative idea of time without end. The time of history was practically infinite, at least in terms of human measurement. It was thought that it would take thousands of years for the planet to freeze to absolute zero; hence the human species had ample time to complete its cycle of evolution, to attain power and wisdom and even unlock the secret of overcoming the second law of thermodynamics. Contemporary science lends no credit to these illusions; the world may come to an end any day. There is an end of time and that end will be unexpected; we live in an unstable world: change is no longer a synonym of progress but of sudden extinction.

Astronomers today often speak of stellar catastrophes, thereby introducing the idea of accident into a sphere that once seemed the very model of order. But it is not necessary to resort to examples from astronomy; there is one closer at hand, more popular and more convincing: the atomic bomb. Its very existence constitutes an argument that literally explodes the idea of progress, whether conceived as a gradual evolution or as a sudden revolutionary leap forward. True, thus far we have managed to avert the hecatomb. Yet the mere possibility is enough to cause our idea of time to lose all consistency. Though the bomb has not destroyed the world, it has destroyed our idea of the world. The critique of mythology undertaken by philosophy since the Renaissance becomes the critique of philosophy: time may be consumed in a ball of fire that will

put an end all at once to the dialectics of mind and the evolution of species, to the republic of equals and the tower of the superman, the monologue of phenomenology and that of analytic philosophy. We are rediscovering a feeling that the Aztecs, Hindus, and Christians of the year 1000 were never without. Technology begins as a negation of the image of the world and ends as an image of the destruction of the world.

The relations between technology and poetry are special: on the one hand poetry, like all the other arts, tends to utilize the resources of technology, particularly those in the communications media: radio, television, records, films, etc.; on the other hand, it must face up to technology's negation of the image of the world. In the first instance, poetry finds support in technology; in the second, it opposes it. This opposition is a complementary one, and in the second part of these reflections I shall come back to it. For the moment I must turn to the subject of poetry's use of these new technical means. I shall begin by distinguishing two phases in the poetic process: the elaboration of the poem and its reception by a reader or listener. I call them phases of a process, because a poem never presents itself as an independent reality; no poetic text has an existence per se: it is the reader who gives the poem reality. In this sense, the poet is simply the first reader of his poem, the first author.

There is no reason why the poet shouldn't use a computer to choose and combine the words that are to make up his poem. The computer no more does away with the poet than do dictionaries of rhyme or treatises on rhetoric. The computer poem is the result of a mechanical process

somewhat comparable to the mental and verbal operations that a seventeenth-century courtier in the West had to go through in order to write a sonnet, or those that a Japanese of the same century performed in order to compose, with a group of friends, the collective poems called *haikai no renga*. Margaret Masterman's studies and experiments at the Cambridge Language Research Unit demonstrate something that classical rhetoric took for granted: to compose a poem we need a syntactical model, a vocabulary to "embody" it, and a set of rules for choosing and combining the terms of the vocabulary. The procedure followed by Margaret Masterman and Robin McKinnon Wood in order to produce series of haikus is not essentially different from the one that thousands and thousands of Japanese have used for several centuries to achieve the same end. The results are also similar: pleasing, sometimes surprising, and in the end monotonous. If it has been provided with the proper syntactical model and vocabulary, a computer can change a gracious thank-you letter into one of gross abuse; the same operation, though intended as an exercise in destroying language as a system of meaning, was performed a century ago by Lautréamont. His "correction" of the thoughts and maxims of Pascal and Vauvenargues was at once a violation of language and a refutation of its powers. Poetry enters the picture at the moment when impersonal memory—the vocabulary of the computer or dictionary— and our personal memory intersect: suspension of the rules and irruption of the unexpected and the unpredictable. A break in the usual procedure, an end to formula—poetry is *always* an alteration, a linguistic deviation. A creative deviation that produces a new and different order.

The text written by the computer or by devotees of *haikai* and another, different text are interchangeable; a true

poem is not interchangeable with any other text. The same thing is true in poetry as in music and painting: each work is unique. This is so because, at some moment in its elaboration, the act of the artist intervened: his decision to interrupt and alter the predictable development of the aesthetic game. It isn't at all certain that this act is entirely voluntary—each artist, each person, is impelled by his or her particular fate—but its liberating meaning and its consequences cannot be doubted. A subversion that is also a conversion: the making of a verbal or plastic object is transformed into the creation of a work.

It is pointless to dwell at length on the utilization of the new means of communication in the transmission of poetry. These means make it possible, as we all know, to return to oral poetry, the combination of the written and the spoken word, to return to poetry as fiesta, ceremony, play, and collective act. In the beginning, poetry was the word spoken and heard by a collectivity. Little by little the written sign displaced the human voice and the individual reader, the group: poetry became a solitary experience. We are now returning once again to the spoken word and come together to hear poets; more and more, instead of reading poems, we hear them, and we hear them in a group. It is quite natural that this is coming back: even in the heyday of books and the printed word, a poem was always an architecture of sounds/meanings. All the great poets of all civilizations, not excluding the Chinese, agree: poetry is the spoken word.

The surface on which signs, whether phonetic characters or ideograms, are inscribed is the equivalent, or rather the manifestation, of the time that, simultaneously, sustains and consumes the verbal architecture constituting the poem. Because it is sound, this architecture is time, so that the

poem is made and unmade there before us. What sustains the poem is the very thing that devours it: the substance it is made of is time. The page and the Chinese written scroll move because they are metaphors of time: space in motion that, as if it were time, constantly negates itself and thereby reproduces itself. Temporalization of the page: the written sign does not rest on a fixed space, as in painting, but on a surface that, because it is an image of time, *elapses*. For this reason Mallarmé saw the typographical arrangement of *Un coup de dés* as being a musical score, that is, a configuration of signs that we *hear* as we read. Every reading of a poem, regardless of what signs it is written in, consists of *speaking and hearing with one's eyes*. A silent recitation that is at the same time a vision: on reading, we hear, and on hearing, we see. Thus what distinguishes our contemporary attitude from the one that still prevailed some fifteen or twenty years ago is not the primacy of the spoken word over the written sign, but the fact that the poetic experience is once more becoming physical, corporeal: the word today enters through our ears, takes on material consistency, becomes embodied. It is no less revealing that the reception of poems is becoming a collective act: the displacement of the book by other means of communication and that of the written sign by the voice go hand in hand with the corporeal embodiment of the word and its collective incarnation.

The change in status of writing also explains the advent of the visual poem. Apollinaire saw his *calligrammes* as "a typographical precision at a time when printing is reaching a brilliant end of its career; at the dawn of the new means of reproduction represented by the cinema and the phonograph." Although the new media did not do away with printing, and will not, they have changed it radically. As

proof of this, we need only remember the compositions of the Russian Futurists or Pound's use of ideograms and pictograms. This tendency culminates in concrete poetry and, as in the case of spoken poetry, it results in a leave-taking: the poem abandons the book. Whether visual text or spoken text, the poem separates itself from the book and becomes an independent, sonorous, and/or plastic object. I shall repeat, yet again, that the written line, even that of the concrete poem, is a metaphor of speech. Unlike what happens in our experience of painting, a silent art, the silence of the page allows us to hear the writing. Nor is this all: on the day that someone finally decides to make full use of cinematographic resources, it will also be possible to combine reading and hearing, written signs and sounds. The screen is a multiple page that engenders other pages: a wall, column, or stele, it is a single immense canvas across which a text might be inscribed in a movement analogous to, though the reverse of, that of a Chinese scroll unfolding.

To conclude: technology changes poetry and will increasingly change it. It could not be otherwise: the role it has been called upon to play affects not only the transmission and reception of poems but also the methods of composing them. But these changes, however profound they may appear to be, do not alter the true nature of poetry. On the contrary, they take it back to its origin, to what it was in the beginning: the spoken word, shared by a group.

The subject of the complementary opposition between technology and poetry calls for a different analysis. In my opening remarks I said that, despite their aggressive reality,

the works produced by technology do not really signify anything: they are not meanings but functions. Though technology has changed the world, it has not given us an image of the world. That, admittedly, is not its mission, which is to transform the world, but what technology has wrought would have been impossible, had the former image of the world not first been destroyed. The modern age subjected mythologies to critical examination; the earth ceased to be holy and, having been swept clear of gods, was left free for the action of technology; today technology is destroying in turn the image of the world that the modern age constructed. Offspring of the idea of progress, technology makes us doubt the very meaning of that word: isn't it synonymous with crisis, anxiety, violence, oppression, and perhaps death? Time conceived of as history, and history envisioned as endless progress, are drawing to a close. From Washington to Moscow, future paradises have turned into a hideous present that makes us doubt if there will be a tomorrow.

To think that the world may end at any moment and to lose faith in the future are nonmodern traits that negate the assumptions on which the modern age was founded in the eighteenth century. It is a negation that at the same time is a rediscovery of the essential wisdom of ancient civilizations. The loss of the future takes us back to modes of being and of feeling that to all appearances were extinct. Christianity gave each human being an immortal soul; although the modern age snatched it away from us, it promised us in exchange the immortality of the human species as a whole, the immortality of history and progress. Today it leaves us prey to the same doubt as that experienced by the Aztec at the end of each fifty-two-year cycle: will the sun rise again tomorrow or will this night be the last? Still,

there is a difference: the ancients feared that the anger or the caprice of their gods would destroy the world, yet their notion of fate was cyclical; for us the image of cosmic catastrophe takes on the form, at once awful and grotesque, of Accident. We live the time of the Aztec and a time that no one before us ever foresaw or dreamed of—a time that is, simultaneously and contradictorily, the time of total destruction and of information science. Because of the former, our situation is to a certain degree analogous to that of other societies in the past; because of the latter, the universe is beginning to take shape as a system of correspondence that, again to a certain degree, resembles the traditional doctrine of analogy. To explain and develop my idea, I shall begin with a brief comparison of the analogical system of medieval Christianity and modern irony.

The predominant mode adapted by poetic communication while Christianity was at its peak was allegory. The favorite genre of the modern age has been the novel. Allegory is one of the expressions of analogical thought. It is based on the following principle: *this* is like *that*, and from this similarity other similarities are deduced or discovered, until the universe becomes a tissue of relations and equivalents. Allegory, as its name indicates, is a discourse in which, by speaking of one thing, one also speaks of another. Analogy is the link. The critic Charles A. Singleton has shown that Dante's *Commedia* is an allegory of allegories: the prologue of the poem is an allegory of the poet's journey through the three worlds, which is in turn the allegory of the wanderings of the fallen soul and its final conversion. The basic code for these circular allegories is the Book of Exodus. Dante himself states in a letter to Can Grande: "If we follow the literal sense, the meaning is the flight from Egypt by the Children of Israel in the

days of Moses; in the allegorical sense, it is the redemption of Christ; in the moral sense, the conversion of the soul."[2] Sacred history is the bridge between two realities: the journey of the poet to the other world, and the soul's trials before contemplating the Divinity. But the Book of Exodus belongs to the Old Testament, and thus the allegory contains within itself yet another allegory: the Gospels. The Passion of Christ is the nexus between the old Word and the new, the link that closes the circle.

The story of humanity is embodied in that of Israel, which is an allegory of yet another story encompassing them all: the Redemption. The correspondence between all these realities is verbal: the message of the poet, the *Commedia*, is deciphered through another message, the Book of Exodus, which in turn is elucidated through another: Christ's Gospel. This circuit is a replica of information theory. Though the values and meanings are different, the system of symbolic transformation and transmission of symbols is not. In the case of the *Commedia* there are two series, one verbal and the other nonverbal. The first is made up of the *Commedia* itself, the Book of Exodus, and the Gospels; the second comprises the vicissitudes of the wandering soul, the flight from Egypt, and the history of humanity since the fall of Adam. Both series are reflected in the journey of the poet to the other world, that is to say in his poem. The correspondence between the word and nonverbal reality is perfect.

With the *Commedia*, Christian society offers us its most perfect and most complete work. With the *Quijote*, the first great work of the modern world makes its appearance.

2. *Dante, a collection of critical essays.* Edited by John Fieccero, 1965. Cited by Charles A. Singleton, *In Exita Israel de Aegipto.*

The subject of Cervantes's novel is also the human soul—not the fallen soul but the alienated one. The hero is a madman, not a sinner. He doesn't share the common lot of mortals, since he has lost his free will. Don Quixote doesn't embody human history; he is the exception to it. He is exemplary in an ironic way, through negation: he is not like the rest of humanity. The correspondence is broken off, or more precisely, assumes the form of a break. The peregrinations of the hidalgo of La Mancha are an allegory not of the wanderings of the chosen people but of a solitary man who has lost his way. Vergil and Beatrice guide Dante; no one guides Don Quixote, and his traveling companion is not a seer but shortsighted common sense. The pattern of the poet's journey is the concentric circle; the madman's ramblings astride his nag obey no geometry, heed no geography: they are an aimless going and coming in the course of which wayside inns turn into castles and gardens into horse corrals. The pilgrimage of the Florentine is a descent and an ascent, that of the Spaniard a succession of setbacks and calamities. Dante's final vision is one of Divinity; Don Quixote's is a return to himself, to the mundane reality of the impoverished hidalgo. In the one case there is contemplation of the supreme reality and conversion; in the other, recognition of our insignificance and resignation to being what one is. Dante sees truth and life; Don Quixote regains his sanity and confronts death.

Analogy is the expression of the correspondence between the heavenly world and the earthly: although the reality of the second is subordinate and a reflection of that of the first, it is reality nonetheless. Irony works in precisely the opposite sense: it emphasizes the abyss that exists between the real and the imaginary. Not content to de-

scribe the yawning chasm between the word and reality, irony sows doubt in our minds: we don't know what is truly real, whether it is what our eyes see or what our imagination projects. The *Paradiso* and the *Inferno* are real, as real as Florence and Rome; the horrible, bare reality of Castile is a mirage, a spell woven by evil sorcerers. There is a continual wavering between the real and the unreal: the windmills are giants and a moment later they are windmills. This wavering produces no conversion: the characters are condemned to be what they are. Hence they are untrue to their models: Aldonza is not Dulcinea, Don Quixote is not Amadís. Yet the hidalgo Quijano is not entirely Quijano the Good: he is Don Quixote—and he is not. People are no less problematical than things. The same applies to language: Dante's is poetry; Cervantes wavers between verse and prose. This ambiguity characterizes the modern novel as a whole: it is poetry and criticism of poetry, epic and mock epic. A problematic reality, problematic heroes, and problematic language: the myth of criticism begins to take shape. Correspondence no longer holds and irony takes the place of analogy. The key to the *Commedia* is the Book of Exodus; the key to Cervantes's novel, the romances of chivalry. The first is holy writ, the universal and eternal model; the second, light entertainment and diversion, not an allegory of the history of humanity but the story of its meaningless adventure. Language is no longer the key to the world; it is the mere mouthing of empty, mad words. Or is it just the opposite: the madness is the world's, whereas Don Quixote is rational speech that wanders here, there, and everywhere disguised as madness? Cervantes smiles and says nothing: irony and the death of illusion.

The breakdown of analogy is the beginning of subjectivity. Humans enter the scene, dislodge divinity, and confront the meaninglessness of the world. A double imperfection: words have ceased to represent the real reality of things, and things have become opaque, mute. Humanity must confront a reality shut up within itself, incommunicado and incommunicable. The denial of the meaninglessness of the world, its transformation into meaning, is the story of the modern age. This story might also be given a title reminiscent of the romances of chivalry: *The heroic feats of subjectivity, or the conquest of the world through the denial of the world.* The one way to restore the unity between things and words was to do away with one of the terms. The either/or proposition presented itself in these terms: Don Quixote is not mad, therefore condemnation of the world; or alternatively, the hidalgo's language is the raving of a madman, therefore elimination of Don Quixote. The first solution implied renunciation of the world, but in the name of what principle or what natural or supernatural reality? Don Quixote's sacred books were not those of the Bible, but tales in which fantasy appears to be sheer nonsense. The modern age chose the second solution, so Don Quixote dies in bed, cured of his madness and brought back to the reality of Alonso Quijano. With the banishing of Don Quixote, a paradigm of language as unreality, what we call imagination, poetry, the sacred word, or the voice from another world, was cast beyond the pale. These names have a reverse side: incoherence, alienation, insanity. Poetry was sentenced to exile; madness, to the asylum. As the boundaries between the two became more and more tenuous, poets too were sometimes shut away and sometimes treated as harmless lunatics.

The splitting of language in two—one half rational and

the other irrational—had its counterpart in the splitting of nonverbal reality. Subjectivity took the place of the Christian God, but human beings are corporeal creatures, not spirits. Through the same process of partial negation, subjectivity suppressed the half that, significantly enough, is designated by the expression *las partes bajas del hombre*: the "lower parts," the genitals. The mutilation of reality was also linguistic, since it is impossible to reduce love to sexuality. Eroticism is a game, a representation in which imagination and language play no less important a role than sensations. It is not an animal act: it is an animal act become ceremony, its transfiguration. Eroticism contemplates itself in sexuality, but sexuality cannot contemplate itself in eroticism. If it were to contemplate itself, it would not recognize itself. Each negation of subjectivity meant the suppression of a reality deemed to be irrational, and consequently condemned to unreality. Irrationality could be absolute or partial, constitutional or temporary. In this way twilight zones were created, inhabited by semirealities: poetry, woman, the homosexual, the proletariat, colonial peoples, the colored races. All these purgatories and infernos seethed in secret underground. A day came in the twentieth century when this subterranean world exploded. The explosion is still going on, and its glare lights the agony of the modern age.

The successive negations of subjectivity were so many attempts to do away with the split between the word and the world; that is, they were the search for a universal principle that would be sufficient and invulnerable to criticism. This principle was criticism itself: the substance and foundation of the world is change, and the most perfect form of change is criticism. Negation became creative: meaning lies in subjectivity. I shall not call to mind all the

chapters of this history, but mention certain of them that seem significant. The first is Kant. The philosopher confronted a problem not essentially different from that of Cervantes: between names and reality there lies an abyss, and he who ventures to cross it plunges into the void, goes mad. The remedy against the fascination of the abyss is called, in aesthetic terms, irony; in rational terms, philosophy. Both are a heroic exercise of wisdom, a tightrope suspended over the void. In Kant's work noumenal reality, real reality, is the equivalent of Don Quixote's castles. It is a region inaccessible to reason: the "thing in itself" is guarded by four magicians, four antinomies that drive philosophers mad as Merlin the wise man drove the unfortunate Durandarte mad.

For Kant, dialectics was the logic of illusions. But resignation is not the virtue of philosophers, and Hegel transformed the logic of illusions into the method that destroys antinomies and produces truths. Each concept, he said, is an antinomy because it contains within itself a contradiction, but this negativity is also positive, since it contains its own negation. Through dialectics, "being contemplates itself in the other," which negates it. In this negation it affirms and knows itself as being: it is what is not the other. Through negation man appropriates the "thing in itself" and makes of it an idea, a tool, a creation, history: he gives it meaning. History is a moment of Mind and man is the transmitter of meaning. Marx goes a step further. Hegel regarded tools and work as embodied concepts, negations turned into acts; Marx asserts that the concept is abstract work: history is the projection not of the concept but of societal work. The task of doing away with the "thing in itself" and transforming it into meaning does not fall to the concept but to industry: to work and to workers. Once

again, humankind is the giver of meaning, and once again, it is that insofar as it is history. Thus, whether idealistic or materialistic, thought of the modern age maintains that meaning resides in humanity, and the meaning of humanity in history. The magic bridge between words and things, the principle that took the place of traditional analogy, was history. Hegel put it with amazing clarity: dialectics is the cure of the split. The negation that is affirmation heals the old wound.

The other philosophies of the nineteenth century lead, by different paths, to similar assertions: the meaning of evolution is humanity; or, to phrase it with greater fidelity to Darwin's thought: the human species is that phase of evolution in which evolution finally becomes conscious of itself. Here is transformation (deformation) of a scientific theory into a belief concerning history: the evolution of nature becomes a synonym of progress, and this progress is measured by the distance that separates humans from animals and the civilized being from the savage. Nietzsche was the dissident voice: faced with the idea of time and history as an unending advance, he proclaimed the eternal return; by announcing the death of God, he revealed the meaninglessness of the universe and of its supposed king, man. Since Nietzsche the poet was also a philosopher, he could not resist the twofold temptation, at once poetic and philosophical, of prophecy and foretold the appearance of the "perfect or absolute nihilist," a figure in whom the opposition between meaningless being and meaning empty of being would finally be resolved: the superman. Evolution, revolution, or subversion: these three words summed up the new wisdom.

The reign of subjectivity had begun as a critique of prophets; at its height it turned into prophecy and

proclaimed the advent of three events that were different yet similar in meaning: the republic of equals, infinite progress, and the reign of the superman. All these prophecies are critical, by which I mean that they are projections of the critical spirit and, furthermore, that their realization requires the active intervention of criticism. In point of fact, the revolution of the proletariat, natural selection, and the subversion of values are processes that are critical in nature: they deny *this* in order to affirm *that*. The difference with respect to antiquity is impressive: analogy is based on the conjunction or correspondence of contraries; criticism is based on the elimination of one of the terms. But what we eliminate through the violence of reason or of power inevitably reappears and assumes the form of criticism of criticism. The era now beginning is that of the revolt of suppressed realities. We are living a return of times.

The return of times, the universal revolt we are now living, began first in art. From its birth, modern art was a critical art; its realism, tinged with passion, was not so much a portrait of reality as a critique. But beginning with Symbolism, poets and novelists, while continuing their critique of the world and of humanity, have also introduced into their works the criticism of language, the criticism of poetry. It is not a question, as has commonly been said, of a destruction of language, but rather of an operation tending to reveal the reverse of language, the other side of signs. The same thing has happened in the other arts; there is no need to call attention to the successive reversals to which music, painting, and sculpture have been subjected. I shall cite an example, however, to illustrate my observations clearly. On visiting the Richard Hamilton retro-

spective at the Tate Gallery, I was amazed and fascinated by the artist's obsession with what one critic calls "negative reversal." In one of his works, by using superimposed signs on thin sheets of glass, Hamilton makes the spectator move from what we call "the front" of it to what we call "the back." A plastic and poetic game not unworthy of Lewis Carroll. It is not by sheer chance that the name of Carroll has spontaneously come to my mind while speaking of painting. All modern painting is at once a language and a criticism of that language. A painting is a system of relations, values, and signs; each painting is an investigation and a critique of itself. Modern art is a critique of meaning and an attempt to show the reverse side *of signs*.

In recent years two movements have shaken the West: the revolt of the body and the rebellion of the young. By both their derivation and their meaning, the two correspond to the revolt of art. By their derivation, since both are expressions—or rather, explosions—of an underground current that had its source in William Blake and the English and German Romantics; that manifested itself in the nineteenth century in the work of certain poets such as Rimbaud and Lautréamont; that burst into full view in Surrealism; and that today, mingled with other currents, has spread to every corner of the globe. By their meaning too, since both movements, and the revolt of the body in particular, tend to reverse the signs that define our civilization: body and soul, present and future, pleasure and work, imagination and reality. I shall use Dante once more to show what this operation consists of. In Dante's world, time—past, present, and future—flows in the end into eternity. Thus, in one of the most striking passages of the *Inferno*, Farinata degli Uberti tells the poet that after the Last Judgment the damned will lose their one privilege:

double vision. The reason: they won't be able to predict the future, because there will no longer be a future. A terrifying idea, unthinkable for moderns: from the very beginning of the modern age the history, morality, and politics of the West have been grounded in an overvaluing of the future. The civilization of progress has situated its geometrical paradises not in the world beyond but in to-morrow. The time of progress, technology, and work is the future; the time of the body, the time of love and poetry, is the present moment. The one is accumulation and the other, expenditure. The revolt of the body—I should say, its resurrection—has evicted the future. Change of signs, change of times.

In Dante's poem the descent to the underworld precedes the ascent to paradise; but we for our part know that no paradise awaits us, either at the end of history or in the next world. As we go up and down we pass through a present that vanishes, an imminence that evaporates. Many will ask themselves whether it is possible to build anything at all on the perpetually shifting sands of the present. Why not? Chinese civilization was built in the image of a myth-ical past no less imaginary than the eternity of medieval Christianity or the futures of the twentieth century. Times— all of them—are not unreal but impalpable: no one will touch tomorrow; no one can touch today. Each civilization is a metaphor of time, a version of change. The preem-inence of the present moment might perhaps reconcile us with a reality that the religion of progress has tried to hide and disguise: death. The time of love is the time of the body, but the vision of the body we love is also a vision of its death (otherwise we wouldn't love it). The desired body and the desiring body know each other to be mortal bodies; in the *now* of love, because of its very intensity,

the knowledge of death is present. Why not imagine a civilization in which human beings, able at last to face their mortality without fear, celebrate the life/death conjunction not as two antagonistic principles but as a single reality? A metaphor of change, *now* dissolves the past and the future and thus dissolves itself. Dissolution of time, not into an immeasurable eternity but into an equally immeasurable vivacity.

Every era chooses its own definition of humanity. I believe this to be the definition of our time: a human being is an emitter of symbols. Among these symbols, two are the beginning and the end of human language, its plenitude and its dissolution: the embrace of bodies and the poetic metaphor. In the first are the union of sensation and image, the fragment apprehended as a cipher of the totality, and the totality shared out in caresses that transform bodies into a fount of instantaneous correspondences. In the second are the fusion of sound and meaning, the marriage of the intelligible and the sensible. The poetic metaphor and the erotic embrace are examples of that almost perfect coincidence between one symbol and another that we call analogy, though its true name is felicity. This moment is but an annunciation, a presentiment of other rarer, more total moments: contemplation, liberation, plenitude, emptiness. All these states, from the most accessible and most frequent to the most difficult and complete, have in common the abandonment of self, the entrusting of oneself to the current: the gift of self, and in extreme cases its obliteration. Whether it lasts for a century or for the blink of an eye, this instant is immeasurable. It is the one paradise open to all, on condition that they forget themselves. It is the moment of the great abstraction and the great distraction: we are the glint of a shard of glass struck by a ray of

sun at midday, the rustle of dark foliage as we walk in the countryside, the creak of wood on a cold night. We are a paltry thing, and yet the whole rocks us to and fro, we are a sign that someone makes to someone, we are the channel of transmission: languages flow through us and our body translates them into other languages. The doors open wide, humanity is returning. The universe of symbols is also a sensible universe. The forest of meanings is the place of reconciliation.

Delhi, May 1967

The Verbal Contract

Television: Culture and Diversity

(This text was delivered at a seminar "The Television Age" on July 24, 1979, at the Second World Congress on Communications held in Acapulco.)

I am participating in this meeting not as a communications expert, which I am not, but as a writer. The subject is television and culture. I shall not speak from the point of view of television but from the point of view of culture: in other words, considering not how television sees culture, but how culture sees television and the hopes it has for it. I shall begin with my idea of what culture is.

As all of you know, *culture* is a word that has a number of different and contradictory acceptations. The word originally had to do with agriculture: cultivating land means tilling it, working it to make it fruitful. Cultivating the mind or imparting culture to a people means improving

them so they will bear fruit. There is a word that is the rival of culture: *civilization*. *Civil* means "pertaining to the city" and *civility* connotes courtesy, politeness toward others. In the word *culture* we find a productive element; the essential is production, bearing fruit. In the word *civilization* we find an element of relationship: what matters most is that human beings get along with each other. The word *civilization* is of urban origin and calls to mind the idea of the city, the rule of law, and a political regime. The opposition between culture and civilization is more profound than it is usually taken to be. They are not two different labels for the same phenomenon, but two opposed conceptions of that phenomenon. *Culture* is a word connected with the land, soil; *civilization* implies the idea of a social, historical construction. It is possible to speak of popular culture but not of popular civilization.[1]

The term *culture* has been preferred by anthropologists and sociologists, especially the English, Americans, and Germans. *Civilization* has been more widely used by historians. I shall return later on to the opposition between culture and civilization. In the early days the term *culture* was used by anthropologists to designate and study small, self-sufficient societies. The model par excellence of culture was the village, whereas the model of civilization was the city, the *urbs*, and for us Latin peoples that *urbs* par excellence, Rome. But today the word *culture* has begun to be used not only to designate primitive societies without a system of writing, as was the case fifty or sixty years ago, but also to study historical societies, although there are, to be sure, certain anthropologists such as Lévi-Strauss

1. I am not entirely in accord with Spengler's celebrated but not always convincing theory regarding culture and civilization.

who are shocked by the use that sociologists make of this word.

What, then, is culture? In the limited sense that I have mentioned, it is the totality of things, institutions, ideas, and images that a given society uses, because it has either invented them or inherited them or borrowed them from other cultures. A culture is above all a totality of things: plows, spoons, rifles, microphones, cars, boats, tilled fields, gardens. It is things made by human beings; things that human beings have invented: a chair, a cup, this microphone I am speaking into; things that human beings have transformed: a piece of land, a river whose course has been straightened; things and beings that humans have tamed or mastered: horses, donkeys, atoms, electric current. Culture is what human beings use—petroleum, for example—and what human beings give a name to, like a star. The Milky Way is part of our culture; it is not a value to be used like petroleum, but it is an item in our store of knowledge, something we know about the sky, and it is also an image—a myth in antiquity and today an everyday metaphor.

Culture is a set of things that have a name. It is likewise a set of institutions: states, churches, families, schools, labor unions, militias, academies. Society is a conglomeration of men and women, not a heterogeneous collection or an amorphous mass. Just as society invents chairs, plows, locomotives, machine guns, so it invents social forms that are organizations, structures of kinship, of production, of distribution, that is to say forms of solidarity. Society invents itself by creating its institutions. To institute means to found, and society founds itself whenever it institutes itself as a culture. This is a most surprising phenomenon: human beings, human beings together, found themselves

through their institutions. In other words, human beings institute themselves through their cultures and thereby transform themselves into states, nations, families, tribes.

On instituting itself society also names itself, thus distinguishing itself from other societies. One society calls itself Athens, another Tenochtitlan, and yet another Babylon. Each member of the society also has a name. Each society and its members thereby enter the universe of names, the world of signs: society is a language. The culture of a society is almost unintelligible, if the meanings of its language are not known. Culture is not only material (things) and institutional (social structures); it is also signs (ideas, concepts). These ideas and concepts occur in pairs and have to do with morals, politics, religion, aesthetics, economics. In every culture we find good and evil, licit and illicit, legal and illegal, profane and sacred, loss and gain, just and unjust, false and true. All societies have a store of knowledge about nature and the beyond, good and evil, the individual and society, and finally knowledge about knowledge itself.

In each society we find, in both verbal and nonverbal forms, a world of images; these images represent ideas, concepts, social beliefs. The simplest and most readily understood of these immediately come to mind: the cross, the crescent, the colors of a flag. These images point not only to the visible but to the invisible, for human beings, who are engaged in continuous dialogue with nature and their fellow humans, also carry on a continuous dialogue with the unknown and the invisible. Sometimes these images represent abstract entities: a triangle, a sphere; at other times, imaginary beings: a centaur, a siren, a dragon. And there is something else: each of the elements I mentioned earlier—material objects and utensils, ideas and institu-

tions—are also images and border on the imaginary; a chair may become a throne, a set of scales an emblem of justice. A contemporary philosopher, Cornelio Castoriadis, has shown that in every culture it is possible to distinguish a functional level and another level that is imaginary. Things and institutions are functions and means; through them society attains hundreds of its ends: feeding itself, clothing itself, waging war, trading. At the same time society imagines itself and imagines other worlds. It thus portrays, re-creates, remakes, and surpasses itself: it speaks to itself and to the unknown. Society creates images of the future or of the other world. The most remarkable thing is that human beings then imitate these images. Thus social imagination is the agent of historical change. Society is continually other, making itself other, different; by imagining itself, it invents itself. Imagination has a cardinal role in human history, even though thus far its crucial importance has not been recognized. Functionalism, which reduces culture to a mere social tool, and Marxism, which conceives of it as a mere superstructure of economics, are not, strictly speaking, false theories but inadequate ones. Not only do many things escape both, but both also fail to see the central characteristic that Castoriadis emphasizes: imagination, society's ability to produce images and then to believe in the very thing that it imagines. All the great undertakings of human history are works of the imagination, which embodies itself in the acts of human beings.

To conclude: culture is the totality of objects, institutions, concepts, ideas, customs, beliefs, and images that distinguish each society. All these elements are in constant communication: concepts and ideas change things and institutions; customs and beliefs in turn modify ideas. There is a continuous interrelation among all the elements of

culture. This reveals to us another essential characteristic: culture, all cultures, from the earliest and most primitive to that of today, are symbolic systems. Precisely because society endlessly produces images, it can produce symbols, the vehicles of the transmission of different meanings. Within the system of signs and symbols that every culture constitutes, human beings have names; they are signs within a system of signs, but also signs that produce signs. Human beings not only use language, they are a language that produces languages.

Society is not an undifferentiated mass but a complex structure, or rather a system of structures. Each part, each element—classes, groups, individuals—is related to the others. These structures are vertical and horizontal. The vertical relation is one of domination; it is hierarchical. The horizontal relation is generally one of rivalry. Often both are relations of antagonism and opposition. At the same time, each society is related to other societies. There is a society of cultures, a society that is international. The relations between cultures may be like those of a society with itself and with the elements that constitute it: relations of opposition—rivalries, wars, revolution—or of interchange of economic goods, ideas, institutions, arts, religions, techniques. Communication between cultures is more complex than communication within each culture, for it includes a new and determining factor: translation. This is an activity that changes the very thing it transmits. I cannot speak at length on the subject and shall say only this: cultures are local, self-sufficient (or rather, they once were self-sufficient), and monolingual; translation introduces *otherness*, the alien, the different, in its most radical form—a different language. And a different language means a different way of thinking and feeling, a vision of the world that is *other*.

Wherever translation makes its appearance, the concept of culture, essentially an anthropological one, becomes inadequate, and we must use the eminently historical concept of civilization. A civilization is a society of cultures linked by a network of beliefs, techniques, concepts, and institutions. A civilization comprises a number of national cultures, as can be seen from all the great civilizations: Greco-Roman, Chinese, Islamic, Mesoamerican, Western. Civilization requires a means of communication between different cultures, each with a language of its own; this means is either a common language—the Latin of the Middle Ages or the Sanskrit of ancient India—or else translation, as in our own day. We participants in this meeting belong to different cultures; each of us speaks his own language, but in order to communicate we use the method of simultaneous translation, which is one of the forms of translation. Though we speak different languages, we belong to the same civilization.

Primitive societies are homogeneous and relatively simple. They can be seen and studied as self-sufficient units. Modern societies are incredibly complex. In societies that are apparently most homogeneous, those of the modern West, for instance, we find an impressive diversity of elements. Within each modern culture, within each society, there are many cultures and societies. Let us consider for a moment a society that for centuries has been the object of a stubborn drive toward unification through the state, education, administration, and economics: France. Yet in this France where great centralist power has been exercised since the seventeenth century, the old national and regional cultures are still alive: Occitania, Brittany, the Basque country. Moreover many beliefs, customs, institutions, ways of life and of living together persist and, contrary to

a common belief, they have not been destroyed by modernization. The plurality of cultures and of historical times is greater still if we call to mind countries in which different civilizations have converged, as is the case with Spain: Celts, Romans, Phoenicians, Visigoths, Arabs, Jews. All of them are still alive, not on the surface but in the historical depths, in the subsoil of the Spanish psyche. Mexico is still more complex. In the first place, because in addition to the rich Spanish heritage we must take into account the no less rich and vital Indian heritage with its plurality of cultures, nations, and languages: Mayan, Zapotec, Totonac, Mixtec, Nahua. In the second place, because all these heterogeneous elements, in continual interaction, have been subjected, since independence and even before, since the last years of the eighteenth century, to a process of modernization still in progress.

In the nineteenth century modernization in Mexico meant the adoption of republican models of government of American and French origin. In the twentieth century it means the adoption of techniques and forms of culture that are likewise not traditional and, again, originated in the United States and Europe. In Mexico there exists, on the one hand, a plurality of cultures and civilizations, and on the other hand, a plurality of historical times. Fifty years ago the poet López Velarde said that strolling side by side down the same street, in the same village, at the same hour, were Peter the Hermit's Catholic crusaders and Jacobins of the Tertiary Era. It should be added that many of us Mexicans are contemporaries of Montezuma, and others of Sor Juana Inés de la Cruz, without thereby, in certain cases, ceasing to be citizens of the twentieth century. The historical eras and the different cultures that have shaped our country live on together in the Mexican soul

and argue, fight, intermingle, and blend into one within each of us.

Besides this plurality of cultures within modern societies, especially in those, like Mexico, in the process of development, there is another duality that was much talked of ten or fifteen years ago and whose ghost has again been conjured up today. Certain American intellectuals and journalists, populists nostalgic for traditional European cultures, invented the existence of two antagonistic cultures: high culture and popular culture. This idea, translated into Mexican, has been used as a polemical weapon in certain quarters. High culture is elitist and reactionary; popular culture is spontaneous and creative. The curious thing is that, in Mexico, the apostles of popular culture are a small group of intellectuals, members of closed confraternities and devotees of ceremonies in catacombs. In all societies there is a specialized knowledge, hence specialized techniques and languages. This knowledge and these languages of a minority coexist with collective beliefs and ideas. In a Catholic country the majority believes in the Holy Trinity, yet only a small handful of theologians are capable of explaining this mystery. Yet even though there is a difference between the "high culture" of the theologian and the "popular culture" of the believer, we obviously cannot say that the theologian betrays popular culture or vice versa. The theologian and the simple believer belong to the same culture. In like fashion: even though only a small minority understands the scientific principles that govern their functioning, all of us hear radio broadcasts and watch television.

The relations between so-called high culture and popular culture—between the different specialized languages and technical know-how on the one hand, and collective beliefs

on the other—are intimate and daily. The professor who explains the theory of relativity or contemporary genetics from his lecture platform may be a great rock fan or a fervent reader of detective stories. Popular culture and high culture converse within this eminent professor. In the 1930s and 1940s jazz became the favorite music of avant-garde writers and artists—yet another example of the coexistence, within an elite, of popular culture and minority culture. Popular music in turn imitates and adapts the minority poetry of a previous generation. At one time, "Modernist"[2] Hispano-American poets were looked down upon as hermetic and decadent. Think of the things that were said of Rubén Darío or of Amado Nervo in their day. Thirty years later, Agustín Lara became a popular songwriter by using images and turns of phrase from Darío and Nervo. A Darío and a Nervo already diluted, I readily grant. In short, high culture and popular culture are terms that continually fluctuate. The relation between the two, like all relations, is one of opposition and attraction. At times there is contradiction between these two extremes, and at times there is fusion. This is what makes a society creative: complementary contradiction.

Throughout the twentieth century the belief (I say belief because it has really been a belief rather than a theory) predominated that the plurality of traditional cultures and civilizations was destined to disappear. The world of the future would be a unified world in which everyone would have one civilization in common: that of science and technology. It was thought that the logical consequence of progress would be the unification of the planet. Different

2. On the sense of the word "Modernism" in Spanish literary tradition see the note on pp. 197–198.

ideologies competed in putting forth justifications for this belief. The Marxists were convinced that the agent of unification would be the international proletariat, which would do away with national boundaries and divergent cultures. The liberals, for their part, were persuaded that free enterprise and free markets, along with the beneficial influence of science and technology, would cause cultural differences and religious and linguistic traditions to disappear, or would at least attenuate them. Industrial civilization would at last complete the great undertaking of modernization begun in the eighteenth century by the philosophers of the Enlightenment: traditional cultures, with their customs and myths, absurd superstitions, curious dances and backward poetry, would disappear from the face of the earth. The history of the twentieth century has proved these predictions to be false. Not only has the process of modernization failed to do away with traditional cultures, but in all corners of the globe today we are witnessing a genuine resurrection of particularisms that appeared to be buried forever. The nineteenth century inherited from the Encyclopedia the idea of universal man, the same in all latitudes; we in the twentieth century have discovered the plural human, everywhere different. Universality for us is not the monologue of reason but the dialogue between human beings and cultures. Universality means plurality.

Think of the panorama of the last ten years: the resurrection—in Europe, no less: the cradle of modernity, science, and technology—of cultural, religious, and political nationalisms: Basque, Catalan, Breton, Sicilian, Irish, Scottish, Walloon. In the United States, the awakening of blacks and Chicanos. In many countries, women's movements and movements of cultural, linguistic, and sexual

minorities claiming their rights. The resurrection—or rather the reappearance, since they never died—of the great religions. Two examples: the rebirth of Judaism and the no less impressive and vigorous awakening of Islam. We Mexicans have another example closer to hand: the Pope's visit revealed a Mexico that a certain few have obdurately refused to see, the traditional Mexico that has always been alive, as Mexican poets have always known, although our sociologists have seldom recognized it. The revolution of the twentieth century has not been the revolution of an international class, nor has it been the revolution of science and technology. We all make use of science and technology, it's true. Right now I am using this microphone, for instance. But each of us uses these apparatuses to voice his particular and unique truth. The revolution has in fact been a *resurrection*: that of the particularism of each culture. We are returning to diversity. This is one of the few positive signs in this terrible end of a century. Uniformity is death, and the most perfect form of uniformity is universal death; hence the collective extermination practiced in the twentieth century. Life is always particular and local: it is *my* life, this life of mine here and now. The resurrection of national and regional cultures is a sign of life.

What can culture, understood as diversity, at this point ask of television, that powerful and prodigious means of communication? We can ask of it only one thing: to be faithful to life—to be plural, to be open. Not television ruled by a group of bureaucrats bent on creating a consensus in favor of the Leader and the Doctrine or on touting this or that product. We ask of it a variety of TV channels expressing the diversity and plurality of Mexican culture: so-called high culture and popular culture, central culture and marginal culture, that of Mexico City and that of the

provinces, that of majorities but also that of minorities, that of dissident critics and solitary artists. We want a television permitting Mexicans to communicate with each other and with the world around them. Not one television but many, all oriented in different directions.

In a striking passage in his autobiography, Lévi-Strauss points out that the invention of writing had a hand in enslaving humanity. In fact, until the invention of printing, writing represented the secret and sacred knowledge of a large number of bureaucratic castes. Even today writing is unilateral communication: reading a book stimulates our receptivity and imagination, but sometimes neutralizes our sensibility and paralyzes our critical sense. Closing the book, we are unable to inform the author that we disagree. A book, in a sense, robs us of the right and pleasure of answering back. That is why Plato mistrusted the written word and preferred the spoken one.

The real basis of a democracy is conversation, the spoken word. But such interchange is possible only in small communities. In modern societies, enormous and complex as they are, television has two possibilities. First, it can accentuate and reinforce lack of communication, as when it magnifies authority and makes of the Leader a divinity who speaks but doesn't listen. Alternatively, television can make social dialogue possible by reflecting social plurality, including two essential elements of modern democracy: free criticism and respect for minorities. Television can be the instrument of the Caesar of the moment and thus become a means of communication. Or it can be plural, diverse, popular in the true sense of the word. It will then be a genuine means of national and universal noncommunication. Some years ago Marshall McLuhan maintained that with television the period of the "global

village," everywhere the same, was beginning. I believe precisely the opposite. History is headed elsewhere: either the coming civilization will be a dialogue of national cultures or there will be no civilization. If uniformity reigns, all of us will have the same face, a death mask. But I believe the contrary: I believe in the diversity that is plurality that is life.

The Verbal Contract

(This text, a companion to the foregoing one, was read at the First International Communications Seminar, held on October 21, 1980, at Cocoyoc, Morelos, Mexico.)

The idea of society as a system of communications is approximately half a century old. It has had a twofold function: on the one hand, it revealed an obvious truth that, as often happens, had previously lain inexplicably hidden; on the other hand, it has been a metaphor fruitfully applied to the study of other phenomena. There is no need to demonstrate further the truth it has revealed, for it is evident that society and communication are interchangeable terms: there is no society without communication, nor is there communication without society. The foundation of society was not the social contract but, as Rousseau himself intuited, the verbal contract. Human society began when human beings began to speak to one another, whatever the nature and complexity of this conversation may have been: gestures and exclamations or, according to more persuasive hypotheses, languages essentially no different from our own. Our political and religious institutions, as well as our cities of stone and iron, rest on what

is most fragile and evanescent: sounds that have meaning. A metaphor, the verbal contract, is the foundation of our societies.

Even though it expresses something quite obvious, the definition of society as a system of communications has repeatedly been criticized. It has been said, and rightly, that it is a reductive formula: society is not only communication but many other things as well, although in all of them—politics and religion, economics and art, war and commerce—communication plays a part. As I see it, this definition has another defect: it is tautological and belongs to the type of circular statement that by saying everything says nothing. To say that society is communication because communication is society is to say very little. Moreover, the tautology contains within itself a solipsism. What do all societies say? The entire endless round of discourse pronounced since the beginning of history in thousands of languages and made up of thousands of affirmations, negations, and questions that multiply and divide into countless meanings, each different from the others and all of them warring opposites, can be reduced to one simple phrase: *I am*. It is a phrase that admits of and contains innumerable variants ranging from *we are the chosen people (or class)* to *we will be destroyed for our crimes*, but in all of them appears the verb *to be*, along with the first person singular or plural. In this phrase, from the beginning, society speaks its will to be in this or that way. Thus it speaks itself.

Communication has been used as a metaphor or analogy to explain other phenomena in many sciences, from molecular biology to anthropology. In antiquity and during the Renaissance, astronomy was the model of human society, and even Fourier—following Plato on this point,

like Bruno and Campanella before him—found in the laws of gravitation governing the movement of heavenly bodies the archetype of his "law of passionate attraction," which rules humanity and its interests and passions. With prideful naiveté, Fourier believed himself to be the Newton of the new society. Today we have turned this perspective upside down: nature is no longer the archetype of society; instead, we have made the transmission of messages the model of the chemical transformation of cells and genes. The metaphor has also met with great success in anthropology, and Lévi-Strauss has been able to explain the exchange of goods—exogamy and barter—as phenomena analogous to the exchange of signs, meaning language.

The linguistic metaphor has enabled Lévi-Strauss to formulate a hypothesis that would appear to resolve the enigma of the incest taboo. What is involved, he maintains, is a simple rule of transformation, similar to those governing our choice of this or that phoneme in order to form a word, or of this or that word in order to construct a sentence. Although in the one case the choice is unconscious and in the other case more or less deliberate, in both the act is limited to the choice between a sign that is positive and another that is negative: yes to this, no to that. The linguistic operation can be translated into social terms: since I cannot marry my own daughter or sister, I marry the daughter or the sister of a warrior of the neighboring tribe and send him my daughter or sister as a wedding present. It is a mechanism ruled by the same economy and rationality that govern the drafting and transmission of linguistic messages. The same laws apply to barter as well. As in exogamy, by exchanging goods primitive people interchange symbols. The *use* value is invariably associated with another value that is not material but magical or religious

or representative of rank and prestige. It is a value that refers to another reality or substitutes for it. Thus the things that are exchanged are also signs of this or that. The exchange of women or goods is at the same time a trading of symbols and metaphors.

Lévi-Strauss's explanation has never entirely satisfied me. Why must primitive peoples exchange women? Or to put it differently: if exogamy explains the function of the incest taboo, what explains exogamy? It has always seemed to me that the prohibition of incest, the first *no* of man to nature, the foundation of all our works, institutions, and creations, must be a response to something more profound than the need to regulate trade in goods, words, and women. A few years ago a young anthropologist, Pierre Clastres, demonstrated in a brilliant and persuasive essay that the hypothesis of the great French master omitted something essential: the exchange of women and goods takes place within the system of offensive and defensive alliances between primitive societies. While Clastres does not offer a new interpretation of the incest taboo, he sheds light on the function of the exchange of goods and women. Exogamy and barter are intelligible only if placed within the social context of primitive peoples: they are the forms that alliances assume; alliances in turn are intelligible only within a world in which the most widespread and permanent reality is war. Primitive peoples form alliances—temporary ones in nearly every case—because they live in a perpetual state of war of all against all. Communication—the exchange of women and goods—is the consequence of the most extreme and violent form of lack of communication: war. Translated into more formal language, Clastres's idea might be stated as follows: the system of communication formed by the network of alliances that primitive groups

conclude with each other is merely the consequence of a vaster reality that determines the alliances and the system of communication: war, noncommunication.

There are those who will object that Clastres takes us one step further but not much more than that: to say that communication is the answer to, or the consequence of, a lack of communication is something of a truism. The idea, nonetheless, is a most fruitful one, once we set it over against what I earlier called the solipsism of communication. If the basis of alliances, trade, and exogamy is war, communication is permanently threatened by its contrary: from outside by the sound of war, and from within by the menacing silence of conspiracies and secret plots aimed at stifling social dialogue and imposing a single voice. Societies negate themselves through inner discord and negate other societies through aggression and war. Both within and without, war is the original state of human society; hence, to protect themselves from within and from without, individuals surrender their freedom either totally or in part to a leader who becomes their sovereign. Thus Clastres harks back to Hobbes. The moment the State is born, the very nature of language changes: it ceases to be the verbal pact of the beginning and becomes the expression of power. Those who fight in a war attempt, on the one hand, to silence their adversary; on the other hand, they fight to impose the exclusive rule of their own language. War is born of noncommunication and aims at replacing multicommunication by monocommunication—the word of the conqueror. As we all know, such triumphs do not long endure: the imperial word eventually breaks down into antagonistic fragments. Communication returns to its source, plurality.

Clastres's hypothesis attenuates solipsism: communica-

tion is plural because it is polemical in its relation to itself
and to other societies. I use the word *attenuates* because
solipsism does not completely disappear; it multiplies and
thereby continually does away with itself and is continually
reborn. Society affirms itself, and each time it does so it
contradicts and belies itself. Every society is a plural act
of affirmation. The verb *to be* is an empty verb and only
really *is* when, as Aristotle says, it realizes itself through
an attribute: I am strong, I am mortal, I am a believer,
tomorrow I shall not be, I have never been, being is only
a sound, and so on. The idea of society as a system of
communications needs to be modified by introducing the
notions of diversity and contradiction: each society is a set
of systems that converse and engage in controversy among
themselves. Neither plurality nor antagonism represents a
threat to unity: systems turn into a system of systems, that
is, into a language. In Spanish or Japanese we can say many
things that are different or basically opposed and say them
in different ways, but the language will always be the same:
Japanese or Spanish. Each language is, at one end the same
time, the affirmation and negation of itself. In each of them
there are many ways of saying the same thing, and the
same way for saying many different things.

If we proceed from language to communications media
—to the systems of establishing, transmitting, and receiv-
ing messages—the nature of the relation changes. Media,
as their name indicates, are not languages. With great
brilliance but faulty logic, Marshall McLuhan once tried
to demonstrate that the relation between messages and
media was similar in type to that between sound and mean-
ing within language: each medium has a corresponding

type of discourse, just as each morpheme and each word emit a meaning or set of meanings. However, even though the signifieds of each word are the result of a convention, they invariably correspond to the same signifier; the communications media, on the other hand, are channels through which all sorts of signs flow, and in the case of television, all sorts of images as well. To a certain degree, the communications media are neutral; no convention predetermines that certain signs will be transmitted and others not. So to speak of the language of television or films is to use a metaphor: television transmits language, but in and of itself it is not a language. It is possible, of course, to say—once again, as a figure of speech or a metaphor—that there is a grammar, a morphology, and a syntax of television, but not a semantics. Television does not broadcast meanings; it broadcasts signs that convey meanings.

The relation between the communications media and a given language is contingent at best: all, or almost all, of the world's languages can be written in the Roman alphabet. There is a clear correspondence, on the other hand, between each society and its media. Political discussion in the agora corresponds to Athenian democracy, the homily from the pulpit to Catholic liturgy, television round-table discussions to contemporary society. In each of these types of communication the relation between the voice that speaks and the public that listens is radically different. In the first case, the listeners have the possibility of agreeing or disagreeing with the speaker; in the second, they collaborate passively, accompanying him with genuflections, prayers, and devout silence; in the third, the listeners—though they may number in the millions—are not physically present: they are an invisible audience. Thus, although the media are not systems of signification, as languages are, we may

nonetheless say that their *meaning*—using this word in a slightly different sense—is part and parcel of the very structure of the society in question. Their form reproduces the character of the society, its know-how and technical skills, the antagonisms that divide it and the beliefs that its individuals and groups share. The media are not the message; the media are the society.

Although each society invents and constructs the means of communication it needs—within, naturally, the limits of its possibilities—this is not necessarily the end of the matter. A medium often survives the society that has invented it: Phoenician script is the basis of the alphabet we use today. We frequently find the reverse as well: the use of a modern technique in a traditional society. In Kabul and other cities of Afghanistan, I was invariably awakened at dawn by the stentorian voice of the muezzin, amplified by loudspeakers. In the modern age, the technology that originated in the West has spread throughout the world. This is particularly true as regards the communications media. Two traits characterize them: universality and homogeneity. In every corner of the globe newspapers, magazines, and books are printed, movies shown, radio and television programs broadcast. This uniformity contrasts with the diversity of the messages and above all with the plurality of civilizations and the differences in social, political, and religious regimes. The modern world is rent not only by violent ideological, political, economic, and religious antagonisms but also by profound cultural, linguistic, and ethnic differences. This world of fierce rivalries and ineradicable singularities is nonetheless united by a network of communications very nearly linking the entire planet. No matter what their religion may be, no matter what political and economic regime they

live under, people read books and magazines, listen to music on the radio, see films in movie theaters, and watch the news on television. As the particularisms of our century grow stronger and more aggressive, images become universal: each night, in a sort of ambiguous visual communion, on our TV screens all of us see the Pope, the famous film star, the great boxer, the dictator of the day, the Nobel Prize winner, the notorious terrorist.

The question of the relation between the media and the society that uses them leads to another: the media and the arts. The subject is a vast one, but I shall concern myself with only one aspect of it, literature. Let me begin with poetry, the most ancient and enduring of the verbal arts. There are societies that have never known the novel, tragedy, and other literary genres, but there are no societies without poems. In the beginning, poetry was oral: the word spoken before an audience. Or more exactly, recited or declaimed. The association between poetry, music, and dance goes very far back in time; the three arts were probably born together and perhaps poetry was originally the word sung and danced. A time came when they split, and poetry created for itself a little realm of its own, between song and the spoken prose of conversation. Years ago in Delhi I attended a gathering of Urdu poets; each of them stepped forward and delivered his poem in a sort of psalmody or recitative, while a stringed instrument, plucked with a plectrum, kept the beat. The effect was extraordinary. Perhaps this was how the Greek rhapsodists, Celtic bards, and Aztec poets recited their poems. Russian poets

today—as anyone who has heard Joseph Brodsky knows—
still preserve the phonic values, the *intonation* that distin-
guishes poetic recitation from speech and, at the other
extreme, from song. Even the recitation of the shortest
traditional poetic form, the Japanese haiku, is punctuated
by the notes of a samisen. Poetry has never entirely broken
away from music; at times, as among the troubadours of
Provence or the madrigalists of the Renaissance and the
Baroque era, the connection has been a very intimate one.
A risky marriage: nearly always the music overpowers the
poetry.

The relations between writing and poetry have been no
less varied and fruitful: at one end of the scale, the illu-
minated manuscript and the fantastic variety of its letters
and characters, its majuscules and minuscules, its blues,
reds, golds; at the other, typography and its wonderful
combinations. Reading and hearing are different acts, and
the appearance of the printed book accentuated the differ-
ence. In general, one hears in public and reads in private.
In the early days of printing, the art of reading for an
audience—usually a small one—lingered on for a while,
but today this custom has died out almost entirely. As
books became more and more popular, reading became
more and more a solitary act. Thus the age-old relation
between poetry and public changed. Nonetheless, despite
the preponderance of the printed word, silent by nature,
poetry has never ceased to be rhythmic speech, a succession
of intertwined sounds and meanings. Each poem is "a
configuration of signs that we *hear* as we read. Reading a
poem consists of hearing it with our eyes. . . . This is the
opposite of what occurs with painting, a silent art. The
silence of the page allows us to hear the poem being

written."[3] The words of the poem set down on paper tend spontaneously, the moment our eyes scan them, to embody themselves in sounds and rhythms. At the same time there is a correspondence between the written sign, the auditory rhythm of the poem, and the meaning or meanings of the text. The apparent gap between silent writing and poetic recitation is bridged by a more complex unity—the simultaneous presence of printed characters and sounds.

The opposition between a public and the solitary reader is of another order. To a certain degree it represents two types of civilization. I was moved, however, to hear some years ago of a tribe of nomadic South American Indians on the border between Paraguay and Brazil; when night falls, as the women and children sleep, the men, each of whom sits facing the immense wilderness with his back to the campfire, recite poems of their own composition celebrating their brave deeds and those of friends and forebears. This rite carries the solitary nature of the poetic act to an extreme and would seem to eliminate communication altogether. But this is not so: as he talks to himself, the nomad poet talks with his people and the ghostly tribe of his ancestors. He also speaks with the darkness and its powers. At one extreme, solitary recitation; at the other, choral poetry. In both cases, the *I* and the *we* bifurcate to form a mouth that speaks and an ear that catches the spiral murmur of the poem.

All the elements and forms of expression that appear in isolation in the history of poetry—speech and writing, recitative and calligraphy, choral poetry and the illuminated manuscript page; in short, the voice, the printed character,

3. See the preceding essay "The New Analogy: Poetry and Technology," pp. 119–142.

the visual image, the color—coexist in the modern communications media. For the first time in history, poets and their interpreters and collaborators—musicians, actors, graphic designers, illustrators, painters—have at their disposal a medium that is simultaneously spoken word and written sign, aural and visual image, in color or in black and white. Moreover, a totally new element appears on our movie and television screens: movement. The page of a book is a motionless space, whereas the screen can be a space that is not only colored but moving. Unfortunately, the relations between poetry and the new media have not been explored. At the dawn of our era, inspired not only by musical scores and astronomical charts but by advertisements in newspapers as well, Mallarmé conceived a poem whose typographical layout on the page—thanks to the combination of different typefaces, the play of blank lines and spaces, of upper and lower case letters—was intended to evoke the rhythmic movement of the spoken word and the figures that thought traces in mental space. But Mallarmé's signs neither move nor speak; the television screen, on the other hand, sends forth signs, moving images, and colors. Unlike the page of a book, it is itself a space in motion. It is an America for the eye, as yet uncolonized.

Some fifteen years ago, intrigued by the Tantric painted scrolls of India and by Mallarmé's example, I composed a poem, "Blanco," in which I attempted to explore all these elements. I limited myself to traditional typography—to the form of a book—but at the same time it occurred to me that this book could be projected on a screen. More precisely, my intention was (and is) to project *the very act of reading this poem.* I conceived of this work as a sort of ballet of signs, words, and aural and visual forms. I won't

recount the story of my film-poem here: suffice it to say that it is a project I have not abandoned. But I think my experience sheds light on the present state of affairs: the wealth of truly extraordinary possibilities that no one today is using—or more exactly, that no one is bold enough to use. I imagine that the timidity of today's poets is due, among other things, to sheer fatigue: for more than half a century we have devoted all our energies to frenetic formal experimentation in all the arts. It is a commonplace that these successive movements have degenerated into sterile manipulation: the avant-garde today repeats itself endlessly and has become a form of academicism. I believe, more-over, that the peculiar situation of poetry in our century, its transformation into a marginal art by and for a minority, has been partially responsible for the general discourage-ment of our poets. But the major obstacle has been and is the stubborn indifference of television, whether publicly or privately owned. Since poetry doesn't have a very high commercial rating and strongly resists being made an ide-ological and political tool of governments, it has been elim-inated almost entirely from the TV screen. This mistake, compounded of ignorance and contempt, is deplorable: the future and its forms, in the realm of art as in other areas of culture, will not be born in the center but on the margins of society.

The case of poetry is extreme, but the fate of the other literary genres—the theater, the novel, the short story—has not been all that different. As I have tried to show elsewhere, one outstanding trait distinguishes modern lit-erature: criticism. Let me explain that by "modern" I mean that characteristic whole of activities, ideas, beliefs, and

tastes that emerged around the end of the eighteenth century and that coincided, all through the nineteenth, with profound economic and political changes. Criticism, to be sure, appears in the literatures of all civilizations, but in none of them—Arabic or Chinese, Greco-Roman or medieval European—does it occupy the central place that it has in ours. The literatures of other civilizations have been, successively or simultaneously, celebration and satire, praise and vituperation, parody and elegy, but only since the beginning of the modern era have the poem and the work of fiction become analysis and reflection. The wonder-filled gaze of the artist has turned into an inquisitive, introspective one. This critical attitude branches off in two directions: a criticism of society and a criticism of language. The novelist is not content to tell a story or to relive the heroic exploits, loves, or heinous deeds of a group of men and women; he prefers to analyze situations and characters. His story becomes a critical description of the world and of people. But the criticism of society—power and classes, beliefs and passions—is only one half of modern literature; the other half is the criticism to which, in each generation, writers subject the works of their immediate predecessors and the works that they themselves are writing. Tradition turns into a continual critical break with the past; writing in turn doubles back on itself to reflect on what is being written. Thus, side by side with the social, political, religious, and historical criticism of a Balzac, Dickens, Zola, or Tolstoi, we find the other criticism, the criticism of language of a Flaubert or a Joyce.

Contemporary literature has undergone violent changes, but essentially it has remained faithful to its origins, and at no time has it ceased to be critical of the world and of itself. Like poetry, and despite any number of aesthetic

revolutions, prose fiction continues to be trapped inside the pages of a book. Novelists, short story writers, and playwrights have not explored the new communications media—or have explored them with distaste and only half-heartedly. The media in turn, and the powers that control them, have had little but contempt for literature. More than once I have wondered whether there is any way out of this situation. I believe that, as this decade begins, light is finally dawning on the horizon. There are two new elements perhaps destined to change the present state of affairs, both of them products of technology: cable television and the video cassette. These two useful innovations will in all likelihood make it possible to bring about the oft-postponed meeting of literature—true literature, critical of society and of itself—and television. I have no idea, naturally, what form or forms this meeting will take. Perhaps the humble TV soap operas—the descendant of movie serials and serialized novels—will be the embryo of a new artistic form. In the case of poetry, I surmise that this form will be born of the marriage of the written sign and the spoken word. It is not my aim, however, to make dubious aesthetic prophecies, but simply to point to the possibility offered by cable television and the video cassette; they are the equivalent of the book or the phonograph record. In other words, they are the beginning of diversification and consequently of the return to the original verbal contract: multiple and contradictory.

At a seminar entitled "The Age of Television," held during the Second World Communications Congress last year in Acapulco, I spoke in favor of a television medium that would reflect the complexity and plurality of our society, not excluding two essential elements of modern democracy: free criticism and respect for minorities. These

minorities are political, religious, and ethnic, but they are also cultural, artistic, and literary. At the beginning of these pages I pointed out that the word of society is discourse that is not single and homogeneous, but multiple and heterogeneous. The communications media may hide this original word behind the mask of unanimity or, on the contrary, they may free it and show us, in the thousand ever-new versions that literature offers us, the age-old image of the human being—a creature at once singular and universal, at once unique and like every other.

Mexico City, October 21, 1980

Picasso:
Hand-to-hand
Combat with Painting

The Museo Tamayo begins its activities with a Pablo Picasso exhibition. It is a chronological anthology, at once demanding and generous, so that as the visitor goes through it he can follow Picasso's evolution through a succession of works—paintings, sculptures, engravings—corresponding to each of the artist's periods. The Mexican public will at last have a vivid, direct view of Picasso's world. In this same catalogue a great connoisseur of modern art, William Lieberman, Curator of Contemporary Art of the New York Metropolitan Museum, provides a sensitive and expert description of this exhibition and emphasizes its historical and aesthetic importance. To avoid pointless rep-

Foreword to the catalogue of the exhibition of "Picasso's Picassos" at the Museo Rufino Tamayo, Mexico City, 1982.

etitions, I have thought it preferable to sum up, in a few brief pages, what a Mexican writer today, in 1982, thinks and feels on confronting the work and figure of Picasso. What follows is neither a critical opinion nor a portrait: it is an impression.

Picasso's life and work are one with the history of twentieth-century art. It is impossible to understand modern painting without Picasso, while at the same time it is impossible to understand Picasso without modern painting. I don't know whether Picasso is the best painter of our time; I do know that his painting, with all its stupendous and surprising changes, is the painting of our time. By this I mean that his art doesn't stand in the face of, against, or apart from his era; nor is it a prophecy of the art of tomorrow or nostalgia for the past, like that of so many great artists at odds with their world and their time. Picasso never remained apart from his, not even in the days of the great rupture that Cubism represented. Moreover, when he opposed it, he was the painter of his time. An extraordinary fusion of individual and collective genius. The moment I set these words down, I stop writing. Picasso was an artist who did not conform, who did away with the tradition of pictorial representation, who lived on the margin of society and, at times, in violent opposition to its morality. A fierce individualist and a rebellious artist, his social conduct, his private life, and his aesthetics were all ruled by the same principle: rupture. How, then, is it possible to say that he is the representative painter of our time?

To represent means to be the image of something, its perfect imitation. A representation requires not only an attunement and an affinity with what it represents, but also a conformity and above all a similarity. Does Picasso resemble his time? I have already said that he resembles it

so perfectly that the similarity becomes an identity: Picasso *is* our time. But his similarity stems precisely from his nonconformity, his negations, and his dissonances. Amid the anonymous uproar of publicity that enveloped him, he remained himself, a recluse, violent, sarcastic, and not infrequently contemptuous; he knew how to laugh at the world and, on occasion, himself. His acts of defiance were a mirror in which all society saw its reflection; the break was an embrace and the sarcasm a shared feeling. Hence his negations and singularities served his era as corroboration: his contemporaries recognized themselves in them, even though they didn't always understand them. They sensed, in an obscure way, that these negations were also affirmations; they also knew, in the same obscure way, that whatever his subject or aesthetic aim, his paintings expressed (and express) a reality that is and is not ours. It is not ours because these paintings express a *beyond*; it is ours because this beyond does not lie either before or after us but *right here*; it is what is within each of us. Or rather, what is *below*: sex, passions, dreams. It is the reality—the untamed reality—that every civilized being bears within.

A society that denies itself and has made of this negation the trampoline of its deliriums and utopias was destined to recognize itself in Picasso, the great nihilist and, at the same time, the man of great passions. Modern art has been an uninterrupted succession of abrupt leaps and sudden changes; what had been the Western tradition since the Renaissance was shattered, again and again, by each new movement and its manifestoes as well as by the appearance of each new artist. It was a tradition based on the discovery of perspective—on a representation of reality that depends simultaneously on a set of objective laws (optics) and on an individual point of view (the sensibility of the artist).

Perspective imposed a vision of the world that was at once rational and sensuous. Twentieth-century artists shattered this vision in two ways, both radical: in some cases by making geometry predominant, and in others by making sensibility and passion predominant. This break with tradition was associated with the resurrection of the arts of remote or vanished civilizations, and with the irruption of the images produced by primitive peoples, children, and the insane. Picasso's art embodies, with a sort of ferocious fidelity—a fidelity consisting of inventions—the aesthetics of rupture that has been the ruling one in our century. It is the same with his life: he wasn't a model of harmony and conformity with the norms of society, but one of passion and passionate reactions. Everything that in other times would have condemned him to social ostracism and the nether reaches below art made him the perfect image of the obsessions and fits of delirium, the terrors and pirouettes, the traps and flashes of mad genius in the twentieth century.

The paradox of Picasso, as a historical phenomenon, lies in the fact that he is the representative figure of a society that detests representation. Or rather, a society that prefers to recognize itself in the representations that disfigure or deny it: the exceptions, pervasions, dissidences. Picasso's eccentricity is archetypical. A paradoxical archetype, in which the images of the painter, the bullfighter, and the circus acrobat merge. These three figures have been subjects and sources of a good part of his life's work and of some of his best painting: the artist's studio with the easel, the nude female model, and the mocking mirrors; the bull-ring with the disemboweled horse, the matador who is sometimes Theseus and sometimes a bloodied doll leaking sawdust, and the mythical bull, ravisher of Europa, or a

beast put to the knife in sacrifice; and the circus with the equestrian, the clown, the trapeze artist, and the tumblers in pink tights lifting enormous weights ("and each spectator searches within himself for the miraculous child/ O century of clouds"[1]). The bullfighter and the circus performer belong to the world of spectacle, but their relation to the public is no less odd and ambiguous than that of a painter. In the center of the bullring, focus of the gaze of thousands, the torero is the image of solitude; for this reason, at the decisive moment the matador turns to his cuadrilla and pronounces the hallowed phrase: *"¡Dejarme solo!"*—Leave me by myself! Alone before the bull and alone before the public. The traveling circus performer is even more of an outsider. His home is a circus wagon. Painter, bullfighter, mountebank: three lonely figures that together form a six-pointed star.

It is difficult to find parallels for Picasso's situation: a figure at once representative and eccentric, a popular star and an unsociable artist. Other painters, poets, and musicians have met with similar popularity: Raphael, Michelangelo, Rubens, Goethe, Hugo, Wagner. The relation between them and their world was always most harmonious, natural. In none of them do we find the peculiar relation that I have described. There was not a contradiction; there was *distance*. The artist disappeared, thereby enhancing the work: what do we know about Shakespeare? The person hid himself, and the poet or painter thus attained a remoteness that at the same time was a superior impartiality. Between the England of Queen Elizabeth and the theater of Shakespeare there is no opposition, but neither is there identity, as in the modern age. The difference

1. Apollinaire, "Un fantôme de nuées."

between the two lies in the fact that, while Shakespeare continues to be contemporary, Elizabeth and her world are now history. In other cases, the artist and his work disappear along with the society in which they lived. Not only were Marino's poems read by courtiers and learned men, but princes and dukes pursued him with their favors and harried him with their hatred; today the poet and his idylls and sonnets are mere names in the history of literature. Picasso is not Marino. Nor is he Rubens, an ambassador and court painter: Picasso refused official honors and posts and lived on the margin of society, without ever ceasing to be centered within himself. To find an artist whose position was comparable to Picasso's, we must turn to a figure of seventeenth-century Spain. He is not a painter but a poet: Lope de Vega. There is no discord between Lope and his world: there is, in fact, the same eccentric relation between the artist and his public. Picasso's destiny in the twentieth century has been no stranger than Lope's in the seventeenth: a dramatist and an adulterous friar worshiped by a devout public.

The similarities between Picasso and Lope de Vega are so numerous and striking that it is scarcely necessary to dwell on them. The most obvious one is the relationship between the many-faceted erotic life of the two artists and their works. Almost all the latter—whether novels or painting, sculptures or poems—are marked, or rather tattooed, by their creators' passions. But the analogy between their lives and their works is neither simple nor direct. Neither of the two conceived of art as a sentimental confession. Though the root of their creations lay in the passions, the elaboration of them was always artistic. A triumph of form, or rather the transfiguration of real-life experience through form: their paintings and poems are not accounts

of their lives but surprising inventions. These two impetuous artists were always faithful to the cardinal principle of all the arts: the work is a *composition*. Another similarity: the abundance and variety of their works. An amazing, inexhaustible fecundity—one beyond all reckoning. No matter how diligently scholars labor, will we ever know how many sonnets, romances, and comedies Lope wrote, how many canvases Picasso painted, how many sketches he left, how many sculptures and unusual objects? In both, abundance meant mastery. In weaker moments, this mastery was mere cleverness; at other moments, the best ones, it blended with the happiest inspiration. Time is the artist's subject, his ally and his enemy: he creates in order to express it, and also to vanquish it. Abundance is a resource in the battle with time, and a danger as well: hastily tossed off or facile, many of Lope's and Picasso's works are failures. Thanks to this same facility, however, other of their works possess that rarest of perfections: that of natural objects and beings. That of the ant and the drop of water.

In the public life of the two artists we find the same disconcerting commingling of extravagance and facility. Lope's stormy private life and his sentimental nomadism stand in sharp contrast to his acceptance of the reigning social values and his docility toward the high and mighty of this world. Picasso was luckier: the society he chanced to be born into was much freer than that of seventeenth-century Spain. But I am being unfair in attributing Picasso's independence only to luck: he was compromisingly faithful to himself and to painting. He never tried to please the public with his art. Nor was he ever the tool of the machinations of art galleries and dealers. In this respect he was exemplary, especially today, when we see so many artists and writers chase after fame and fortune with their

tongues hanging out. Two leprosies and one degradation: submission to ideological dogmas, and prostitution to the market. The Party, or best-sellerism and the art gallery. Not everything, however, is in Picasso's favor in this comparison. Lope was a familiar of the Inquisition, and in the last days of his life, by virtue of his office he was obliged to be present at the burning of a heretic; but the nature of the society in which he lived makes this sad episode comprehensible. Why, on the other hand, did Picasso choose to join the Communist Party at the very moment when Stalin was at the height of his power? In the last analysis, all the similarities between the poet and the painter come down to one basic one: their tremendous popularity was not at odds with the complexity and perfection of many of their creations. The decisive factor, nonetheless, was their personal magic. An unusual mixture of the grace of the bullfighter and his death-defying courage, the melancholy of the circus acrobat and his self-assurance, the dash and roguishness of a popular hero. A magic consisting of gestures and postures, in which the genius of the artist goes hand in hand with the clever tricks of the prestidigitator. There are times when the mask of the artist devours his face. But the masks of Lope and Picasso are living faces.

The similarities between them should not conceal the differences. They are profound. Two currents feed Lope's art: the forms of traditional poetry and those of the Renaissance. Through the first, its roots reach down to the very origins of our literature; through the second, it takes its place within the tradition of Greco-Roman humanism. Thus Lope is doubly European. In his works there are almost no echoes of other civilizations; his Moorish ballads, for instance, belong to a thoroughly Spanish genre. Lope lives within a tradition, whereas Picasso's aesthetic

universe is characterized by his break with this very same tradition. Hittite and Phoenician figurines, African masks, the sculptures of American Indians, all those objects that are the pride of our museums, were regarded as demoniacal works by Lope's European contemporaries. After the fall of Mexico-Tenochtitlan, the horrified Spaniards buried the colossal statue of Coatlicue in the main square of the city, thereby confirming that this sculpture's powers partook of what Otto has called the *mysterium tremendum*. By contrast, for Picasso's friend and comrade the poet Apollinaire, the fetishes of Oceania and New Guinea were "Christs of another form and another belief," perceptible manifestations of "dark hopes"; he slept surrounded by them like a devout Christian amid his relics and symbols. The rupture of the tradition of classical humanism opened the doors to other forms and expressions. Baudelaire had discovered "bizarre" beauty; the artists of the twentieth century discovered—or rather rediscovered—the beauty of the hideous and its powers of contagion. Lope's beauty was shattered. Amid the rubble there appeared the forms and images invented by other peoples and civilizations. Beauty was plural, and above all it was *other*.

By collecting and re-creating the images that the idealistic naturalism of classical antiquity had left behind, Western art consecrated the human figure as the supreme canon of beauty. The attack on the Greco-Roman and Renaissance tradition by modern art was first and foremost an assault on the human figure. Picasso's work was decisive and ushered in the Cubist period: decomposition and recomposition of objects and the human body. The sudden appearance of other representations of reality, alien to the archetypes of the West, accelerated the fragmentations and dismemberment of the human figure. In works of many

artists the image of man disappeared, and with it the reality that our eyes see. (Not the other reality; microscopes and telescopes have shown that nonfigurative artists, like all the rest of humanity, cannot escape either the forms of nature or those of geometry.) Picasso vented his cruelty on the human figure but did not do away with it altogether; nor did he aim, as did so many others, at the systematic erosion of visible reality. For Picasso the outside world was always the point of departure and the end point, the primordial reality. Like every creator, he was a destroyer; he was also a great restorer. The Mediterranean figures that people his canvases are resurrections of classical beauty. A resurrection and a sacrifice: Picasso fought hand to hand with reality in a contest that calls to mind the bloody rituals of Crete and Mithraic mysteries of the decadent era. Here appears another of his great differences from the artists of the past and from many of his contemporaries: for Picasso, all history is an instantaneous present, sheer actuality. In truth, there is no history: there are works that live in an eternal now.

Like all the art of this century, though with greater ferocity, Picasso's is shot through with an immense negation. He himself once said: "In order to *make*, one must make against." Our art has been and is critical; by this I mean that in the great works of our day—novels or painting, poems or musical compositions—criticism is inseparable from creation. I correct myself: criticism is creative. Criticism of criticism, criticism of form, criticism of time in the novel and of the self in poetry, criticism of the human figure and of visible reality in painting and sculpture. In Marcel Duchamp, Picasso's opposite pole, the negation of our century is expressed as a criticism of passion and its phantoms. More than a portrait, the *Large Glass* is

an X-ray plate: the Bride is a lugubrious, ludicrous mechanism. In Picasso the disfigurements and deformations are no less savage, but they are imbued with a contrary sentiment: it is passion that criticizes the beloved form, therefore its violences and severities have the innocent cruelty of love. A criticism born of passion, a profanation of the body. The rips, tears, toothmarks, razor slashes, and butchery he inflicts on the body are punishments, vengeances, awful lessons: homages. Love, rage, impatience, jealousy—adoration of the alternately terrible and desirable forms in which life manifests itself. Erotic fury in the face of the enigma of presence and an attempt to descend to the origin, into the pit where bones and seeds commingle.

Picasso did not paint reality; he painted the love of reality and the horror of being real. For him, reality was never real enough: he always asked more of it. So he wounded it and caressed it, raped it and killed it. And brought it back to life again. His negation was a deadly embrace. He was a painter without a *beyond*, without another world, except for the other world of the body, which in truth is *this world*. Therein lies his great power and great limitation. In his assaults on the human figure, the female figure in particular, it is always his line that triumphs. This line is a knife that carves to pieces and a magic wand that restores to life. A line that is alive and flexible: a snake, a whip, a flash of lightning; a line that is a sudden shower pouring down, a river that curves, the trunk of a poplar, a woman's waist. The line passes swiftly across the canvas, and in its wake a world of forms springs up, forms as age-old and eternally present as natural elements without a history. A sea, a sky, rocks, a grove of trees, and the daily objects and detritus of history: shattered idols, knives with nicked blades, a spoon handle, the handlebars of a bicycle. Every-

thing returns to nature, which is never at rest and never moves. Nature which, like the painter's line, perpetually invents, then erases what it has invented. How will people tomorrow look upon this work, so rich and violent, made and unmade by passion and haste, by genius and facility?

Mexico City, September 8, 1982

Literature
and Literalness

To learn to speak is to learn to translate; when the child asks his mother the meaning of this word or that, he is really asking her to translate the unknown term into his language. In this sense, translation within a language is not essentially different from translation from one language into another, and the history of all peoples is a repetition of the child's experience: at some time or other even the most isolated tribe must confront the language of an alien people. The astonishment, anger, horror, or amused perplexity we feel when faced with the sounds of a language we don't know soon turns to doubt concerning the one we speak. Language loses its universality and shows itself to be a plurality of tongues, all of them foreign and unintelligible to each other. In the past, translation dispelled the doubt: if there was no such thing as a universal lan-

guage, languages nonetheless formed a universal society in which, once certain difficulties were overcome, everyone understood everyone else. And they did so because in different languages people always say the same things. The universality of the human mind was the answer to the confusion of Babel: there are many languages, but meaning is one. Pascal regarded the plurality of religions as a proof of the truth of Christianity; as the answer to the diversity of languages, translation posited the ideal of universal intelligibility. Thus translation was not only a supplementary proof but a guarantee of the unity of the human mind.

The modern age destroyed this certainty. On rediscovering the infinite variety of temperaments and passions, and on confronting the multiplicity of customs and institutions, human beings began no longer to recognize themselves in other human beings. Up until that time the savage had been an exception to be suppressed through conversion or extermination, baptism or the sword; the savage who appears in the salons of the eighteenth century is a new creature, one who, even though he speaks the language of his hosts perfectly, embodies an irreducible strangeness. He is not a subject of conversion but of polemics and criticism; the originality of his opinions, the simplicity of his manners, and even the violence of his passions are a proof of the madness and vanity, if not the infamy, of baptisms and conversions. A change of direction: the religious search for a universal identity is succeeded by an intellectual curiosity bent on discovering no less universal differences. Strangeness ceases to be an aberration and becomes exemplary. Its exemplary nature is paradoxical and revealing; to the civilized person, the savage represents a nostalgia: he is his other self, his lost half. Translation reflects these changes: it is no longer an operation trying

to demonstrate the ultimate identity of all human beings, but the vehicle of their singularities. Its function had been to reveal the similarities above and beyond the differences; from this point on it shows that these differences are insurmountable, whether the strangeness in question be that of the savage or our neighbor.

One of Dr. Johnson's reflections in the course of a journey expresses the new attitude very well: "A blade of grass is always a blade of grass, whether in one country or another. . . . Men and women are my subjects of inquiry; let us see how these differ from those we have left behind." Dr. Johnson's comment has two meanings, prefiguring the twofold path that the modern age was to take. The first concerns the separation between humanity and nature, a separation that was eventually to become an opposition and a battle: the new mission of human beings is not to earn salvation but to dominate nature. The second concerns the separation between humans: the world ceases to be a world, an indivisible totality, and splits into nature and culture; culture in turn divides into cultures. A plurality of languages and societies: each language is a vision of the world, and each civilization is a world. The sun exalted in the Aztec poem is different from the sun in the Egyptian hymn, though the heavenly body is the same. For more than two centuries first the philosophers and historians, and today the anthropologists and linguists, have accumulated data documenting the irreducible differences between individuals, societies, and eras. The great division, scarcely less profound than that between nature and culture, is the one separating primitive peoples from civilized; next comes the variety and heterogeneity of civilizations. Within each civilization the differences appear once again: the languages we use to communicate also trap us within

an invisible net of sounds and meanings, so that nations are the prisoners of the languages they speak. Within each language the divisions are repeated: historical eras, social classes, generations. As for the relations between isolated individuals belonging to the same community, each of them is walled up alive inside his or her own language.

All the foregoing should have disheartened translators. But this has not been the case: through a contradictory and complementary movement, there is more and more translation. The reason behind this paradox is the following: on the one hand, translation does away with the differences between one language and another; on the other hand, it brings them into sharper focus: thanks to translations, we discover that our neighbors speak and think in a way different from our own. The world is revealed to us at one extreme as a collection of heterogeneities, and at the other extreme, as a superimposition of texts, each slightly different from the one preceding—translations of translations of translations. Each text is unique, yet at the same time it is the translation of another text. No text is entirely original because language itself, in essence, is already a translation: of the nonverbal world, first of all, and secondly because each sign, each sentence is the translation of another sign, another sentence. But this line of reasoning can be reversed without losing its validity: all texts are original because each text is different. To a certain degree, each translation is an invention and hence constitutes a unique text.

The discoveries of anthropology and linguistics do not condemn translation but rather a certain naive idea of translation—the literal translation that in Spanish we call,

significantly enough, *servile*. I do not maintain that literal translation is impossible, but that it is not a translation. It is a device, generally made up of a string of words, to help us read the text in its original language. It is somewhat closer to the dictionary than to translation, which is always a literary operation. In every case, not excluding those in which it is necessary to translate only the meaning, as with scientific works, translation involves a transformation of the original. This transformation is—and can only be—literary, because all translations are operations that employ the two modes of expression to which, according to Roman Jakobson, all literary procedures are reducible: metonymy and metaphor. The text never reappears in the other language (that would be impossible); yet it is ever-present, because the translation, without *saying* it, mentions it constantly or else turns it into a verbal object that, though different, reproduces it: metonymy or metaphor. Unlike explanatory translations and paraphrases, these two are rigorous forms that are not at odds with exactitude: the first is an indirect description, and the second a verbal equation.

The possibility of translating poetry has met with the most vehement opposition of all. A singular condemnation, if we remember that many of the best poems in every Western language are translations, and that many of these translations are the work of great poets. In the book that the critic and linguist Georges Mounin devoted to translation some years ago,[1] he points out that it is generally conceded, albeit reluctantly, that translation of the denotative meanings of a text is possible; on the other hand, opinion is near unanimous that translation of the conno-

1. *Problèmes théoriques de la traduction*, 1963.

tative meanings is impossible. Woven of echoes, reflections, and correspondences between sound and meaning, poetry is a fabric of connotations and therefore untranslatable.

I confess that this idea repels me, not only because it is opposed to my own image of the universality of poetry, but also because it is based on a mistaken notion of what translation is. Not everyone shares my ideas, and many modern poets maintain that poetry is untranslatable. They are moved, perhaps, by an immoderate love of verbal substance or have become entangled in the snare of subjectivity. A fatal trap, as Quevedo warns us: *las aguas del abismo/ donde me enamoraba de mí mismo.*[2] An example of this verbal enticement is Unamuno, who in one of his lyrico-patriotic outbursts proclaims:

> *Ávila, Málaga, Cáceres,*
> *Játiva, Mérida, Córdoba,*
> *Ciudad Rodrigo, Sepúlveda,*
> *Úbeda, Arévalo, Frómista,*
> *Zumárraga, Salamanca,*
> *Turéngano, Zaragoza,*
> *Lérida, Zamarramala,*
> *sois nombres de cuerpo entero,*
> *libres, propios, los de nómina,*
> *el tuétano intraducible*
> *de nuestra lengua española.*[3]

2. The waters of the abyss/wherein I fell in love with myself.— TRANS.

3. Ávila, Málaga, Cáceres . . . etc./you are full-length portrait names, /free, proper names, nominatives, /the untranslatable marrow/of our Spanish tongue.—TRANS.

The "irreducible marrow" of the "Spanish tongue" is an outlandish metaphor (a tongue with marrow?), though perfectly translatable, and one that points to a universal experience. Any number of poets have used the same rhetorical device, though in other languages: the lists of words are different but the context, emotion, and meaning are analogous. It is curious, moreover, that the untranslatable essence of Spain consists of a succession of Roman, Arabic, Celtiberian, and Basque names. It is no less curious that Unamuno translates into Castilian the name of the Catalan city Ilerda (Lérida). But the oddest thing of all is that, without realizing that to do so was to belie the pretended untranslatability of these names, he cited the following verses of Victor Hugo as the epigraph of his poem:

> *Et tout tremble, Irún, Coïmbre,*
> *Santander, Almodovar,*
> *sitôt qu'on entend le timbre*
> *des cymbales de Bivar.*[4]

In Spanish and French the meaning and feeling are the same. Since proper names, strictly speaking, are not translatable, Hugo merely repeats them in Spanish without even trying to Gallicize them. The repetition is effective because these words, stripped of all precise meaning and transformed into verbal bells, real mantras, have an even stranger ring in the French text than in the Castilian. Translating is extremely difficult—no less difficult than writing more or less original texts—but it is not impossible. These two

4. And all is set to trembling, Irún, Coimbra,/Santander, Almodovar,/the moment the clang/of Bivar's cymbals resounds.—Trans.

poems by Hugo and Unamuno show that connotative meanings can be preserved, if the translator-poet succeeds in reproducing the verbal situation, the poetic context in which they are set. Wallace Stevens has given us a sort of archetypical image of this situation in an admirable passage:

> . . . *the hard hidalgo*
> *Lives in the mountainous character of his speech;*
> *And in that mountainous mirror Spain acquires*
> *The knowledge of Spain and of the hidalgo's hat—*
> *A seeming of the Spaniard, a style of life,*
> *The invention of a nation in a phrase.*

Language becomes landscape and this landscape in turn is an invention, the metaphor for a nation or an individual. In this verbal topography everything is communicated, everything is translation: the phrases are a mountain range and the mountains are the signs, the ideograms of a civilization. Dizzying in itself, this game of echoes and verbal correspondences conceals a real danger. Surrounded on every hand by words, at a given moment we are overwhelmed with anxiety: the strangeness of living amid names and not things. The strangeness of having a name:

> *Entre los juncos y la baja tarde*
> *¡qué raro que me llame Federico!*[5]

This experience too is universal: García Lorca would have had the same feeling of strangeness if his name had been Tom, John, or Chuang-tzu. Losing our name is like

5. Amid the rushes and the late afternoon/How strange that my name is Federico!—TRANS.

losing our shadow; to be nothing more than our name is
to be reduced to a shadow. The absence of relation between
things and their names is doubly intolerable: either mean-
ing evaporates or things vanish. A world of pure meanings
is as inhospitable as a world of things without meaning—
without names. Language makes the world habitable. The
instant of utter bewilderment at being called Federico or
Sô Ji is immediately followed by the invention of another
name, one that in its own way is the translation of the old
one: the metaphor or the metonymy that, without saying
it, says it.

In recent years, owing perhaps to the imperialism of
linguistics, there has been a tendency to minimize the em-
inently literary nature of translation. No, there is not, nor
can there be, a science of translation, although the subject
can be, and should be, studied scientifically. Just as liter-
ature is a specialized function of language, so translation
is a specialized function of literature. As for translating
machines, when such machines become really capable of
translating, they will perform a literary operation; they will
create precisely what translators now create: literature.
Translation is a task in which, leaving aside the indispen-
sable store of linguistic knowledge needed, the decisive
factor is the initiative of the translator, regardless of whether
the latter is a computer "programmed" by a human being
or a human being surrounded by dictionaries. To convince
ourselves of this, let's listen to Arthur Waley:

A French scholar wrote recently with regard to trans-
lators: *Qu'ils s'effacent derrière les textes et ceux-ci, s'ils*

ont été vraiment compris, parleront d'eux-mêmes.[6] Except
in the rather rare case of plain concrete statements
such as *The cat chases the mouse* there are seldom sen-
tences that have exact word-to-word equivalents in
another language. It becomes a question of choosing
between various approximations. . . . I have always
found that it was I, not the texts, that had to do the
talking.

It would be hard to add a word to this statement.

In theory, only poets should translate poetry; in reality,
poets are seldom good translators. They are not, because
almost always they use another poet's poem as a point of
departure for writing one of their own. The good translator
moves in the opposite direction: his goal is a poem anal-
ogous to, not identical with, the original poem. He departs
from the poem only to follow it more closely. The good
translator of poetry is a translator who is a poet as well,
like Arthur Waley; or a poet who is a good translator as
well, like Nerval when he translated *Faust*, Part I, and later
Heine. In other instances Nerval produced (admirable) *im-
itations* of Goethe, Jean-Paul, and other German poets.
"Imitation" is the twin sister of translation: they bear a
close resemblance but must not be mistaken for each other.
They are like Justine and Juliette, the two sisters in Sade's
novels. The reason behind the inability of many poets to
translate poetry is not purely psychological, even though
narcissism enters into it, but functional: translating poetry,
as I will demonstrate in a moment, is a process analogous

6. Let them efface themselves behind the texts, and the latter, if
they have been truly understood, will speak for themselves.—
TRANS.

to poetic creation, but one that unfolds in the opposite direction.

Each word contains a certain plurality of virtual meanings; the moment a word is associated with others to constitute a sentence, one of these meanings becomes actualized and predominates. In prose the meaning tends to be univocal whereas, as has often been said, one of the characteristics of poetry, perhaps the chief one, is its preservation of the plurality of meanings. In reality, this is a general property of language; poetry accentuates it, but it is also present, in attenuated form, in ordinary speech and even prose. (Which confirms that prose, in the strict sense of the word, has no real existence: it is an ideal requirement of thought.) Critics have long dwelt upon this disturbing peculiarity of poetry, without noticing that this sort of mobility and lack of determination of meanings has as its counterpart another equally fascinating particularity, the immobility of the signs. Poetry radically transforms language and does so in a direction contrary to that of prose. In the one case, the mobility of the signs has as its counterpart the tendency toward a single fixed meaning; in the other case, the fixity of the signs corresponds to the plurality of meanings. Language is a system of movable signs that, to a degree, are interchangeable: one word may be substituted for another, and each sentence may be said (translated) by another. Parodying Charles Sanders Peirce, it might be said that the meaning of one word is always another word. As proof of this we need only remember that every time we ask the question "What does this sentence mean?" the answer we receive is another sentence. But once we enter the realm of poetry, words lose their mobility and interchangeability. The meanings of a given poem are multiple and ever-changing; the words of the

same poem are unique and no others can be substituted for them. To change them would be to destroy the poem. Poetry, without ceasing to be language, is something beyond language.

Immersed in the movement of language, a continuous verbal coming and going, the poet chooses certain words—or is chosen by them. By combining them, he constructs his poem: a verbal object made of irreplaceable and immovable signs. The translator's point of departure is not language in movement, the poet's raw material, but the fixed language of the poem. A frozen language, yet perfectly alive. His operation is the reverse of the poet's: he doesn't construct an immovable text with movable signs, but takes the elements of that text apart, places the signs in circulation again, and returns them to language. Thus far the activity of the translator is like that of the radar and the critic: each reading is a translation, and each critique is, or starts out as, an interpretation. But reading is a translation within a single language, and criticism is a free version of the poem, or more precisely a transposition. For the critic, the poem is a point of departure in the direction of another text, his own, whereas the translator must compose, in another language and with different signs, a poem analogous to the original. Thus in its second phase the translator's activity is parallel to the poet's, with this major difference: as he writes it, the poet doesn't know what his poem is going to be; when he translates, the translator knows that his poem must reproduce the poem before him. In its two phases translation parallels poetic creation but proceeds in the opposite direction. Its result is a reproduction of the original poem in another poem that, as already stated, is not so much its replica as its transmutation. The ideal of poetry translation, according to a

definition of Valéry's that cannot be improved upon, is to produce similar effects with different means.

Translation and creation are twin operations. On the one hand, as Baudelaire and Pound demonstrate, translation is often indistinguishable from creation; on the other hand, there is a constant ebb and flow between the two, a continual and mutual fecundation. The great creative periods of Western poetry, from its origin in Provence to our own day, have been preceded or accompanied by interweavings between different poetic traditions. These interweavings sometimes take the form of imitation and sometimes that of translation. From this perspective, the history of European poetry might be seen as the history of the conjunctions of the various traditions making up what is known as the literature of the West, leaving aside the Arabic presence in Provençal lyric poetry or that of the haiku and Chinese poetry in modern verse. Critics study "influences," but this term is ambiguous; it would be wiser to regard the literature of the Western world as a single whole in which the central roles are played not by national traditions—English, French, Portuguese, or German poetry—but by styles and tendencies. There is no style or tendency that has been exclusively national, not even so-called artistic nationalism. All styles have been translinguistic: Donne is closer to Quevedo than to Wordsworth; there is an obvious affinity between Góngora and Marino, whereas nothing except language links Góngora with the Arcipreste de Hita, who in turn reminds us at times of Chaucer. Styles are collective and make their way from one language to another; works, all of them rooted in their own verbal soil, are unique. Unique but not iso-

lated: each of them is born and lives in contact with other works in different languages. Thus neither the plurality of languages nor the uniqueness of works means an irreducible heterogeneity or an irremediable confusion, but the contrary: a world of relations made of contradictions and correspondences, unions and separations.

In each period European poets—and today those of both hemispheres of America as well—have written the same poem in different languages. Each of the versions is a different, original poem as well. The synchrony, to be sure, is not perfect, but we need only stand a little apart to realize that we are listening to a concert in which the musicians, playing different instruments, obeying no conductor, and following no score, are creating a collective work in which improvisation is inseparable from translation, and invention indistinguishable from imitation. Now and then one of the musicians launches into an inspired solo; in a moment the rest follow him, introducing variations that make the original theme unrecognizable. In the last years of the past century all Europe was amazed and shocked by that solo of French poetry begun by Baudelaire and concluded by Mallarmé. Hispano-American Modernist[7] poets were among the first to hear this new music; by imitating it

7. Toward 1880 the literary movement called *Modernismo* appeared in Hispano-America and Spain. *Modernismo* is the equivalent of French Symbolism and has no connection with what in English is called *modernism*. In English, *modernism* refers to the literary and artistic movements and tendencies that began in the second decade of the twentieth century. As used by North American and English critics, it is what in France, Italy, Germany, Russia, and the rest of Europe—as well as in the Spanish-speaking world—has been called "the avant-garde," a term that includes Futurism, Expressionism, Cubism, Surrealism, Ultraism,

they made it their own, changed it, and passed it on to Spain, which in turn re-created it all over again. A little later the English-speaking poets did the same, though with different instruments and in a different key and tempo: a more staid and critical version in which Laforgue rather than Verlaine occupied a central place. Laforgue's predominant position in Anglo-American Modernism helps to explain the particular nature of this movement, at once Symbolist and anti-Symbolist. Pound and Eliot, following Laforgue in this respect, introduced into their practice of Symbolism the critique of Symbolism, mocking what Pound himself called "funny symbolist trappings." This critical attitude armed them to write, a little later, a poetry that was not Modernist but truly modern, and thus to begin, with Wallace Stevens, William Carlos Williams, and others, a new solo—the solo of contemporary Anglo-American poetry.

The role played by Laforgue in poetry in English and Spanish is an example of the interdependence between creation and imitation, translation and original. The influence of the French poet on Eliot and Pound is well known,

etc. It is regrettable that English-speaking critics ignore both the general use of the term "avant-garde" and the traditional use in Spanish, since 1880, of the term "Modernismo." This practice is more puzzling when we remember that the English-speaking countries have had in our century many great poets, writers, and artists but no poetic or artistic movements of importance, with the exception of the short-lived Vorticism of Pound and P.W. Lewis, a feeble echo of Futurism and Cubism. To avoid confusion I will write "Modernism" to refer to the Hispano-American movement, "avant-garde" for the artistic and poetic movements of the twentieth century and *modernism* for Anglo-American poetry and art.

while his influence on Hispano-American poets has attracted little notice. In 1905 the Argentine Leopoldo Lugones, one of the great poets of our language and one of the least studied, published a volume of poems, *Los crepúsculos del jardín* (Twilights in the garden), in which a number of Laforguian traits appear for the first time in Spanish: irony, the clash of literary and colloquial language, violent images that juxtapose the absurdity of urban life with a nature that has been turned into a grotesque matron. Some of the poems in this book seemed to have been written on one of those "dimanches bannis de l'Infini" of the Hispano-American bourgeoisie in the waning years of the last century. In 1909 Lugones published *Lunario sentimental* (A moon calendar of the sentiments): while an imitation of Laforgue, this book was one of the most original of its day and can still be read with amazement and delight. Among Hispano-American poets the influence of *Lunario sentimental* was immense, but on none of them was it more beneficial and stimulating than on the Mexican López Velarde. In 1919 López Velarde published *Zozobra* (Anxiety), the key book of Hispano-American "Postmodernism," meaning our anti-Symbolist Symbolism. Two years before, Eliot had published *Prufrock and Other Observations*. In Boston, just out of Harvard, a Protestant Laforgue; in Zacatecas, a runaway from a seminary, a Catholic Laforgue. Eroticism, blasphemies, humor, and as López Velarde put it, "an intimate reactionary sadness." The Mexican poet died shortly thereafter, in 1921, at the age of thirty-three. His work ends where Eliot's begins. Boston and Zacatecas: the coupling of these two place names makes us smile, as though it were one of those incongruous associations that Laforgue took such pleasure in. Two poets write—in very nearly the same year, in

different languages, neither so much as suspecting the exis-
tence of the other—two different and equally original ver-
sions of poems that, a few years earlier, a third poet had
written in another language.

<div align="right">

Cambridge, Mass., July 15, 1970

</div>

Latin-American Poetry

I shall begin with a confession: I am certain of the exis-
tence of poems written by Latin-American poets in the last
fifty years, but I am not certain of the existence of Latin-
American poetry. I experience the same doubt about a
number of similar expressions, such as "English poetry"
or "French poetry." Both the latter designate heteroge-
neous and at times incompatible realities: La Fontaine and
Rimbaud, Dryden and Wordsworth. Apart from this gen-
eral difficulty, there is another, more immediate one: al-
though the phrase "Latin-American poetry" seems natural,
it is not: it links two unknown terms. At this juncture,
after more than two millennia of aesthetic speculation from

This article was written for *The London Times Literary Supple-
ment*.

Aristotle to Heidegger, we are suffering from a sort of philosophical vertigo, and no one knows for sure what the word poetry really means. On the level of politics and history, the same thing happens with the term "Latin America": how many of them are there—one? several? none? Maybe it is just a label that doesn't so much name as conceal a reality in a state of ebullition—something that doesn't yet have a name of its own, because it doesn't yet have an existence of its own. I enumerate these difficulties not as a rhetorical device but to justify my method in this article: negation and comparison. Since it is impossible to define or even describe our poetry for what it is, I shall try to say what it is not. My aim is to clear the terrain; once the underbrush has been hacked away, those who are curious can come closer to see, and above all to hear—not poetry, which is mute from birth, but poems, those verbal realities.

If poetry is first and foremost a verbal object (a poem), it will be difficult to deal with several different linguistic realities in one and the same article. In Latin America a number of languages are spoken: Portuguese, Spanish, French, and the indigenous languages. These latter are the only really American ones—but they are not Latin. Moreover, the literatures of these indigenous languages are traditional and almost always oral; hence, strictly speaking, they are not contemporary either. American poetry written in French confronts us with a curious problem. If Haitian poets are Latin Americans, doesn't the same term apply to Canadian poets who write in French? Saint-John Perse was born in Guadeloupe, and Aimé Césaire in Martinique. The former is the author of *Éloges* and the latter of *Cahier d'un retour au pays natal* (Return to my native land), two books that are two visions of the Antilles. Mention of these works,

so profoundly Latin American and at the same time so intimately linked to the modern French poetic tradition, makes the notion of a "Latin American literature" a shaky one. The truth is that Latin America is a historical, sociological, or political concept: it designates a group of peoples, not a literature.

The relationships between Brazilian and Hispano-American literature are of a different order. In the past there was constant communication between Portuguese and Spanish. It is scarcely necessary to mention that many great Portuguese poets—Gil Vicente, Sá de Miranda, Camoëns— also wrote in Castilian. Nonetheless, Brazilian literature is not part of Hispano-American literature; it possesses an independence, a character, and a physiognomy that are unmistakable. Brazil is something more than a nation: it is a linguistic universe irreducible to Spanish. The phrase "Guimaraes Rosa is a Brazilian writer" refers not only to the poet's vital statistics but to literature; to say that Rubén Darío is Nicaragua's great poet is to confuse political boundaries with styles. There is no Argentine, Cuban, or Venezuelan literature; the Mexican Carlos Pellicer is closer to the Ecuadorian Carrera Andrade than to his compatriot José Gorostiza. In Hispano-American artistic tendencies and literary styles, while not excluding "nationalism," have always crossed national borders but have halted at Brazil's. As for the great Brazilian poets (Bandeira, Drummond de Andrade, Murilo Mendes, Cabral de Melo), none of them has had an influence on Hispano-American poetry. The group of concrete poets in São Paulo that has awakened such great and legitimate interst in England is barely known to poets of our countries; only in Mexico, as far as I know, has an anthology of Brazilian concrete poetry been published.

The literary evolution in Brazil and Hispano-America has been simultaneous, almost exactly parallel, and totally independent. Critics distinguish three phases in modern Brazilian poetry that are the precise equivalent of three in Hispano-America: the "Modernism"[1] of 1920, equivalent to our avant-garde; the generation of 1945, equivalent to that of Cintio Vitier and Alberto Girri; and "concrete poetry," equivalent to our young poets. The tendencies, influences, attitudes, and manifestoes have been similar; Brazilians and Hispano-Americans discovered, at almost the same time, Dada and primitive art, Surrealism and their own past, Eliot and tradition, cosmopolitanism and nationalism. They were victims of the same maladies, discoverers of the same truths, enamored of the same gods—yet totally isolated from each other. Moreover, if we look attentively we discover that, as with those myths studied by Lévi-Strauss which are transformed by each tribe that adopts them, thanks to different combinations of the same elements, the movement of Brazilian poetry unfolds in a temporal order that is the symmetrical reverse of ours. Thus Brazilian "Modernism" lacks the radicalism of the Hispano-American avant-garde; there is nothing and no one comparable to Huidobro. The most representative figure of the generation of 1945, Cabral de Melo, is a strict, rigorous poet whose verse is the contrary of Lezama Lima's baroque elaborations or of Enrique Molina's luxuriant verbal vegetation. And finally, it would be useless to try to find among the young poets of Hispano-America the equivalent of a group such as Invenção (Haroldo and Augusto de Campos, Décio Pignatari, Braga). In 1920

1. On "Modernism" in Spanish literature, see the note on pp. 197–198.

the avant-garde was in Hispano-America; in 1960 it was in Brazil.

Ibero-American literature is dual: that written in Portuguese and that written in Castilian. The second is my subject. But once announced, the subject immediately bifurcates again: if the Spanish language distinguishes us from Brazilians, what distinguishes us from Spaniards? First of all, certain linguistic differences, and most important, a different attitude toward the language that they and we speak. Specialists maintain that there is greater linguistic unity in Hispano-America than in Spain. This is quite understandable: Castilian was transplanted to our shores when it was already a fully mature idiom, the language of a state that had chosen it as its official and exclusive vehicle: Charles V's ambassador pronounced his discourse at the papal court in Spanish and not in Latin, to the scandal and consternation of his audience. The fate of the other languages of the Iberian peninsula was not unlike that of the old medieval kingdoms subjected to the rule of Castile, except that the unity of Spain has always been precarious, which accounts for the survival both of regional separatisms and of local languages and dialects. In America, on the other hand, Castilian did not have to do battle with Catalan and Basque, Gallego and Majorcan. None of us speaks Asturian or Valencian.[2] At the same time, the Spanish of America

2. It is impossible to deal in this article with the subject of indigenous languages. I shall merely remind my reader that they are spoken by millions. If they should disappear, as is quite possible, not only Latin America but all humanity would be impoverished: every language that dies is a vision of humanity that is lost forever.

is a more open language than that of Spain, more exposed to outside influences—the indigenous languages, English and French, the Italianisms and Africanisms brought by immigrants and slaves. The linguistic fabric reveals different histories: in Spain, the persistence of medieval plurality; in America, the centralism of the Spanish empire and its final disintegration: nineteen countries (if I count a colony, Puerto Rico, and several pseudonations invented by the native oligarchies and Yankee imperialism). The Spanish of Spain is more earthbound, more attached to things: it is a substantialist language. Rather than sinking its roots in the soil, the Spanish of America seems to spread out in space. The purity of language of certain Spanish writers is exasperating; the hybridism of certain Hispano-American ones is no less so.

The attitude toward language is also different: ours is critical, theirs trusting. Between Spaniards and their language there is no distance; none of its modern writers has radically questioned language, and a Spanish Wittgenstein or Joyce has yet to be born. Since the era of our independence, we in America have denounced the Spanish past—in Spanish. In the twentieth century first Darío and later Huidobro decided that Spanish must be Gallicized—in order to Americanize it. Spanish is and is not ours. Or more exactly: language is one of our uncertainties. Sometimes a mask, sometimes a passion—never a habit. Spaniards believe what they say, even if what they say is a lie; Hispano-Americans hide themselves in words, believing that language is a garment. If we tear it, we rend our own flesh: we discover that language is the person and that we are made of words, those said and those not said, some of them banal and others horrible. But to know this, we have to prove it to ourselves by skinning ourselves alive, and

few have dared to. Although Spaniards too have had a critical attitude toward their history, the implicit or explicit object of this criticism has always been regeneration or restoration: the return to an essential, substantial, or original Spain. This is the theme of the *verdadera España*—the true Spain—that runs from Larra to Unamuno and Machado. An elegiac theme. In Hispano-America there is no return because, as in Argentina and Chile, there is no other history than that of the sad nineteenth century, or because, as in Peru and Mexico, history is *other*: the pre-Columbian world. The real Argentina does not lie in the past nor is it an essence: it is a day-by-day invention, something we must make. In Mexico the past is something we cannot abandon, yet we cannot return to it either; there is a tension between past and present.

Poetic movements make all these Hispano-American choices visible. "Modernism" (1890) and the avant-garde (1920) were born in Hispano-America and later transplanted to Spain. In both instances the Spaniards greeted these revolutions with reluctance; although in the end they adopted them, they modified them with the touch of genius and bathed them in traditionalism (Unamuno, Machado, and Jiménez in the first quarter of the century; Guillén, Lorca, Cernuda, Alberti, and Alexaindre in the second). Thus the first distinctive note of Hispano-American poetry, setting it apart from Spanish poetry, is its sensitivity to the temporal, its decision to face up to modernity and become one with it. Its nostalgia for the future, so to speak. A second distinctive note is its curiosity, its cosmopolitanism. The first haikus in Spanish were written by a Mexican, José Juan Tablada, around 1919; three years later another volume of his appeared, this time a collection of "ideographic" poems. In 1917 Antonio Machado

published *Campos de Castilla*, while in 1918 Vicente Hui-
dobro brought out *Poemas árticos*.

Huidobro's best book is a vast poem, *Altazor*. His hero
is a magus-antipoet-aviator-comet: the Luciferian tradition
of the rebellious fallen angel. Movement refutes itself and
ends in immobility: modernity is an abyss into which Al-
tazor-Huidobro hurls himself. There is a double tempta-
tion here: to be at the spearhead of time, or to be in a space
that is all spaces, all worlds. A particular cosmopolis. The
library of Babel is not in London or Paris but in Buenos
Aires; its librarian, god, or ghost is named Jorge Luis Borges.
The Argentine writer discovers that all books are the same
book and that, "abominable as mirrors," they all repeat
the same word. Altazor seeks a time that is after time and
vanishes in the ether. Borges questions mirrors and con-
templates the gradual fading away of images. His work
undertakes the refutation of time; it may simply be the
fable of the vanity of all the eternities we humans invent.

Another temptation, another reply to the West and to
modernity, is finding a time that is *before* time, an antiquity
prior to history. Neruda's first great book—one that left
its mark on those of us who came later—is called *Residencia
en la tierra* (Residence on earth). It is not Chile, nor is it
pre-Columbian America; it is a mythical geology, a planet
that is fermenting, rotting, germinating: the primordial
dough. Not intrauterine but intraterrestrial life: "the time
beneath the ocean that looks at us." The modernity of
Residencia en la tierra is a nonhistorical antiquity, the erasing
of all dates. César Vallejo answers Neruda's terrestrial,
generative barbarity with his "sermon on barbarity." His
poetry is religious, a sermon, and its subject is barbarous-
ness—not the earth at its beginning, but primordial man.
Not the Indian or the black or the halfbreed—though he

is all three—but the orphan. Who is this orphan? Here Americanism, Marxism, and Christianity meet: he is the dispossessed Latin-American; the proletariat, the landless, rootless international class; and the victim abandoned by the father, humanity as a collective Christ. The mother of this universal orphan is an "immortal dead woman." A dead woman who is neither the Church nor History nor the earth: "the pleasure that engenders us and the pleasure that banishes us." There is no home on earth, there is no "resting" in earth's bosom; there is exile.

The four poets I have mentioned belong to the generation before mine. Their works, needless to say, do not represent all Hispano-American poetry between 1920 and 1945; nor can they be pinned down in the phrases in which I have endeavored, for the moment, to define them. I have used their names as symbols, or rather as signs pointing to certain directions that Hispano-American poetry has taken. Four ways of embodying modernity and, to a certain degree, of denying it. Four answers to the same question. In total contradiction to what is implicitly affirmed in the poetry of their Spanish contemporaries, for none of them is there such a thing as an original substance or a past to recover: there is only emptiness, orphanhood, the unbaptized earth of the beginning, the conversation of mirrors. Above all, there is the search for the origin, the word as foundation.

The destiny of the Spanish language in America suggests a parallel: that of English in the New World. The analogy may be misleading if we fail to note that, once again, the phenomenon is one of reverse symmetry. The situation of the speakers and the content of the dialogue have been

different. The Anglo-American colonies were true colonies, more or less dissident offshoots of the great dissidence that English Protestantism was and still is. The Hispano-American colonies were viceroyalties created in the image and likeness of the Catholic monarchy. In the one case, little settlements united by religious ties that set them apart as a group (and consecrated them as a community of the *elect*) within Protestant Christianity; in the other case, an anomalous population spread out over an immense territory but ruled by a single church and subjected to a complex bureaucratic machine. There is an organic relation between Protestantism, Anglo-Saxon democratic institutions, the idea of progress, and capitalism. The independence of the United States can be seen in this light as a conflict within a system: not a rupture but a separation. Hispano-American independence was a negation of the Spanish past: Catholicism and absolute monarchy. A true revolution. Hence many Spanish liberals such as Mina fought on the side of the Hispano-American insurgents: our battle was theirs. The Anglo-Americans founded a society that, far from denying its origins, had as its one aim completing the great European revolution begun by the Reformation. The Hispano-Americans wanted to overthrow the old order and replace Catholic and monarchical universalism with the universalism of the Enlightenment and the French Revolution.

The resistance to Anglo-American independence came from outside, from the mother country; in Hispano-America not only the movement for independence but the resistance as well came from within: the Spanish order had taken root throughout the continent. It had done so not only because of the conversion of millions to Catholicism and because of the notable creations of the Spaniards in

the sphere of culture, but also because all the inhabitants participated in the colonial order, since it was the basis of the social structure. The Hispano-American colonies were a complicated network of institutions, sentiments, and interests that linked not only Creoles but Indians and those of mixed blood as well. Among its horrors were slavery and feudal servitude, but it did not produce "outcasts." Perhaps for this reason our independence movement was a revolution that miscarried; it adopted republican constitutions but left the social order intact and replaced rule by the mother country with rule by military *caudillos* and land-owners. The democratic institutions were (are) a façade, like certain recent Asiatic and African "socialisms." An imaginary reality, but a perverse and long-lasting one. Falsehood has been consubstantial with our political life ever since. The fragmentation of the continent and the interference of imperialisms, especially that of the United States, sealed the failure of our independence.

Anglo-Americans have lived their history as a collective action in which they feel they participate and for which they feel responsible. It matters little that for Whitman this common enterprise was synonymous with freedom and fraternity, while for Robert Lowell it was criminal. Both poets, each in his own way, in accordance with his time and temperament, affirmed their responsibility and participation. To be sure, the unfortunate expression "confessional poetry" not only calls to mind the grille of the confessional and the psychoanalyst's couch, but also betrays the Protestant obsession with original sin (and I for my part prefer the *other* central theme of the West, that of Rousseau and Blake: original innocence). But confession is redeemed, or more precisely, finds absolution, once it situates itself within the context of a society and its

historical and moral upheavals. The Hispano-American attitude is the opposite: Vallejo, no less religious than Lowell, does not feel guilty but a victim. Nor does Neruda, in no sense a Christian, feel burdened with guilt: he accuses. No, we have not lived our history; we have suffered it, as a catastrophe or a punishment. Our heroes are those who defend us from the local tyrant or, like Juárez and Sandino, from foreign power. We have not been subjects but objects of history. To sum up: in the one case we find consecration of the act or confession of crime; in the other, complaint or accusation. Two monologues.

Whitman and Pound are perhaps the representative poets of the United States (representative does not necessarily mean best). Both proclaim a universalism that is basically an Americanism (which is to say a U.S.-ism). Both maintain that the United States has a global mission. Whitman Americanizes freedom and makes of his country the chosen land of "camaraderie." In his *Cantos* Pound piles on top of one another Chinese ideograms, Egyptian hieroglyphs, quotations in Greek and Provençal. His method resembles that of the Roman conqueror, a thief who steals the gods of the vanquished. Appropriating a foreign god and making off with the text of an alien people are magic rites whose meaning is the same: in both cases the aim is not so much to build a universal museum of spoils as to erect a sanctuary of powerful idols. The rite is an homage and at the same time a sacrilege, a violation: the divinity is forcibly removed from its temple and the text from its context. A question in passing: how and why in the world did Pound ever think that Confucius could be the great teacher of the United States? The Chinese master based his teachings on a belief in a natural order, founded on cyclical time and immutable hierarchies; the United States,

since its birth as a nation, has identified itself with two anti-Confucian ideas: progress and democracy.

Whitman's attitude is not radically different: "Passage to India" should rightfully be called "Passage to the U.S.A." The poem celebrates the reconciliation of Asia and America: "the Elder Brother found, the Younger melts in fondness in his arms." But this meeting is the result of an intrusion: the American poet portrays himself as the spiritual descendant of Alexander, Tamerlane, Babur, Vasco da Gama, Marco Polo, and even the picturesque and mendacious ibn-Batuta. In his enthusiasm it does not occur to Whitman that "old occult Brahma and tender junior Buddha" might find his embrace rather uncomfortable. Disturbing the meditation of the yogi who is lost in contemplation of the One or in the dissolution of all bonds, even fraternal ones, is at the very least an impertinence. There is a sort of rapacity in this excessive cordiality. A truly ecumenical appetite; other peoples have been content to destroy the idols and the texts of the dead and the humbled.

The poetic theory of the *Cantos*, the method of *presentation*, is the contrary of translation. Every translation admittedly implies transmutation and hence disfiguration and appropriation, usually unconscious. Nonetheless, the ideal of the translator is objectivity, respect for the original text. In other words, recognition of the *other* and of *otherness*. Translation is a civilized activity because, like imitation, it is born of the veneration of what is exemplary or unique. Its roots are ethical and aesthetic. Veneration does not exclude but on the contrary demands fidelity. An example: the Chinese and Tibetan versions of the Buddhist sutras and shastras. For this reason translation is also a civilizing activity: it presents us with an image of the other and thus

forces us to recognize that the world does not end in our-
selves and that each human being is humanity. Pound was
a great translator, and in this sense he was a civilizer, and
not only of the English-speaking world: we would search
in vain in French, Spanish, or Italian for a version of the
Shin Ching comparable to his. But the method of the *Cantos*
is based on a false analogy: what Pound calls "presentation"
is often merely juxtaposition. In no case, moreover, is his
writing truly ideographic, not even when his discourse is
heavily inlaid with Chinese ideograms. In fact, if the mean-
ing of all signs is to mean, what do ideograms mean *within*
a text written in English? One of two things: either they
are quotations requiring a translation that can only be non-
ideographic, or else they are magic marks, signs that have
lost their power to mean.

My objection is not only aesthetic—Pound, after all, is
a great poet—but also moral. Apart from being ingenuous,
his theory—this must be said even though it sounds shock-
ing—is barbarous and arrogant. The barbarity and arrog-
ance of the conqueror—Rome, not Babel. True, in a certain
sense we might think of the *Cantos* as a poem from Borges's
library. But there is a difference: Pound's poem has (or is
intended to have) a meaning; it is the image of the "his-
torical process," the "tale of the tribe." A *tale* that for
Borges, more Buddhist than Confucian, is without mean-
ing. Pound's library is a set of signs with meanings
contradictory to those signs upon which the poet tries
(sometimes successfully) to impose meaning; Borges's li-
brary is a system of signs whose precarious meanings are
progressively dissolved by the combinations into which
they enter. For the Argentine writer, Pound's "ideas in
action" are the reverse of ideas. Or rather, the reverse of
the idea of ideas. The founding of Buenos Aires, a favorite

theme of Borges's, is not an act but an idea—a *hypothesis*. The poets of the United States are condemned to the future, to progress—whether to hymn it or criticize it, it makes no difference. We Hispano-American poets are condemned to search for our origin or—again, it makes no difference—to imagine it. We two groups of poets are alike—if alike in any way—in that we both feel out of place in the present. We are fugitives from any and every sort of eternity, including the circular time of Confucius.

While throughout this article I have intermingled, perhaps excessively, literary and historical considerations, I don't believe in the omnipotence of history. I do believe, on the other hand, in the sovereignty of poetry: one of the finest poems I have ever read (yes, in translation) is a funeral hymn of the Pygmies, a people without a history. But history and poetry intersect and at times coincide. History traces figures and signs that the poet must recognize and decipher—what some call the "logic of history" and others "destiny." A Hispano-American poet cannot be insensitive to this continuity: to find the word that is the origin and to found a society are essentially not contradictory but complementary tasks. When history and poetry are consonant, the name of this coincidence is, for instance, Whitman; when there is discord between the two, the dissonance bears the name Baudelaire. Confronted with the second situation, poetry can only withdraw into itself, found itself: *l'action restreinte*—the limited action—of Mallarmé. The dangers attendant upon discord are irresponsible song or silence, unless this silence become *Un coup de dés*, which happens only once in a century. The dangers inherent in coincidence are exemplified by Mayakovski's

tragic case and the merely regrettable instances of Aragon, Neruda, and any number of others. Poetry and history complete each other, *provided the poet knows how to keep his distance.* By its very nature, power invariably tends to neutralize and cancel out not only heterodoxies but differences. My generation has seen both extremes, discord and coincidence.[3] Most poets have resisted both temptations: soliloquy, and ardent rhetoric on command. Though certain of the poets of my generation have written verse that figures among the most beautiful Hispano-American poetry of the century, this is not what I wish to stress; my point is that thus far the best of them have not forgotten that poetry is dissidence, even within coincidence. I am not preaching heterodoxy, even though by temperament I am attracted to heterodoxies: I am asserting that poetry is irreducible to ideas and system. It is the *other* voice. Not the word of history or of antihistory but the voice that, in history, always says *something else*—the same something since the beginning. I don't know how to define this voice or explain what it is that constitutes this difference, this tone which, though it doesn't set it altogether apart, makes it unique and distinct. I will say only that it is strangeness and familiarity in person. We need only *hear* it to recognize it.

<div align="right">

Delhi, 1967

</div>

3. I have not spoken of this generation, first of all out of modesty, and second because this text is not a review of contemporary Hispano-American poetry.

A Literature
of Convergences

Latin America is a land renowned not only for its contributions to the sad political folklore of the twentieth century, but also for the works of its writers and artists. As the past century marked the appearance of two great literatures, those of the United States and Russia, this century has seen the appearance of Latin American literature, written in Spanish or Portuguese. The historical novelty of our peoples does not lie in their unfortunate upheavals and tyrannical regimes but in a small though exceptional body of poems, novels, and short stories. Thanks to this handful of works, world literature in the second half of this century is richer and more diverse. I confess, however, that it is hard for me to speak and write about the literature of Latin America; apart from the difficulties inherent in this vast and taxing subject, in my case there is yet another that is

truly insuperable: it is not possible to be both an impartial judge and an interested party. My vision is inevitably a partial one—the vision not of a spectator but of an actor. My opinions and observations are the expression of a very personal point of view and are more a confession than a theory.

Literatures are complex realities; authors who write works and publishers who bring them out, a public and critics who read them or consign them to oblivion. All these elements enter into the literary phenomenon, not as isolated entities but as parts of a whole in continuous relationship and interchange. The author writes the work and the reader, by reading it, re-creates it, remakes or rejects it; the work in turn brings about a change in the reader's taste, morale, or ideas; and finally, the reader's opinions and reactions have an effect on the author. Thus literature is a network of relations, or more precisely a circuit of communication, a system for interchanging messages and reciprocal influences among authors, works, and readers. It should be added that it is a system in constant motion. The publication of a new work changes the order and position of the other works that have gone before; the same can be said for the appearance of each generation of readers and critics. After Freud, we read Sophocles with different eyes. Though every reader's tastes and opinions have been formed by social class, education, age, and milieu, each is a unique person, and moreover a person who is never the same. Our tastes and opinions today are not those of yesterday. The same is true of the author: except for the name, the libertine poet John Donne and the Reverend Donne, preacher and Dean of Saint Paul's, have little or nothing in common.

What I have said concerning authors and readers is ap-

plicable to works as well. Although structuralist criticism has demonstrated the existence of constant elements in each literary form, it is evident that every work of real value possesses a particular character and a unique, unmistakable flavor. The structures of the *Odyssey*, the *Aeneid*, and the *Lusiads* may be similar, yet each of these poems is different from and irreducible to the others. Literature is a relation between ever-changing, unrepeatable realities: authors, works, and readers. Hence it is impossible to reduce a literature to a few general features. Except for the Spanish language, what is there in common between the popular wisdom of *Martín Fierro* and the personal lyricism of Rubén Darío, between Borges's metaphysical fictions and José Vasconcelo's *Ulises criollo*, between the *Primer sueño* of Juana Inés de la Cruz and the *Residencia en la tierra* of Pablo Neruda?

As much as or more than a system of relations, a literature is a history: the domain of the particular, the changing, and the unpredictable. A history within the vast history that every civilization, every language, and every society constitutes. Nonetheless, historical explanations with their complicated network of social, economic, political, and ideological causes never entirely explain literature. In each artistic work there is an element—poetry, imagination, who knows what?—irreducible to historical causality. Latin American literature is no exception: it was born in and with the history of our peoples, yet its development cannot be explained solely by the action of historical, social, and political forces. The influence of literary tradition, for example, has perhaps been greater than that of social conditions.

Despite the great differences between Latin American and U.S. society, there is a trait common to the literatures

of the United States, Brazil, and Hispano-America: the use of a European language transplanted to our hemisphere. This fact has marked the literatures of the Americas in a more profound and more radical way than their economic structures and technological and political changes. The three literatures attempted from the beginning to break the ties of dependency that linked them with the literatures of England, Portugal, and Spain. This aim was pursued and attained through a twofold movement: they sought to adopt the literary forms and styles in vogue in Europe, and they endeavored to give voice to the nature of the American continent and to the peoples who lived on our soil. Cosmopolitanism and nativism. Or as the U.S. critic Philip Rahv put it: two races of writers, "palefaces" and "redskins," the Henry Jameses and the Walt Whitmans. In Spanish-speaking America these two attitudes are represented, respectively, by the tradition that links Darío to Reyes and Borges, and by the one that goes from Sarmiento to Vallejo.

The opposition between cosmopolitan or Europeanizing writers and nativist or Americanizing ones divided the Latin-American literary conscience for several generations. José Enrique Rodó hailed the publication of *Prosas profanas*, the volume of Rubén Darío's that represents the culmination of Symbolism in its first phase, as the work of a great poet, at once new and exquisite; he nonetheless expressed his deep regret that neither the nature nor the typical man of the American continent had appeared in those surprising verbal constructions. "He is a great poet," Rodó said, "but he is not our poet." Later, for many long years, the adjective "telluric" was fashionable; literary critics used this word, usually as a term of praise, to emphasize that a writer had deep roots in the soil of the American continent. I

remember how the first time I met Gabriela Mistral, now almost forty years ago, she very kindly asked me to show her my poems. Nothing more natural: she had just been awarded the Nobel Prize and I was an unknown writer, a beginner. Delighted, I did as she had asked, sending her a little volume of mine that had just come out. A few days later we happened to meet again at the house of a mutual friend; when she saw me, she greeted me politely, in words filled at once with regret and a sort of reproof: "I like your poems, though they are not at all what I feel. You could well be a European poet; for my taste, you are not *telluric* enough." My face turned deep red when I heard that fatal adjective: I was doomed. Not being "telluric" was a congenital defect, like having been born deaf in a land of musicians.

In those days I envisioned the "telluric" poet as a venerable tree with a broad trunk, a luxuriant crown, and innumerable roots sunk deep into native American soil. Whitman's beard struck me as being the aerial roots of the banyan, the sacred tree of India. I took consolation in the thought that the poet Vicente Huidobro had never expressed the least desire for roots. He even preached the need to sever them; to fly—and for him poetry was verbal aviation—what is needed is not roots but wings. Neruda's poetry, on the other hand, is impelled in exactly the opposite direction, and in one poem he compares his feet with roots. Not for nothing is his best volume called *Residencia en la tierra.*

I smile today when I remember Gabriela Mistral and *tellurism.* Who uses that word today? The division of writers into cosmopolitans and Americanists, into those airborne and those deeply rooted, was artificial and did not reflect the reality of our literature. Our great authors have

been at once cosmopolitan and American, their feet on the ground and their heads in the clouds. Or vice versa: some have practiced flight upward and others flight downward; some have been miners of the heights and others aviators of the depths. Darío the *afrancesado*[1] wrote poems full of vibrant American color, and to be able to speak of Peruvians with their language of bone and lunar stone, César Vallejo had first to adopt the innovations of the European avant-garde following World War I. The same can be said of the other great Hispano-American authors. The two attitudes should be seen not as separate and antagonistic tendencies but as lines that intersect, bifurcate, intertwine, and separate once again, forming a living fabric. This fabric is our literature. We Latin American writers, like those of the United States, live somewhere between the European tradition, to which we belong by virtue of our language and civilization, and the reality of America. For us Hispano-Americans the original tradition, the one that is most ours, the primordial one, is the Spanish one. We write from out of it, toward it, or against it; it is our point of departure. By denying it, we continue it; by continuing it, we change it. A relation at once erotic and polemic that is repeated by our hemisphere's literatures in English and Portuguese. Our roots are European, but our horizon is the land and history of the Americas. This is the challenge that we confront each day of our lives and that each of us must meet in his own way. Latin American literature is simply the sum total of answers, each of them different, that we have given to this question put to us by our original condition.

1. One who adopts French manners, styles, turns of speech, and literary forms.—TRANS.

The opposition between cosmopolitanism and Americanism is a complementary one; the two attitudes are modalities of the American conscience, torn between two worlds. They are two phases of the same spiritual and intellectual adventure. Cosmopolitanism is the sallying forth of ourselves and our reality; Americanism the return to what we are and to our origin. In order to return, one must venture forth; in order not to disappear in the void, he who sallies forth must return to where he started. Cosmopolitanism and Americanism are extremes of the dialectic between the open and the closed. In the literary geography of Hispano-America—Brazil is a case apart—these two poles are represented by two capitals, Buenos Aires and Mexico City. One with its eyes focused on Europe, the other hemmed in by its mountains; one wearing the burden of its past lightly, the other weighted down by age-old and contradictory traditions. I am, of course, speaking of these two cities more as ideal emblems than as concrete realities. Buenos Aires and Mexico City represent historic vocations, but neither works nor their authors are always faithful to these geometries of the intellect. How can we forget, for example, that it was in Argentina that *Martín Fierro* was written—the Hispano-American work that is the most complete and most precise embodiment of the ambitions, perils, and limitations of traditionalism and regionalism? And is it not a Mexican, José Gorostiza, who is the author of the most rigorous work of our modern poetry, *Muerte sin fin* (Death without end), a crystal-clear, unyielding construction, untouched by the tempting charms and facile effects of local color and popular speech?

The process is cyclical. There are periods in which outward-oriented sensibility and love of exploration and travel predominate, and others in which tendencies toward self-

absorption, withdrawal, and introspection prevail. An ex ample of the former was the initial phase of Hispano-American Modernism, between 1890 and 1905, characterized in poetry by the influence of European Symbolism, and in prose by that of Naturalism. This phase was followed around 1915 by so-called Postmodernism, which represented a return to our hemisphere and to colloquial speech. Another example, closer in time to us, is the rich period of the avant-garde between 1918 and 1930. This was a time of searching and experimentation. The successive European movements, from Expressionism to Surrealism, had a profound influence on our poets and novelists. This first phase, to which we owe a number of outstanding works of exceptional boldness of expression, was followed by another characterized by reconstruction, consolidation of the gains made, and creation of works less indebted to trends of the moment. Immediately after the avant-garde writers, who appeared in the 1920s, a new group came upon the scene around 1940—my generation. It was followed, fifteen years later, by another in which novelists were the outstanding figures. Thus in this second half of the twentieth century three generations have occupied the stage together (not to mention the next younger generation). In the three of them the double rhythm of rupture and return that I have mentioned is clearly evident. The obsessive concern for novelty, experimentation, and the search for new forms has been followed by a literature of exploration of reality and language. A return to origins, but at the same time a conquest of territories previously untouched by the poetic imagination.

During these years, particularly after World War II, and in almost every corner of the globe, there appeared tendencies and ideological movements heralding, in various

forms, the advent of what was given the infelicitous name of *literatura comprometida*.[2] Artists tried to play a role in living history, yet almost invariably they mistook politics for history. They very often became the servants of ideological causes and turned into propagandists. The foundations of "committed art" were shaky at best: it was taken as axiomatic that history was a movement upward and that this movement was represented, in our time, by a class led by a party, which in turn was ruled by a committee, and the committee by a chairman. Little, very little, has remained of this ideological art. The saddest thing about it was not the aesthetic poverty of the works it produced but the loss of a moral and political tension that is salutary: the "ascent of history" led to the concentration camp and bureaucratic dictatorship.

The situation of contemporary Latin American literature is essentially no different from what it is in the rest of the world and can be characterized by two distinctive traits. The first is the disappearance of those schools and tendencies that enlivened the avant-garde movements of the first half of the twentieth century. The second is ideological disenchantment; the utopias turned into prisons and the dream of a free and fraternal society turned to stone— barracks instead of phalansteries. But the twilight of the artistic avant-gardes and the discredit of political ideologies signify neither the rejection of art nor desertion in the face of history. In the concluding pages of a book that I devoted to this subject (*Los hijos del limo*, 1973),[3] I pointed out that while the art of the immediate past had developed under the sign of rupture, the art of our era is one of

2. The expression comes from Sartre: *littérature engagée*.
3. American ed., *Children of the Mire*, 1974.

convergences: the intersecting of times, spaces, and forms. This end of a century has also been a return of times; we now discover what the ancients knew: history is an empty presence, a blank face. The poet and the novelist must restore the human features of this face. It is an undertaking that requires imagination, and moral courage as well. The literature we write doesn't turn its back on history, though it rejects the simplifications of ideological art and its categorical affirmations and negations. It is not an art of certainties but one of exploration; it is not a poetry that shows the way but one that seeks it. It is an art and poetry sketching the sign that, from the beginning of time, humanity has seen in the sky: a question mark. The hands that trace this sign may be Latin American, but its meaning is universal.

Quevedo, Heraclitus, and a Handful of Sonnets

To Raimundo Lida, in memoriam

I came to know Quevedo early in my life. He was one of my grandfather's favorite authors and in our home we had many of his works—the poetry, the satirical prose, and the essays.

Quevedo is not one author but many; the Quevedo that I read in those years and tried vainly to imitate was the Christian and Stoic poet of the verses on the passage of time, sin, and death. Of course I also spent a good deal of time with the erotic and satiric poet, the author of the *jácaras*[1] and *entremeses*[2] of pimps and whores, but my reading of these was not reflected in what I wrote at the time.

1. An old type of ribald ballad.—Trans.
2. A one-act farce often presented between two acts of a comedy in Quevedo's day.—Trans.

Years later, in 1957, I adapted for the stage an *entremés* and a number of *bailes*[3] of braggarts and strumpets; then in 1960 I wrote *Homenaje y profanaciones* (Homage and profanations), a return to the love poet.

Quevedo's "moral" poems, grouped by his first editor, Jose Antonio González Salas (1648), as those invoking the muse Polyhymnia, "reveal and manifest the passions and habits of man, endeavoring to amend them." Among these poems, many merely censure vices and defects: pride, avarice, lust, envy. But those we still read today and find moving are the ones whose theme is the awareness of man's fallen state, not only in the religious but in the existential sense. Man's fall is inseparable from freedom and grace, evil and time, from being born and having to die. Nearly every modern critic has pointed out that the act of falling, in its many senses from the physical to the theological, was a constant obsession of Quevedo's. The least incident was repeatedly transformed, by means of the universal *passe-partout* of the play on words, into a symbol of the original human condition. In a letter he reports, in rather coarse terms, that he has had a fall and adds: "I fell. Saint Paul fell. Lucifer's fall was greater still."

The fall, like everything else, has a double meaning in the Baroque worldview: falling may be a way of rising. A key symbol of this inversion of meaning is Saint Paul's fall on the road to Damascus. Again and again, in various texts, Quevedo alludes to what we might call an *upward fall*. Did he ever have such an experience? The cure he recommends is not the flight of the mystic, but refuge in a Christian Stoicism. His vision of human existence is Christian, yet he confronts it in a wholly Stoic spirit. Or,

3. Songs for dancing.—TRANS.

to put it another way: I find in his poetry a true under-
standing of man as a fallen being; I don't find in it either
reconciliation or communion with God. This trait, which
sets him apart from nearly all his contemporaries, is re-
markably modern. It would be an exaggeration to say that
Quevedo is Baudelaire's contemporary; it is not one to
note that, at certain moments and in certain verses, he
anticipates him. His poetry is a prefiguration of what was
to come, which may be defined thus: while the feeling of
suffering a sickness unto death (and living in the midst of
evil) has grown more intense, the vision of transcendence
has faded, to the point of almost disappearing altogether.
Quevedo said it all in two lines that still make me shudder:
"Nada me desengaña,/el mundo me ha hechizado."[4]
Knowing that we have fallen continues to be the back-
ground—almost always unexpressed—of our ideas and
notions about human existence, even in those intellectual
traditions as hostile or alien to the Christian religion as
Marxism and psychoanalysis. But it is a knowledge split
in two, with the other half missing: the vision of divine
being. Quevedo is one of the first European poets in whom
this split begins to be visible.

The core of his "moral" poems is a collection of sonnets
and psalms: *Lágrimas de un penitente* (Tears of a penitent),
1613. Many of the compositions in this series also figure
in another, probably written in the same year, with the
unusual title of *Heráclito cristiano y Segunda harpa a imitación
de la de David* (The Christian Heraclitus and Second harp
in imitation of David's). Those responsible for this con-
fusing double title were Quevedo's nephew, Don Pedro

4. Nothing breaks the spell,/the world has bewitched me.
—TRANS.

de Alderete, and his publisher, José Antonio González de Salas. It must be said in their defense that the two titles they strung together correspond perfectly. Quevedo's Heraclitus is the philosopher who weeps, and the David he imitates is the composer of the psalms of contrition and repentance: in both cases, the theme is the tears of a penitent. At no point does Quevedo see Heraclitus as the philosopher of change; more precisely, in accordance with the view of his era, change and movement are merely fateful accidents of the sublunary world, subject to time and its horrors: decline, disease, sin, death. This is why Heraclitus weeps.

No one is further removed from Quevedo's Heraclitus than the one we are acquainted with, the philosopher of energy and contradiction, at once Hegelian and Marxist, Nietzschean and Spenglerian. The overvaluation of change is modern and is linked to the appearance of the idea of progress. For Heraclitus, as for all antiquity, change was of no value in and of itself; on the contrary, it was the symptom or consequence of a lack or imperfection. Things change because through movement they seek repose, the plenitude of being. Hence movement is at one and the same time the consequence of original imperfection—the lack of being—and the means to overcome it. Not all movements are such, but only those that, by a sort of paradox, succeed in nullifying or neutralizing themselves—those movements that take as their model the identity of being, its perfect coincidence with itself. One of these privileged modes of movement is the Heraclitean accord of contraries; the Platonic circular movement of the stars is another. Hegel's dialectic is successive—a process leading to ever higher and vaster syntheses. The struggles and reconciliations of Heraclitus's contraries are recurrent moments of

discord and concord: a rhythmic vision of the universe. Between Heraclitus's vision and ours have crept in, first, the Judeo-Christian notion of unilinear and successive time, and then, later on, the modern conception of history as creative change: temporal succession, whether evolutionary or revolutionary, has a meaning and direction. It is a constant conquest of the future and it is called progress.

Quevedo's image of Heraclitus is the traditional one, as passed on by classic authors (quotations, fragments, anecdotes). His principal sources were almost surely Diogenes Laërtius and Sextus Empiricus. I say this because they are the authors of antiquity most abundantly cited in his essay on Stoicism. In this essay—which, like almost all his writing, is polemical in nature—he also defends Epicurus and, curiously, relies on arguments borrowed from the skeptic Señor de la Montaña (Montaigne). In Quevedo's prose works, moreover, the name of Heraclitus appears only twice, once in a list of pagan philosophers and the second time coupled, as was the custom, with that of Democritus. His Heraclitus is the one known to the Renaissance and the Age of the Baroque: an archetype of the melancholy temperament, as described by Aristotle in one of his *Problems* (xxx). Among the melancholiacs who were illustrious warriors, Aristotle cites Hercules and Bellerophon; among those who were philosophers, Heraclitus and Democritus. This list became traditional and was handed down intact to the seventeenth century.

To Quevedo and his contemporaries all over Europe, the two poles or extremes of the saturnine temperament were Democritus, the cheerful philosopher, and Heraclitus, the moaner and groaner. This division derived from the lucubrations of Marsilio Ficino regarding the two types of melancholy temperament: the man who is self-absorbed

and withdrawn, and the raging maniac. This conception has come down to our own day; Freud himself, perhaps without realizing its source, makes use of it and systematizes it in his studies on the complementary duality of manics and depressives. Two smiling figures appear in the frontispiece of the third edition of the *Anatomy of Melancholy* (1628): above that of Democritus Abderites, and below that of Democritus Junior, who is none other than the author, Robert Burton. In the prologue of his work Burton says: "Democritus, as he is described by Hippocrates and Laertius, was a little wearish[5] old man, very melancholy by nature," although much given to "laughing heartily." And further on: "I did sometimes laugh and scoff with Lucian, lament with Heraclitus." Burton was simply repeating a commonplace of his time. There is a *Melancholy Heraclitus* by Rubens, staring into space, resting his chin on his hand, with his head slightly bowed. It was the traditional pose for representing those of melancholy temperament, which Dürer adopted for his famous engraving. Flemish realism: Rubens painted a weighty tear rolling down the philosopher's left cheek.

This pair of philosophers enabled Quevedo to pen the following in his *Migajas sentenciosas* (Crumbs of wisdom), a collection of maxims in the Stoic vein: "Seneca, who was a great moral teacher, felt, along with Heraclitus and Democritus, that everything in this life was to be laughed at or wept over." In the psalms and sonnets of the *Heráclito cristiano*, he Christianizes the melancholy and the lamentations of the Greek philosopher; but in a burlesque sonnet the pair of philosophers appear as objects of derision, though

5. Wizened.—Trans.

232

it is hard to say whether wine or philosophy makes the one laugh and the other weep:

> *¿Qué te ríes, filósofo cornudo?*
> *¿Qué sollozas, filósofo anegado?*
> *Sólo cumples con ser recién casado,*
> *como el otro cabrón recién viudo*

> *¿Una propia miseria haceros pudo*
> *cosquillas y pucheros? ¿Un pecado*
> *es llanto y carcajada? He sospechado*
> *que es la taberna más que lo sesudo.*

> *¡Que no te agotes tú; que no te corras,*
> *bufonazo de fábulas y chistes,*
> *tal, que ni con los pésames te ahorras!*

> *Diréis, por disculpar lo que bebistes,*
> *que son las opiniones como zorras,*
> *que uno las toma alegres y otro tristes.*[6]

6. Free version: Why are you laughing, philosopher with horns?/ Why are you sobbing, philosopher drowned in tears?/One of you buggers has just got married/and the other had a wife he's recently buried.//Is it your own misery that's tickling you/and making the other screw up his face?/Are tears and guffaws a mortal sin? I suspect it's a tavern you learned wisdom in.//Don't wear yourself out; don't overdo it,/you clown with taller tales than the devil,/why, even your condolences aren't on the level!// The pair of you, to excuse your sousing/will say thoughts are like strumpets you bed while carousing,/to the one they're happy harlots, to the other sad whores.—TRANS.

Quevedo's poems impressed me so much that one of my essays of those days (*Poesía de soledad y poesía de comunión* [Poetry of solitude and poetry of communion]), is in large part a gloss on *Lágrimas de un penitente*. I chose other verses in that same collection—some with a slightly blasphemous flavor—as epigraphs for poems of mine and even for a book. I remember all this with a touch of sadness. I still read and admire this great poet and great rhetorician, but I no longer feel the same affection I once did for his personal image. Raimundo Lida's studies of his machinations made me see the deviousness of this schemer who often lacked scruples, this opportunist who became a turncoat several times over, this writer whose attacks and adulation were dictated by self-interest. In his political writings his admirable rhetoric serves as a smokescreen to conceal reality. A moral flaw but also an intellectual one: *conceptismo*[7] masks reality, always irregular, behind the symmetry of conceits. Quevedo the political schemer and Quevedo the moralist disappointed me and this disappointment opened my eyes. I then saw the other side of the coin: his gloomy temperament, his infatuation with words, his cruelty, his quarrelsome and envious disposition, his hatred of women, his lack of spontaneity.

And the erotic Quevedo? There are two of them: the one who composed the satires and the burlesque poems, and the one who penned the Neoplatonic sonnets. The

7. The seventeenth-century Spanish literary style, characterized by conceits and puns. The equivalent in English was Elizabethan euphuism.—TRANS.

first is admirable, but his *letrillas*,[8] *jácaras*, and *bailes* are not
so much a picaresque celebration of the body and its wan-
derings from the path of virtue as a somber allegory of the
two powers that rule this world: money and the grim
reaper. Quevedo does not love the body, he fears it. Sen-
suality and carnal appetite are not, as in the *Libro de buen
amor* of the Arcipreste de Hita, the secret sovereign of
human life; they are the servants of self-interest, which is
the mask of death. As for his love sonnets, they figure
rightfully among the most intense of all of European lyric
poetry, from the Renaissance to our own day. It is an
intensity gained not in spite of, but because of, their bare,
spare, perfect form. These sonnets show once again that,
more than a disorder, passion is a vital excess turned into
an obsession. Passion is idolatry; that is why it worships
form and consumes itself in it. That is also why it has great
affinities with asceticism and heroism: the lover enjoys his
sufferings; to triumph, he must have undergone super-
human trials. Quevedo's famous sonnet "Amor constante
más allá de la muerte" (Love constant beyond death), which
Dámaso Alonso regards as "probably the best in Spanish
literature," is an extraordinary example of the crystalli-
zation of desire in an idée fixe. The desiring imagination
asserts itself with a sort of blasphemous obstinacy, not in
the face of life and its changes but in the face of death.
Although it is well known, I must quote it so my gloss
that follows will be better understood.

> *Cerrar podrá mis ojos la postrera*
> *sombra que me llevare el blanco día,*

8. Verses, often with a refrain and set to music.—TRANS.

y podrá desatar esta alma mía
hora a su afán ansioso lisonjera;

mas no de esotra parte en la ribera
dejará la memoria, en donde ardía;
nadar sabe mi llama la agua fría
y perder el respeto a ley severa.

Alma a quien todo un Dios prisión ha sido,
venas que humor a tanto fuego han dado,
medulas que han gloriosamente ardido:

su cuerpo dejarán, no su cuidado;
serán ceniza, mas tendrá sentido;
polvo serán, mas polvo enamorado.[9]

These fourteen verses fascinated me for many years. The link between the chalk-white day and the darkness that steals over the soul of the dying man; the spirit able to swim in the dead waters of the other world; the veins and the last lively spluttering of the marrow in the bones; but above all the final mention of the ashes animated by *lo*

9. The final shadow may close my eyes,/carry me off from white of day,/unchaining my soul at the hour/of its anxious obsequious desire://but it will not leave the memory/of that other shore where once it burned,/for my fire can swim me through the frigid water,/irregardless of the strictures of law.// A soul which once imprisoned an entire God,/veins that brought fuel to such flames,/marrow that so gloriously burned://they'll leave this body, but not its cares;/ash they'll be, yet still aware;/ they will be dust, but dust in love.—TRANSLATION BY ELIOT WEINBERGER.

sentido and *el sentido*—feeling and meaning—aroused in me, each time I remembered the sonnet or reread it, an emotion that almost always ended in a disconsolate question. Do ashes feel, does the dust know it is inflamed with love? Quevedo departs from Platonism and Petrarchism: he affirms the immortality not of the soul but of the body, literally reanimated by passion. Quevedo's love is transformed into an eminently Christian affirmation that had already scandalized the pagan philosophers: the resurrection of the body. For Neoplatonists and Stoics the body, once abandoned by the soul, disappeared in the sublunary world. Yet at the same time Quevedo's image is scandalous for a Christian: the agent of resurrection is not God but human love for another human creature. More scandalous still, there is not really a resurrection of the body but a *reanimation* of its remains. Instead of abandoning the body to appear before God (who has been its "prison"), the soul of the lover obstinately insists on inhabiting and animating what is left of this idolized matter: bone, marrow, ashes.

It is not surprising that I have been tempted to compare Quevedo's sonnet with the image of modern passion. Ever since humans have been humans, the physics of love—the ways of going about it—have always been the same; what has changed is our way of experiencing it, thinking of it, and above all imagining it. The body is not historical, but the imagination is. Our image of love is rent by the opposition between the idée fixe that every passion represents and the decline, in the modern consciousness, of the idea of the soul. Unlike eroticism, which is always plural, love is the choice of one particular body and one particular soul. We always love one person. Can there be *persons*, in the deepest sense of the word, without a soul? For most people, the word no longer designates anything more than a

mechanism of impulses moved by libido, instinct, and other material agents; for the few who still believe in it, the soul cannot have the reality that it had for those who lived in the seventeenth century. Thus my attempt to capture the modern image in Quevedo's sonnet necessarily led to the shattering of this image into shards that were at once bright reflections and incongruous bits and pieces.

In 1960 I wrote *Homenaje y profanaciones*, a poem of 118 verses, divided into three parts each in turn subdivided into three. I called this composition, with naive pedantry, "a sonnet of sonnets." Quevedo's sonnet affirms the superhuman immortality of love. It is a poem written out of belief in the immortality of the soul, but also out of belief in the return of the soul inflamed by love to the ashes to which the body has returned. My poem, written out of different beliefs, was intended to affirm not the immortality but the vivacity of love—a timeless vivacity. In the first part I endeavor to express the senseless aspiration toward the survival of love; in the second, ironic resignation; in the third, the attempt to conjoin, for the space of an instant, the two states. The first and second parts contain two sonnets a little more orthodox than the rest, though unrhymed. Although I have few illusions as to their poetic value, I reproduce them for their documentary value, in the historical and psychological sense. Quevedo's sonnet worked on my conscience—I am surely not the only one—as a true reagent:

ASPIRACIÓN

Sombra del sol Solombra segadora
ciega mis manantiales trasojados

el nudo desanuda siega el ansia
apaga el ánima desanimada

Mas la memoria desmembrada nada
desde los nacederos de su nada
los manantiales de su nacimiento
nada contra corriente y mandamiento

Nada contra la nada
 Ardor del agua
lengua de fuego fosforece el agua
Pentecostés palabra sin palabras

Sentido sin sentido no pensado
pensar que transfigura la memoria
El resto es un manojo de centellas

ESPIRACIÓN

Sol de sombra Solombra cegadora
mis ojos han de ver lo nunca visto
lo que miraron sin mirarlo nunca
el revés do lo visto y de la vista

Los laúdes del laúdano de loas
dilapidadas lápidas y laudos
la piedad de la piedra despiadada
las velas del velorio y del jolgorio

Convergences

> *El entierro es barroco todavía*
> *en México*
> > *Morir es todavía*
> *morir a cualquier hora en cualquier parte*
>
> *Cerrar los ojos en el día blanco*
> *el día nunca visto cualquier día*
> *que tus ojos verán y no los míos*[10]

Quevedo's love sonnets—needless to repeat—are terri-fying, but they are so because in them the body, doomed

10. ASPIRATION

Shadow of the sun sickle Sunshadow/casts over my downcast well/unknots the knot mows down desire/unflames this heart-sick heart//Yet dismembered memory swims/from the birthsprings of nothing/from the wellsprings of birth/swims against the current and commands//swims against nothing/ The flaming of water/the tongue of fire phosphorescing the water/the wordless words of Whitsuntide//Aware without un-thought awareness/thought recasting memory itself/The rest is a handful of flares

RESPIRATION

Sun of shadow dazzle Sunshadow/my eyes will see the never seen/what they saw without looking/the far side of sight and the seen//The Lauds of the laudanum of praise/gravestones decayed stones the graves/engraved in ungrateful rock/the sorry soirees of unshackled wakes//Burial is still baroque/in Mexico/ To die is still/to die some hour somewhere//To close one's eyes in the white day/the day never seen the day someday/your eyes—not mine—will see

—TRANSLATIONS BY ELIOT WEINBERGER.

to die, consumes itself in the red-hot coals of unsatisfied desire. It is love as martyrdom. Unsatiated sensuality becomes obsession, fury, delirium. In the great Renaissance poets such as Ronsard and Garcilaso, the female body emerges from the waters of a river or the greenery of a grove with the same serene sovereignty with which the sun and the moon appear on the horizon. An appearance that is a metamorphosis: the bodies transform themselves into brooks, stones, trees, stags, snakes. Ronsard, Robert Sabatier says, "mineralizes" and "vegetalizes" his lovers, "turns them into mythology."[11] Death itself is not an end but a metamorphosis. One of Ronsard's sonnets on the early death of Marie Dupin reveals in admirable fashion the difference between these two visions:

Comme on voit sur la branche au mois de mai la rose,
En sa belle jeunesse, en sa première fleur,
Rendre le ciel jaloux de sa vive couleur,
Quand l'aube de ses pleurs au point du jour l'arrose:

La grâce dans sa feuille et l'amour se repose,
Embaumant les jardins et les arbres d'odeur
Mais, battue ou de pluie ou d'excessive ardeur,
Languissante elle meurt feuille à feuille déclose.

Ainsi en ta première et jeune nouveauté,
Quand la terre et le ciel honoroient ta beauté,
La Parque t'a tuée, et cendre tu reposes.

11. *La Poésie du seizième siècle*, 1975.

Pour obsèques reçois mes larmes et mes pleurs,
Ce vase plein de lait, ce panier plein de fleurs,
Afin que vif et mort ton corps ne soit que roses.[12]

The following century stylizes and martyrizes the body. Still, at certain moments in Lope de Vega's poetry it shines forth again, and in the end its nakedness triumphs over clerical prudery and Baroque rhetoric. In Quevedo, nakedness bleeds beneath the spurs of cruel desire, and the one triumph is that of ashes. His exacerbated Petrarchism is the other side of his misogyny and his affection for whores. But Lope cures us of Quevedo: he is the great poet of human love, love that desires and is fulfilled, happy and peevish love, deceived and undeceived, raving mad and lucid. Lope de Vega is not only the opposite pole of Quevedo and Góngora: he is their antidote as well. I grant that, from one point of view, the latter two are more original, novel, and surprising, particularly Góngora, the great inventor of pellucid architectures. In the literal meaning of the word, however, the truly original poet is Lope: his verse is born of what is primordial and most elemental. Moreover, he is vaster and richer; he knows more about

12. As in the month of May the rose on the branch appears,/In its pristine beauty, in its first flower,/Making heaven jealous of its bright hue,/When the dawn's tears bathe it at break of day://Grace in its leaves and love repose,/Filling gardens and groves with their perfume,/But then, bowed down by hard showers or excessive ardor,/Opening petal by petal, it languishes away.//Thus, in your first young bloom,/When heaven and earth honored your beauty,/Fate cut you down, and you rest as ashes.//For funeral offerings receive my grief and my tears,/This pitcher of milk, this basket of flowers,/So that, alive and dead, your body may be naught but roses.—TRANS.

men and women, about their bodies and souls. Quevedo's sonnet moves us by its somber intensity and its mad desire to vanquish death; at the same time it reveals an ignorance of the reality of love and its contradictory nature. Human love is inseparable from the awareness of death, but in a sense radically different from Quevedo's. For the lover, death constantly threatens the body of the beloved; to lose the body of the other is to lose one's own soul. Without this concern for the beloved, there is no love—only, at most, desire. And perhaps not even that, for desire is a thirst to see and touch a living being. Quevedo's beloved is a literary and philosophical fiction; Lope's women really exist: when we hear the poet, we hear them.

In European lyric poetry of the first third of the seventeenth century, the two great poets of total love—by which I mean complete and mutual love between man and woman—are, for me, Donne and Lope de Vega. Donne's mind was richer, more complex, freer, but the Spaniard surpassed him in the ability to create—or rather re-create—images and emotions, made as palpable as physical presences. Lope's defect—I am thinking of the lyric poet—is his monotonous abundance: his facility and technical mastery led him to write countless variations of a single sonnet. This false wealth of his ought not to hide his true riches from us. We need a really modern selection of his poetry, and above all we need someone who will do for him what Dámaso Alonso did for Góngora or Eliot for Donne: situate him, give him his rightful place in the modern tradition.

Coupling the names of Lope and Donne may seem a forced comparison: the English poet's wit is closer to Quevedo's *ingenio* than to Lope's writing, which left "the day book dark and the verse light." Nor am I forgetting

that Donne was an intellectual and a polemicist, as was Quevedo, whereas Lope was a lyric poet who composed sonnets and *letrillas* and ballads that everyone sang, as well as an immensely popular dramatist and author of novels and entertainments. But there is something these two very different temperaments have in common: passion in love and religious passion. These two loves meet in certain souls; Donne and Lope belong to this spiritual family. Both were worldly libertines, both sought the sun of power, both were men of the cloth, and both wrote some of the most intense love lyrics and religious verse in all European poetry. I know that this sort of comparison, based on taste as much as, or more than, on reason, does not demand proofs or demonstrations. Nonetheless, above all for the pleasure of reading it again, it is worth citing Sonnet LXI of Lope's *Rimas humanas*. Each of its verses describes with admirable exactitude a phase or state of amorous passion:

> *Ir y quedarse y con quedar partirse,*
> *partir sin alma e ir con alma ajena,*
> *oír la dulce voz de una sirena*
> *y no poder del árbol desasirse;*

> *arder como la vela y consumirse*
> *haciendo torres sobre tierna arena;*
> *caer de un cielo y ser demonio en pena*
> *y de serlo jamás arrepentirse;*

> *hablar entre las mudas soledades,*
> *pedir prestadas sobre fe, paciencia,*

y lo que es temporal llamar eterno;

crear sospechas y negar verdades,
es lo que llaman en el mundo ausencia,
fuego en el alma y en la vida infierno.[13]

Quevedo's world is different. A world at once wider and narrower: moral reflection and political action, conscience alone with itself or confronting the city and history—two forms of solitude. His life is divided between his study and the antechambers of grandees, tavern and brothel, the secret rendezvous of confederates and the haunts of the ambitious. In bringing this world to life on the page, Quevedo had no rival in his own time, and he has none today. One must read him to know what the nights and days of the loner are really like, the goad of unsatisfied appetite, the weight of the shadow of death on a man's conscience, the sleepless nights of rancor, the depths of melancholy, the mood swings from burning anger to cold contempt—in short, the whole gamut of feelings and sensations ranging from desperation to proud resignation. A man of contrasts and geometrical oppositions, violent and symmetrical, sententious and sarcastic, Quevedo mocks

13. Going and staying and by staying departing,/leaving without a soul and taking along the soul of another,/ hearing the sweet voice of a siren/yet unable to loose oneself from the mast;// burning down like the candle and consuming oneself/erecting towers on soft sand;/falling from a heaven and being a devil in hell/yet never repenting so being;//speaking in mute, solitary retreats,/borrowing on faith, patience,/and calling what is temporal eternal;//creating doubts and denying truths,/is what in the world is called absence,/in the soul, fire, and in life, hell.
—TRANS.

himself and others, lingers for a moment to contemplate his face in

> *las aguas del abismo*
> *donde se enamoraba de sí mismo*[14]

and on seeing himself, neither smiles nor takes pity on himself, but freezes in a hideous grin. Though Lope is not irreproachable either, his weaknesses are real weaknesses—failures of will, not of understanding. For that reason, we forgive him more easily. In Quevedo there is something demoniacal: the pride (the rancor?) of intellect. This is no doubt why we moderns are so drawn to him. I am setting down what I think without the least joy, afraid of being ungrateful. But I needed to say it: Quevedo was one of my gods.

14. the waters of the abyss/ in which he fell in love with himself —TRANS.

The Tradition of the Haiku

To Etiemble

In 1955 a Japanese friend, Eikichi Hayashiya, in view of my admiration for certain of the poets of his language, proposed that, my ignorance of Japanese notwithstanding, the two of us undertake a joint translation of *Oku no Hosomichi*. Early in 1956 we handed our version over to the publishing department of the National University of Mexico, and in April of the following year our little volume appeared. It was received with the usual indifference even though, to pique the critics' curiosity, we had emphasized in our foreword that our translation of this famous diary was the very first one into a Western language. Today, thirteen years later, we are repeating the gesture, trying the same gambit not to win critical reviews—Basho doesn't need them—but readers. Let me say straight out: it is readers, it is ourselves—busy, harried, all on edge—who gain by reading him; his poetry is a real tranquilizer, though his is a tranquillity resembling neither the lethargy

produced by drugs nor the drowsiness following a heavy meal. Producing an alert serenity that unburdens us, *Oku no Hosomichi* is a travel diary and at the same time a lesson in detachment. The French poem is wrong: to travel is not "to die a little," but to practice the art of saying good-bye so that, our burden that much lighter, we may learn to receive. Detachments are apprenticeships.

The title of the books, *Paths to Oku*, evokes not only a journey to the far borders of the country, along arduous and little used paths, but also a spiritual pilgrimage. In the very first lines Basho presents himself as a hermit-poet who has taken limited vows; both he and his traveling companion, Sora, set out in the robes of Buddhist pilgrims; their journey is practically an initiation, and before departing Sora shaves his skull in the manner of a bonze. Basho's and Sora's expedition is a religious pilgrimage and a visit to famous places—spots known for their splendid views, temples, castles, ruins, historical and natural curiosities—and also a poetic exercise: each writes a diary liberally interspersed with poems, and in many of the places they visit, local poets receive them and compose with them the collective poems called *haikai no renga*.

The number of translations of *Oku no Hosomichi*—four of them have come my way—is yet another instance of the fondness of Westerners for the Orient. In the history of the passions of the West for other civilizations, there have been two periods of fascination for Japan (not counting the Jesuit "infatuation" in the seventeenth century and that of the *philosophes* in the eighteenth). One of them began in France around the end of the last century, and after having been a fertile source of inspiration to a number of extraordinary painters, culminated in the Imagism of

Anglo-American poets; the other began in the United States a few years after World War II and has yet to end. The first phase was above all an aesthetic phenomenon; the meeting of Western sensibility and Japanese art produced notable works, both in painting—the most important example is Impressionism—and in poetry: Yeats, Pound, Claudel, Éluard. In the second phase the dominant note has been less aesthetic and more spiritual or moral; we have become passionately interested not only in Japanese artistic forms but also in the religious, philosophical, or intellectual currents expressed by them—Buddhism in particular. Japanese aesthetics—or rather, the fan of visions and styles that this artistic and poetic tradition unfolds before us—has never ceased to intrigue and charm us, but our perspective differs from that of previous generations. Though all the arts, from poetry to music and from painting to architecture, have benefited from this new approach to Japanese culture, I believe that what we are all looking for is another way of life, another vision of the world, and of the world beyond as well.

Despite the diversity and even the opposition between the contemporary viewpoint and that of the first quarter of our century, there is a bridge linking these two moments: neither in the earlier period nor today has Japan represented for us a school of doctrines, systems, or philosophies, but a sensibility. To the contrary of India, it has not taught us to think but to feel. In this case, naturally, we must not reduce the word *feel* to its connotations of sentiment or sensation; nor does the second sense of the word (opinion, subjective judgment) entirely correspond to what I am trying to express. It is something that lies between thought and sensation, between feelings and ideas.

The Japanese use the word *kokoro*: heart. But even in his day José Tablada[1] noted that this was a misleading translation: "*Kokoro* is something more, it is the heart and the mind, sensation and thought and one's very bowels, as though the Japanese were not content to feel with the heart alone." The hesitations we experience on trying to translate this term, the way in which the two meanings, affective and intellectual, blend in it without fusing completely, as though perpetually wavering back and forth between the two, is precisely the sense (the senses) of the word *feel*.

In a recent essay Donald Keene points out that this indefiniteness is a constant characteristic of Japanese art. He illustrates his statement with Basho's well-known haiku:

> *The withered branch*
> *A crow*
> *Autumn nightfall.*

The original does not say whether one crow or several are perched on the branch; moreover, the last line may refer to the end of an autumn day or to a nightfall at the end of autumn. It is up to the reader to choose between the different possibilities offered by the text, but—and this is essential—his decision cannot be arbitrary. The Sistine Chapel, Keene points out, presents itself to us as something finished, perfect: by claiming our admiration, it keeps us at a distance; but the garden of Ryoanji, an arrangement of irregular stones on a monochrome surface, invites us to reorganize it and opens to us the doors of participation. Poems, paintings: verbal or visual objects that offer themselves simultaneously to contemplation and to an act of

1. *Hiroshigue*, 1914.

the imagination on the part of the reader or the spectator. It has been said that in Japanese art there is an exaggeration of aesthetic values which often degenerates into that malady of the imagination and senses known as "good taste," an implacable taste bordering at one extreme on monotonous severity and at the other on a no less tedious elaborateness. The contrary is also true, and Japanese poets and painters might say with Yves Bonnefoy: imperfection is the acme of achievement. This imperfection, as has been noted, is not really imperfect: it is a voluntary act of leaving unfinished. Its true name is awareness of the fragility and precariousness of existence, an awareness of that which knows itself to be suspended between one abyss and another. Japanese art, in its most tense and transparent moments, reveals to us those instants—because each is only that, an instant—of perfect equilibrium between life and death. Vivacity: mortality.

The classic Japanese poem (*tanka* or *waka*) is composed of five verses divided into two stanzas, one of three lines and another of two: 3/2. The dual structure of the *tanka* gave rise to the *renga*, a succession of *tankas* written usually not by one poet but by several: 3/2/3/2/3/2/3/2 . . . Beginning in the sixteenth century, certain practitioners of the *renga* chose in turn to write in a witty, satirical, and colloquial vein. This type was called *haikai no renga*. The first poem in the sequence was called *hokku*, and when the *haikai renga* came to be divided into separate units—thereby following the law of separation, reunion, separation that would appear to govern Japanese poetry—the new poetic unit was called *haiku*, a combination of *haikai* and *hokku*. The shift from the traditional *renga*, ruled by a severe and

aristocratic aesthetic, to the *haikai renga*, popular and humorous, was primarily the work of the poets Arakida Moritake (1473–1549) and Yamazaki Sokan (1465–1553). Here is an example of Moritake's brisk style, based on lightning-quick contrasts:

> *Summer night:*
> *the sun on high awake,*
> *I close my eyelids.*

Another example of the lively wit—not altogether free from affectation—of the new style is this brief poem by Sokan:

> *Summer moon:*
> *if you put a handle on it*
> *a fan!*

In reaction to the tradition of the exquisite, courtly *renga*, Sokan's and Moritake's *haikai* gave proof of a salutary horror of the sublime, but also of a dangerous inclination toward the superficially clever image and emptily witty wordplay. Moreover, and most important, the *haikai* signaled the appearance in Japanese poetry of a new element: the language of the city. Not the so-called popular language—a vague expression meant to designate the archaic, traditional language of rural folk—but simply the language spoken in city streets: that of the urban bourgeoisie. In this sense it was a revolution similar to those occurring in the West, initially in the Romantic period and later in our own time. The speech of the day, I would call it, to distinguish it from the timeless speech habits of the peasant, the cleric, and the aristocrat. It is the sudden appearance of the his-

torical—and hence the *critical*—element in poetic language.

Matsunaga Teitoku (1571–1653) is another link in the chain that leads to Basho. Teitoku tried to return to the more conventionally poetic, timeless language of the traditional *renga*, without abandoning his immediate predecessors' predilection for strikingly clever conceits. Indeed, he so exaggerated this trait that it became mere parading of his wit:

> *Year of the tiger.*
> *Spring fog*
> *and striped as well!*

This tense terseness can also produce less ingenious, more genuinely felt poems, like this one by Nishiyama Soin (1605–82), the founder of the *Danrin* school:

> *May rain:*
> *the whole world*
> *is a sheet of paper.*

Basho no doubt had this poem in mind when he said, "Had it not been for Soin, we would still be licking the feet of old Teitoku." Basho took it upon himself to turn these exercises in clever aesthetic effects into spiritual experiences. When we read Teitoku, we smile at the amazing verbal invention; when we read Basho, our smile is one of understanding and—let us not shrink from the word—pity. Not Christian pity but that feeling of universal sympathy with everything that exists, that fraternity in impermanence with human beings, animals, and plants, which is the most precious gift that Buddhism has given us. For Basho, poetry is a path toward a sort of momentary

feeling of blessedness that does not exclude irony and does not mean closing one's eyes to the world and its horrors. In his indirect, almost oblique manner, Basho confronts us with terrible visions; very often existence, both human and animal, is revealed to us simultaneously as suffering and a stubborn will to persist in this suffering:

> *Cruel spiked collar:*
> *its insatiably thirsty gullet*
> *misleads the rat.*

This expressionistic picture of the rat with the parched gullet drinking ice-cold sewer water is succeeded by other visions—not contradictory but in complementary opposition—in which aesthetic contemplation leads to a vision of the unity of contraries. Here is simultaneous perception of the identity of plurality and its final emptiness:

> *Narcissus and screen:*
> *the one illuminates the other,*
> *white on white.*

In three lines the poet traces the image of illumination and then, as though it were a tuft of cotton, blows on it and makes it disappear. True illumination, he seems to say to us, is nonillumination.

A replica in black, in both the physical and the moral sense of the word, of Basho's poem is this one by Oshima Ryata (1718–87):

> *Darkest night,*
> *I hear coal falling*
> *on coal.*

Ryata's resources—against black, green; against anger, a tree:

> *I return home, irritated*
> *—but then, in the garden:*
> *the young willow.*

Rivaling the poem I have just cited is a haiku by Enamoto Kikaku (1661–1707), one of the best and most personal of Basho's disciples. In Kikaku's poem we find a courageous and almost joyful assent to poverty as a form of communion with the natural world:

> *Ah, the beggar!*
> *Summer clothes him*
> *in earth and heaven.*

In another haiku by another disciple of Basho's, Hattori Ransetu (1654–1707), also a consummate poet, even darkness takes on a crystalline transparency:

> *Against the night*
> *the moon paints blue pines*
> *with moonlight.*

The night and the moon, interpenetrating light and shadow, the cyclic victory of darkness followed by the triumph of day:

> *The New Year:*
> *dawn breaks and the sparrows*
> *repeat their gossip.*

(The other morning, dawn and the birds awoke me earlier than usual. I reached for a pencil and jotted these lines down on a piece of paper:

> *Dawn breaks: the sparrows*
> *repeat their gossip*
> *is it the New Year?)*

Among Basho's successors there is one, Kobayashi Issa (1763–1827), who breaks with the tradition of Japanese reticence, not to fall into Western-style personal confession but to discover and stress a keenly painful relation between human existence and the lot of animals and plants. Cosmic brotherhood in suffering, community in the universal damnation, whether we are human beings or insects:

> *For the mosquito too*
> *the night is long,*
> *long and lonely.*

The return to one's native village is, as always, a fresh wound:

> *My village: everything*
> *that comes out to meet me*
> *turns into brambles.*

Who, on seeing certain faces, has not recalled our unclean animal nature? Few, however, with Issa's intensity and directness:

In that face
there is something, there is something . . . what?
Ah yes, the serpent.

If horror is one of Issa's reactions to the world, in his
vision of it there is also humor, sympathy, and a joyous
resignation:

You are climbing Fuji
very slowly—yet still climbing,
little snail.

I look into your eyes,
dragonfly,
distant peaks.

Wondrous:
seeing through cracks
the Milky Way.

I shall not discuss the influence of Japanese poetry on
poetry in English and French: it is a familiar story and has
been told a number of times. The story of its influence on
poetry in our language, both in Hispano-America and Spain,
is much less well known and there is still no good study
on the subject—yet another gap in our criticism. Here I
shall only remind my readers that among the first to con-
cern themselves with Japanese art and literature, at the turn
of the century, were two Mexican poets: Efrén Rebolledo
and José Juan Tablada. Both lived in Japan, the first for
several years, and the second for several months in 1910.

Their affection was no doubt one they "caught" from French sources: the book that Tablada devoted to Hiroshige—perhaps the first study of that painter in our language—is dedicated to the "revered memory of Edmond de Goncourt." Even though Rebolledo was more intimately acquainted with Japan than Tablada was, his poetry never went beyond Modernist rhetoric; the stereotyped image of Japanese culture propagated by turn-of-the-century French poets often blocked his own direct view of it, and his Japan was more of a Parisian exoticism than a Hispano-American discovery. In the beginning Tablada's work was much like Rebolledo's, but he soon discovered in Japanese poetry certain elements—verbal spareness, humor, colloquial language, and a love of the apt, unexpected image—that impelled him to abandon Modernism and seek a new manner.

In 1918 Tablada published *Al sol y bajo la luna* (In the light of the sun and the moon), a volume of poems with a prologue in verse by Leopoldo Lugones. In those years the Argentine writer was rightly regarded as the one poet writing in Spanish who was comparable to Darío; his poetry (we now know) foreshadowed that of the avant-garde and paved the way for it. The Mexican's book was still Modernist; its relative novelty lay in the appearance of those ironic and colloquial elements which historians of our literature have seen as the hallmarks of a movement that, with notorious inexactitude, they label Postmodernism. This movement is a textbook invention: Postmodernism is simply the criticism that, within Modernism and not venturing beyond its aesthetic horizon, certain Modernist poets level against Modernism. It is the line of descent, via Lugones, of the anti-Symbolist Symbolist Laforgue. In addition to this critical note, another element in Tablada's book foreshadowed his imminent change of

style: the growing number of poems on Japanese subjects, among them one, famous in its time, dedicated to Hokusai. In the following year, 1919, Tablada published in Caracas a slender volume: *Un día . . .* It was almost a journal and consisted exclusively of haiku, the first ever written in our language. A year later his *Li-po* appeared, a volume of ideographic poems in which Tablada closely follows the Apollinaire of *Calligrammes* (although more personal poems also figure in this collection, among them the unforgettable, perfect "Nocturno alterno"). In New York in 1922, he published *El jarro de flores* (The pitcher of flowers), another volume of haiku. In these years Vicente Huidobro published *Ecuatorial*, *Poemas árticos*, and many other poetic texts in Spanish and French, which began the great shift that poetry in Castilian was to undergo a few years later. Tablada's poetry is situated along this same line of exploration and discovery. The Mexican was what is called a "minor poet," particularly by comparison with Huidobro, but his work, thanks to its strict and deliberate limitations, was one of those that extended the boundaries of our poetry. It did so in two senses: in space, toward other worlds and civilizations; and in time, toward the future—the avant-garde movement. There is a double injustice: Tablada's name figures in hardly any of the studies of the Hispano-American avant-garde, nor does his work appear in Hispano-American anthologies. This is most regrettable. His highly concentrated little poetic compositions, besides being the first transplant of the haiku to Spanish, were something truly new in his time. Their novelty and intensity were such that even today many of them still preserve their original freshness, their ability to take us by surprise. Of how many more pretentious works can the same be said?

Tablada always called his poems *haikai* and not, as is the

custom today, haiku. All things considered, he was quite right to do so, as we shall see. His brief compositions, though generally grouped together in a series with a common theme, may be regarded as separate poems, and in this sense they are haiku; at the same time, thanks to their ingenious construction, their irony, and their fondness for the brilliant image, they are *haikai*:

> *Royal peacock, long splendor:*
> *through the democratic poultry yard*
> *you pass like a procession.*[2]

Almost always Tablada is closer to Teitoku than to Basho:

> *Insomniac:*
> *on his black slate*
> *he adds phosphorous figures.*

> *For no reason geese*
> *sound the alarm*
> *on their clay trumpets.*[3]

The Mexican poet retains the tripartite structure of the haiku, although he very seldom conforms to its metric scheme (17 syllables; 5/7/5). But there is one example of perfect metrical adaptation and real poetry:

2. Pavo real, largo fulgor:/por el gallinero demócrata/pasas como una procesión.
3. Insomnio:/en su pizarra negra/suma cifras de fósforo.//Por nada los gansos/tocan alarma/en sus trompetas de barro.

> *Bits of clay:*
> *along the path in shadow*
> *toads hop.*[4]

An almost photographic objectivity which, by its very precision, frees the indefinable feeling that comes over us when we remember a walk along a wet path as night is falling. In his most felicitous moments Tablada's objectivity confers on everything his eyes discover the religious character of an *apparition*:

> *Tender willow:*
> *almost gold, almost amber,*
> *almost light.*[5]

With exquisite mastery the visual image and the friction of the syllables and phonemes are juxtaposed:

> *Flying fish:*
> *at the blow of solar gold*
> *the glass of the sea shatters in shards.*[6]

Tablada conceives of the haiku as the union of two realities in a few words, a poetics as close to Reverdy as to his Japanese masters. I shall now cite two poems that are two absolutely modern visions, the first through the alliance of the everyday and the unusual, and the second through its humor and the verbal and visual associations between moon and cats:

4. Trozos de barro:/por la senda en penumbra/saltan los sapos.
5. Tierno saúz:/casi oro, casi ámbar,/casi luz.
6. Peces voladores:/al golpe del oro solar/estalla en astillas el vidrio del mar.

Flying together in the quiet evening
notes of the Angelus,
bats and swallows.[7]

Beneath my window the moon on the rooftops
and the Chinese shadow play
and the Chinese music of the cats.[8]

Almost never sentimental or decorative, the Mexican poet achieves in a few of his haiku a difficult simplicity that might have won Basho's approval. In them humor becomes complicity, a shared destiny with the animal world, that is to say, with the world.

Ants on a
motionless cricket. Memory
of Gulliver in Lilliput.

As they take on their load
the little burro sheltered from the flies
dreams amid the trees of emerald paradises.

The little monkey looks at me
he'd like to tell me
something he's forgotten![9]

7. Juntos en la tarde tranquila/vuelan notas de Angelus,/murciélagos y golondrinas.
8. Bajo mi ventana la luna en los tejados/y las sombras chinescas/y la música china de los gatos.
9. Hormigas sobre un/agrillo inerte. Recuerdo/de Gulliver en Liliput.//Mientras lo cargan/sueña el burrito amosquilado/en paraísos de esmeralda.//El pequeño mono me mira/¡quisiera decirme/algo que se le olvida!

Tablada's work is brief and uneven. He made his living by writing for newspapers, and in the end journalism devoured him. He died in 1945; it has not yet been possible to bring out in Mexico a volume of his poems and those few texts in prose (feature articles and art criticism) worth rescuing. His last collection of poems, *La Feria* (The fair), appeared in 1928; there must be other poems that have never been brought together in a volume of his works. I happened to find one, in French: "La Croix du Sud" (The Southern Cross); it is from Part II of *Offrandes* (Offerings), a cantata composed by Edgar Varèse in 1922; for the first part Varèse used a poem by Huidobro, also in French. Until fairly recently, not only was Tablada's poetry dismissed as insignificant, but he himself was regarded as the naive, semieducated victim of an absurd infatuation with all things Oriental—the usual condemnation without appeal in the name of classical culture and Greco-Roman and Christian humanism. A culture falling apart, and a humanism that refuses to see the humanity is all humans and culture all cultures. Tablada's philosophical and religious ideas were admittedly a curious mixture of real Buddhism and unreal occultism, but what are we to say then of Yeats and Pessoa? His familiarity with Japanese culture is beyond question, although it was, naturally, not the familiarity of the erudite man of letters or the scholar. His knowledge of Japanese writing must have been rudimentary, but his books and articles reveal his direct contacts with the people, art, manners and customs, ideas, and traditions of that country. If having written a book on Hiroshige in 1914 in Mexico is something quite out of the ordinary, the fact that in this book Tablada also spoke, with taste and discrimination, of the No theater and Basho, of Chikamatsu and Takizawa Bakin, is even more unusual. Another

interesting fact: a great admirer of the plastic arts, he managed to gather together in his house in Coyoacán more than a thousand prints by Japanese artists, a collection that was broken up when he left the country in 1915.[10] Having said all this, I repeat: Tablada is not memorable for his erudition but for his poetry.

What were the models that inspired his adaptation to Spanish of haiku? If we are to believe him, his efforts were independent of similar attempts in French and English in the same period. Since it may be objected that his testimony is biased, it is best to turn to the chronology of events: the experiments in France took place before those of the Anglo-American Imagists and before Tablada's; thus Tablada may have followed the French example, though I must say that the haiku of the Mexican poet strike me as more spontaneous and original than those of the French. In other words, it was a question of stimulus, not of influence or imitation. As for the Imagism of Pound, Hulme, and their English and American friends, Tablada knew English well, but I don't believe that poetry in that language interested him particularly in those years. On the other hand, we know from his correspondence with López Velarde that he followed what was happening in Paris very closely. He was one of the first Hispano-Americans to speak of Apollinaire, and the latter's *calligrammes* fired his enthusiasm. This is quite understandable, for he saw in them what he himself was aiming at: the union of avant-garde innovation with the poetry and calligraphy of the Far East. In short,

10. This collection of prints, paintings, objets d'art, and books was scattered because his home was sacked when Mexico City was occupied by revolutionary troops. Tablada had collaborated with the dictator Victoriano Huerta.

Tablada was attuned to the tendencies of his time and expressed them, but it would be false to speak of imitation. The sources of his haiku were not those written by French and Anglo-American poets but the Japanese texts themselves: their English and French translations, first of all, and second, his more or less direct reading of the originals with the aid of Japanese friends and advisers.

Tablada's influence was immediate and was felt throughout the language. He was very widely imitated and, as always happens, the majority of these imitations have ended up in the gigantic trashbin of unread literature. But something more and something better than colorless imitations and gross caricatures of his work remained: in his haiku young poets discovered humor and the image, two central elements of modern poetry. They also discovered something that the poets of our language had forgotten: verbal conciseness and objectivity, the correspondence between what words say and what eyes see. The practice of haiku was and is an education in concentration. In the youthful works of many Hispano-American poets of this period— between 1920 and 1925—Tablada's influence can be clearly discerned. In Mexico the lesson he taught was assimilated by those in the first rank: Pellicer, Villaurrutia, Gorostiza. Years later the Ecuadorian poet Jorge Carrera Andrade rediscovered the haiku on his own and published a precious little volume: *Microgramas* (Tokyo, 1940). In Spain the phenomenon occurred a little later than in America: Juan Ramón Jiménez had a Japanese phase, as did Antonio Machado: there have been very few studies of either. The same is true of García Lorca's earliest poetry. In these three poets there is a curious alliance of two disparate elements: haiku and popular verse. Unlike in spirit, though remarkably alike as regards metrics, both the *seguidilla* on the one hand,

and the *tanka* and the haiku on the other, are composed of verses of five and seven syllables. The metrical similarity, however, merely underlines the profound differences between these two forms. In the *seguidilla*, poetry and dance are allied, since it is both a song and a dance, whereas in haiku the word leads to silent contemplation, either pictorial as in Buson, or spiritual as in Basho. None of the three Spanish poets—Jiménez, Machado, García Lorca—was inspired by the haiku because of its metrical similarity to the *seguidilla* (though they were doubtless struck by the resemblance), but because each saw in this Japanese form a model of verbal concentration, a remarkably simple construction consisting of a very few lines and a multiplicity of reflections and allusions. Had they read Tablada's poems? It seems extremely unlikely that they did not know of them. Moreover, it is revealing that, unlike the Spanish poets, Tablada saw in the haiku the possibility of a break with tradition rather than an occasion to return to it. Contradictory (complementary) attitudes of Spanish and Hispano-American poetry.

Following World War II Hispano-Americans again became interested in Japanese literature. I have already stressed that the attitude of our time is not that of fifty years ago: it is not only less aesthetic but also less ethnocentric. Japan has ceased to be an artistic and cultural curiosity: it is another vision of the world, different from ours but neither better nor worse; not a mirror but a window that shows us another image of humanity, another possibility of being. Within this perspective, what is really significant is perhaps not the translation of classical and modern texts but the meeting in Paris, in April 1969, of four poets, the purpose of which was the composition of a *renga*, the first in the West. The four poets were the Italian Edoardo Sanguineti,

the Frenchman Jacques Roubaud, the Englishman Charles Tomlinson, and the Mexican Octavio Paz. A collective poem written in four languages, but based on a common poetic tradition. Our effort was, in its own way, a real translation: not of a text but of a *method of composing texts.* The reasons that impelled us to undertake this experiment are not difficult to guess. The writing of *renga* is consonant with the principal concerns of many contemporary poets, among them the aspiration toward a collective poetry; the decline of the notion of an author; the deliberate introduction of chance, conceived of as a counterpart of the classic idea of inspiration; the identity of an original work and its translation. The haiku was a criticism of explanation and reiteration, those sicknesses of poetry; the *renga* is a criticism of the idea of an author. I ought to bring this rambling, prolix prologue to a close, but I would feel that I was betraying Basho if I didn't add one more thing: his simplicity is deceptive; reading him is an operation that consists of seeing through his words. The poet Mukai Kyorai (1651?–1704), one of his disciples, explains better than I can the meaning of Basho's verbal transparency. One day Kyorai showed this haiku to the master:

> *At the top of the crag:*
> *there too is another*
> *guest of the moon.*

"What were you thinking of when you wrote it?" Basho asked him. Kyorai answered: "One night as I was walking on a hillside beneath the summer moon, trying to compose a poem, I discovered another poet atop a rock, no doubt also thinking about a poem." Basho shook his head: "It

would have been much more interesting if the lines 'There too is another/guest of the moon' referred not to someone else, but to yourself." The subject of this poem, reader, should be yourself.

Cambridge, Mass., March 22, 1970

Blank Thought

We are living the end of linear time, the time of succession: history, progress, modernity. In art the most virulent form of the crisis of modernity has been the criticism of the object; begun by Dada, it is now ending in the destruction (or self-destruction) of the "artistic thing," painting or sculpture, in celebration of the act, the ceremony, the happening, the gesture. The crisis of the object is little more than a (negative) manifestation of the end of time; what is undergoing crisis is not art but time, our idea of time. The idea of "modern art" is a consequence of the idea of a "history of art"; both were inventions of modernity and both are dying with it. The overvaluing of

Preface to the first exhibition of Tantric art in the West, at the Le Point Cardinal gallery, Paris, February 1970.

novelty is part of a historicist conception: art is a history, a succession of works and styles governed by certain laws. The most immediate expression of the new is instant art, but it is also its refutation: all times fuse in the instant only to destroy one another and disappear. Is another art dawning? In certain parts of the world, particularly in the United States, we are witnessing different attempts to resurrect Fiesta (the "happening," for example). Do these attempts express a nostalgia for an irrecoverable past, or do they prefigure the future rites of a society still in a very early period of gestation—which, if not happier than ours, may at least be freer? I don't know. In any case, I recognize in them the old Romantic dream, taken up and transmitted to today's younger generation by the Surrealists: that of erasing the boundaries between life and poetry. An art embodying images that satisfy our world's need for collective rites. At the same time, how can we not imagine another art satisfying a no less imperative need: solitary meditation and contemplation? This art would not be a relapse into the idolatry of the "art object" of the last two hundred years, nor would it be an art of the destruction of the object; rather, it would regard the painting, sculpture, or poem as a point of departure. Heading where? Toward presence, toward absence, and beyond. Not the restoration of the object of art but the instauration of the poem or the painting as an inaugural sign opening up a new path. My reflections on Tantric art are situated within the framework of such concerns.

The vision of the human body as the double of the universe is central in Tantrism and is reflected in a magical physiology and an erotic alchemy. The universe breathes

like a body, and the body is governed by the same laws of union and separation that animate substances and produce their incessant metamorphoses. In Tantric Buddhism, sexual alchemy culminates in the transmutation of semen into "thought of enlightenment" (*bodhicitta*): the sperm ascends and silently explodes inside the skull of the adept. Ritual copulation is a homologue of meditation and ends, like the latter, in the disappearance into emptiness: blank thought. In Hindu Tantrism, the yogi offers his sperm as a "loving oblation to fire" and leaves it in his partner.[1] The body of the woman is a homologue of the Vedic altar, and the sexual rite is a lived metaphor of the age-old sacrifice to fire. Both rituals try to abolish the contraries we are made of, contraries that endlessly war with each other and tear us apart—us and the world: female and male, this and that, good and evil, subject and object.

A rite of transgression, Tantrism is an attempt to unite what has been separated and return to the primordial androgyne, to the original indistinction—before castes, before the you and the I, before the here and the there. But this return is a transmutation; the return to the unity of the beginning is above all entry into an unknown region, into that which does not change and is before all beginnings and after all ends: Nirvana, Brahma. The reconquest of original time, the time that contains all times, ends in the dissolution of time. Tantric Buddhism conceives of this state as *śūnyatā*: emptiness identical to the Zero identical to the vulva; Hindu Tantrism conceives of it as *ananda*: union with being identical to the One identical to the phallus. The round *stūpa* and the erect *liṅga*. A new reversal of signs: the Zero is full, filled to overflowing, fulfilled; the

1. See Agehananda Bharati, *The Tantric Tradition*, London, 1965.

One, transparent, is empty. Here is a monism that postulates the abolition of the subject, and another that predicates the disappearance of the object: the two faces of nonduality, the double face of ancient India.

A magical physiology and a sexual alchemy, Tantrism is also a corporeal astrology. Heaven and earth, the sun and the moon, the stars and the planets are bodies in perpetual, rhythmic conjunction and disjunction. The human body, in turn, is a space peopled with constellations of signs. Tantrism adopts the age-old metaphor and interprets it literally: stars = signs = destinies. This metaphor appears among us as well: in the Romance languages the word for sign comes from *signum*, a celestial sign, a constellation. In Spanish there is also *sino* meaning "fate," a doublet of the word for "sign" (*signo*). The vault of heaven is not only the theater of cosmic eroticism, but an expanse as sensitive and vibrant as human skin; in like manner, because it is a constellation of signs, the human body is a semantic universe, a language. Each correspondence engenders another: if the semantic archetype of the body is the starry sky, the body is the erotic archetype of language. This language is a hermeticism—*sandhābāsā*, a "twilight language" or, as modern interpreters prefer to translate it, an "intentional" one—which consists of attributing erotic and material meanings to terms that generally designate spiritual concepts and ritual objects.

Profanation of the sacred language: reincarnation or, more exactly, *reincorporation* of the word. Heaven is a sign, a language, and language is a body. *Padma* is lotus, but in *sandhābāsā* it is the vulva; *súkra* (semen) designates *bodhicitta* (thought of enlightenment); *sūrya* (sun) is *rajas* (menstrual blood); *upāya* (method of meditation) is *vajra* (lightning bolt) which is *liṅga* (phallus). This verbal eroticism pro-

272

duces all sorts of semantic associations and offspring. Like bodies, language produces and reproduces itself; in each syllable lies a seed (*bija*) that, on being actualized in sound, is a vibration emitting a form and a meaning: Our Lady Prajñāpāramitā is born of an eight-petaled red lotus that in turn is born of the syllable *ĀH*. Tantrism is a system of incarnated metaphors.

The "intentional language" and the metaphors of the Tantras are not only a way of concealing the real meaning of the rites from the intruder; they are also verbal manifestations of the universal analogy on which poetry is founded. Tantric texts, the despair of philologists and exegetes, are ruled by the same poetic necessity that led our Baroque poets to invent a language within the Spanish language, and that inspired Mallarmé and Joyce: the conception of writing as the double of the cosmos. But the poetic hermeticism of the West closest to Tantrism is the *trobar clus* of the Provençal poets. Like Tantrism, the Provençal erotic is a transgression, not only because of its celebration of adultery but also because of other characteristic features such as the curious ceremony of the *asang*, the counterpart of *coitus reservatus* in the Tantric Buddhist rite. The difference would appear to be this: in Provence we find a poetics that leads to an erotics; in Tantrism, we encounter an erotics that culminates in a ritual of transmutation of human nature. There is, moreover, another difference: in Provençal poetry, no doubt through the influence of Sufi mysticism—infused, so to speak, into the Arabic forms adopted by the Provençal poets—hermeticism tends to idealize and spiritualize language; in Tantrism, words become corporeal.

The place of painting and sculpture within Tantrism is similar to that of poetry. Like poems, plastic forms are

intelligible only in relation to their contexts: they are par-
ticles. Like a poem, each painting and sculpture is by itself
a microcosm of the system, a self-sufficient whole. The
relation between the universe and the human body, and
between the body and the poem, is repeated in painting
and sculpture. Everything, from the signs in the heavens
to the circles and triangles of the mandala, is a metaphor,
and in this property—which out of bodies makes constel-
lations of signs, and out of groups of signs, corporeal
realities—lies the secret of transformations and metamor-
phoses. Analogy is a river of metaphors.

The Tantric tradition offers us two types of plastic works:
some are more or less realistic representations of symbols,
myths, and divinities; others are not so much representa-
tions as associations, configurations of signs. Works in the
first category, because of both their iconic function and
their figurative character, are similar to the religious images
of the West. Those in the second category offer more than
one surprising affinity with modern art, particularly with
Surrealist works and with those of certain abstract painters.
In both cases the secret of their radiation lies in what I
would call the syntax chosen by the pictorial vision for its
unfolding: the preeminence of metaphor turns the painting
into a tattoo that invites us both to decipher and to con-
template it. It is the art of Klee and Max Ernst, of Miró
and Victor Brauner. It is Michaux's painting, and his po-
etry as well. This is intrusion of the verbal element in
painting, and profanation of painting by the sign.

The affinities between Tantric and modern art should
not hide from us their radical differences. Unlike modern
painting, which is (or claims to be) a language expressing
nothing but painting itself, Tantric works are the vehicle
of an already constituted system to which nothing can be

added. It is difficult—or rather impossible—to translate a
modern painting into verbal language; it is not impossible
to translate a Tantric painting in this way. Sculpture and
painting are one of the languages of Tantrism, a language
no less strict and complex, precise and precious, than those
of poetry and erotic rites. Verbal languages, languages of
the body, pictorial languages (not to mention the sounds
and scales of vibrations that constitute, in and of them-
selves, other semantic worlds)—all these are translatable,
all are languages within another language that encompasses
them all: the Tantric system. Modern painting presents
itself as a language irreducible to other languages; Tantric
painting is a translation not of the world but of the language
that constitutes the world. Poem, rite, speculative text,
painting: languages of a language, versions of a Word spo-
ken from the beginning, one and unchanging. The resem-
blance between Tantric works and those of certain modern
artists of the West vanishes.

Our painting seeks to be a language without ceasing to
be a presence; the oscillation between these two incom-
patible requirements constitutes the entire history of mod-
ern art, from Baudelaire to our own day. Tantric painting
aspires to be not so much a presence as a sign. In the West
we went from the painting of presence to painting *as* pres-
ence; I mean that painting ceased to represent this thing or
that—gods, ideas, naked young women, mountains, or
bottles—in order simply to present itself: painting does not
seek to be representation but presence. Baudelaire was the
first to note this change and also the first to note the con-
tradiction. Color, he said, thinks for itself. Now if color
really thinks, it destroys itself as presence; it transforms
itself into sign. Language, signs, are not presence but what
points to presence, what *signifies* it. Modern painting lives

within this contradiction between language and presence; more exactly, it lives thanks to it. It is the contrary of Tantric art, which, though it turns aside from representation, does so not to constitute itself as presence but to enhance the sign.

To reject painting *as* presence, in Tantrism, is not to reject presence: the Tantric sign, like all signs, is a bridge, and this bridge leads us to another sign—not to presence but to the doors of presence. By comparison with the painted presence of Western art, Tantrism evokes another presence that is beyond painting. The sign—any sign—has the property of drawing us on and on. A perpetual *toward*—which is never a *here*. What writing says is beyond what is written; what Tantric painting presents does not lie within it. Where the poem ends, poetry begins; presence is not the painted signs we see, but what these signs invoke. Hence the real analogy (if we must look for one) is less with the modern painting of the West than with its poetry: Tantric signs, whether painted or sculpted, are a hermetic writing; they are poems without ceasing to be plastic objects. They lie at the other extreme from Chinese and Arabic calligraphy: in the latter one goes from the letter toward the painting, while in Tantric art one goes from the painting toward the letter. And in the same way that Chinese calligraphy is not entirely painting, so Tantric painting is not wholly writing: the first demands of us that we *read* it as we contemplate it; the second, that we *contemplate* it as we read it.

The metaphor of painting as writing leads us, almost without our realizing it, to the initial metaphor: writing as a body. To read painting is to contemplate it—to touch it as though it were a body. The image of the body leads us in turn to another: a journey and a pilgrimage. To touch a body is to travel across it like a country, to enter it like

the streets and squares of a city. The poet Sarāha discovers in himself a sacred geography:

I went with the pilgrims, I wandered through the sanctuaries,
I found nothing more holy than my body.
Here are sacred Jamuna and mother Ganges,
Here Prayaga and Benares, here the Sun and the Moon.

The pilgrimage sites of Tantric initiates are secret and are located at the four cardinal points in accordance with a symbolic system. Legend has it that Shakti, the wife of Shiva, immolated herself and that the god, mad with grief, took the cadaver on his shoulders and, dancing furiously, scattered parts of it throughout India: the breasts of the goddess fell in one place, the mouth and tongue in others, the vulva in another. In each one of these places a sanctuary was erected. The religious geography of Tantrism is a homologue of the rite of sacrifice. (Another example of mythico-corporeal geography: in certain Buddhist Tantras the place where the doctrine is preached is the vulva of Prajñāpāramitā = Perfect Wisdom = other shore reached = emptiness.) Not only does Sarāha turn his body into a sacred geography, but this body is the place where the scattered members of the goddess are reunited. The operation is a reconstitution; the return of times is a return to unity. The analogy is all the more striking if we recall two ancient texts. The first: according to a Vedic hymn (*Rig Veda* 10.72), Shakti is the daughter of Daksha, which is one of the names of the creator god and the origin of the mother goddess. The second text: according to another Vedic hymn (*Rig Veda* 10.90), the world and humanity were born thanks to the self-sacrifice of a demiurge who tore his body to pieces as Shakti's had been: "His mouth

was Brahma, from his arms the warrior was born, from his legs the craftsman, from his feet the servant . . . the air came forth from his navel, from his head there sprang the sky, from his feet the earth: thus was the world made."

Each turn of the spiral of analogies brings us back to the starting point, and simultaneously brings us face to face with a perspective we don't recognize: the image of the body as a pilgrimage takes us back to the image of the body as a writing. To write or to read is to trace or to decipher signs one after the other: to journey, to go on a pilgrimage. By its very nature, writing always goes beyond itself; what we are looking for is not in the writing, except as a pointer or an indication: the writing cancels itself out and tells us that what we are searching for lies *farther on*. A path of signs: at the end of the writing, at the end of the pilgrimage by way of the body, another sign awaits us. Unlike the others, that sign is no longer the antecedent or consequence of another sign. There is a break in the succession, an interruption of the flow of time, a halt in the pilgrim journey, an end of writing, and a beginning of painting: in that sign all signs converge, and reading ends in contemplation. But the Tantric pictorial sign is not the place where presence appears either. The painting is supported by a text, it depends on a writing, and its function is to cancel out that writing and thus to cancel itself out; the pilgrimage by way of the canvas or the body tattooed with signs leads to an image that, as it vanishes, opens doors to us: beyond is presence or its reverse. Art has no existence of its own; it is a path, a freedom. Tantric painting really shows us nothing: to read it, to contemplate it, is a pilgrimage that becomes a detachment.

Austin, Texas, December 29, 1969

Constellations:
Breton and Miró

Last December (1983) Joan Miró died. I first met him many years ago, around 1947 or 1948, in Paris, in a café on the Place Blanche where André Breton, Benjamin Péret, and a group of young Surrealists dropped in almost every day. Or perhaps it was a little later, in a café in the Rue Vivienne. Or near Les Halles, in another café with a name no less evocative than that of the charming sorceress who was Merlin's undoing: La Promenade de Vénus. But in those days I scarcely had a nodding acquaintance with him. He had already gone to Catalonia to live, and his visits to Paris were brief and infrequent. Besides, he was sparing of words and the hubbub of those young poets, neophytes of Surrealism, accentuated his natural taciturnity. I never heard him express an opinion: he would sit listening wide-eyed, with the smile of a country moon that had somehow

got lost in the city. Years later I was able to talk with him in a more relaxed and calmer atmosphere, in Paris and Barcelona, with a number of friends of his who were also friends of mine: José Luis Sert, the poet Jacques Dupin, Aimé Maeght. The latter, a generous, luxury-loving soul, gave a party for him on a Seine river barge to celebrate his eightieth birthday. During the evening, with incredible powers of vivid and accurate recollection despite his advanced years, Miró told my wife, Marie José, the story of a memorable lunch that had taken place in the fall of 1958 at André Breton's. I use the word memorable because of what I am about to recount.

In 1958 neither Miró nor I lived in Paris. The two of us were merely there on a visit, he to attend the vernissage of an exhibition of his paintings and I to attend a meeting of writers. Elisa Breton telephoned me one morning: could I lunch with them in their apartment on the Rue Fontaine the following Saturday? I accepted the invitation. On the day of the lunch, when I entered the little living room, I discovered that besides André and Elisa there were two other people present: Joan Miró and Pilar, his wife. A few minutes later Aube, André's daughter, arrived, accompanied by a young painter friend. Though it was very small, that room always seemed immense to me, doubtless because of the extraordinary collection—on the shelves, on the walls, in every corner—of books, paintings, sculptures, masks, and unusual objects from all parts of the world and from several ancient cultures, not excluding tomorrow's. But I believe it was Breton's own person that caused that little living room to open out into a dimension that was *other* and truly immeasurable. Standing in the midst of all those works, some of real artistic merit and others mere curiosities, Breton looked like a Des Esseintes of the twen-

tieth century, not a decadent but a visionary, fascinated not by Byzantium and the end of the ancient world but by the dawn of the human species, by "the men from a long way off," as he used to call primitive peoples.

At lunch there was talk of painting and poetry, politics and magic. The names of Trotsky and Rousseau, Paracelsus and María Sabina, the sorceress of Huatla and bestower of hallucinogenic mushrooms, came up. Breton did not hide his passion for occult sciences, esotericism, and magic. Listening to him, it was impossible not to think of Cornelius Agrippa and Giordano Bruno, torn like him between a proud rationalism and the belief in obscure revelations. Yet Breton always expressed his disapproval of what he called "induced vision," the use of drugs. He did not regard such visions as "trustworthy." One time, speaking of Artaud, he said to me: "I am touched by him, as a man and a poet. His book *Au pays des Tarahumaras* (In the land of the Tarahumaras), for instance, is admirable, but I find his account upsetting: where does the poet's vision end and the treacherous visions of drugs begin?" I think he was right. Even the ancients made a distinction between fantastic dreams, nightmares, and true revelations. During the lunch the subject of drugs came up, and we deplored the fact that modern medicine abused chemical remedies. Suddenly André complained of a slight headache and asked for an aspirin. With the cruelty of the young, Aube commented: "How odd you ask for an aspirin instead of calling in a shaman! He'd rid you of your headache with two passes of the hands." Breton answered with a smile and embarked upon a complicated, confused disquisition. Joan and Pilar exchanged nervous smiles. They had scarcely opened their mouths during lunch. Elisa rose from the table and invited us to have coffee in the studio.

We sat in a semicircle. Breton picked up a few sheets of paper from his desk and with that air at once completely natural and ceremonious that was one of his great charms, told us that he was about to read us some poems in prose. He had written them to *illustrate*—that was the word he used—the series of gouaches by Miró entitled *Constelaciones* (Constellations). Breton's voice was deep and rhythmical; he read slowly, with slight liturgical modulations. On hearing these brief, dense texts, I remembered his first poetic experiments, in the very early days of so-called automatic writing: the same love of the unexpected image and the phrase perhaps too well-rounded and overpolished, the same mixture of deliberate and chance effects. Freedom and preciosity. Less swift-moving and violent than those of his youth, these poems seemed like slow spirals metamorphosing into crystallizations that vanished the moment they took on spoken form. Something closer to Chirico than Miró. Miró's constellations are clusters of celestial and marine fruit; Breton's, constructions of echoes and reflections. Miró listened to the reading with his air of a wonderstruck child. When it was over, he murmured a few words of thanks. Pilar didn't open her mouth. What were they really thinking? The poems for *Constelaciones*, if I am not mistaken, were the last ones Breton ever wrote.

During the conversation that followed the reading, André told us that he had been impelled by a twofold impulse, at once aesthetic and ethical, to write those poems. Aesthetic because *Constelaciones*, by virtue of the unity within variety and the vital and plastic energy of its compositions, struck him as one of the *happiest* moments of Miró's life work. The adjective was particularly apt: these gouaches of Miró's are a surprising fireworks display—a *feu d'artifice* with nothing artificial about it. The painter's hand threw

down onto the canvas a fistful of seeds, germs, colors, and living forms that couple, separate and develop branches with a joy at once generative and fantastic. Metaphors of being born, growing, loving, dying, being reborn. The instantaneous happiness of existing, a happiness repeated each day by all living beings. But this joyous explosion is also a lesson in ethics. For Breton, Miró's *Constelaciones* literally *illuminated* the obscure relationships between history and artistic creation. Miró had painted these rather small-sized gouaches at a terrible moment in his life and modern history: Spain under Franco's dictatorship, Europe occupied by the Nazis, his poet and painter friends persecuted in France or in exile in America. The appearance in those dark, gloomy days of a work that is a fountain of colors and living forms was an answer to the pressure of history. As I listened to Breton, I remembered e. e. cummings's poem: the earth always answers humanity's insults with spring greetings. Perhaps art is only the expression of the tragic joy of existence.

Breton did not deny social determinisms, but he believed that they always operate in an unexpected way and almost always contrary to the march of events. His favorite example was the Gothic novel. Appearing at the end of the eighteenth century, in a period of moral criticism and intellectual and political effervescence, at the culmination of the *Encyclopédie* and on the eve of the French Revolution, the Gothic romance was a genre indifferent to history, philosophy, and politics. Like Apollodorus and the other authors of romances in antiquity, Walpole, Ann Radcliffe, and their followers had no other aim than to intrigue and captivate their readers, not by recounting stories of impossible passions and adventures in remote realms, however, but by exploiting cruder and more secret emotions:

terror, fear, the dark side of eroticism, suspense. Castles, catacombs, dungeons, ghosts, vampires, erotomaniacal monks. Yet these works of pure fiction harbor undoubted powers of subversion that materialize, so to speak, in the primary role of the subterranean in the development of the plot: in this underground realm lurk the vengeful forces— eros, desire, imagination—destined to blow up the ancien régime. As Annie Le Brun puts it in her fascinating book on the subject, *Les Châteaux de la subversion*: the Gothic novel "is an aberrant wall of darkness obstructing the view of the Century of Enlightenment." But Miró's *Constelaciones* do not foreshadow, as do the Gothic romances, the outbreak of revolution; they are an explosion of life humiliated by dictatorship and war. It was not difficult to agree with Breton at the time—nor is it today. The mission of art—of modern art, at least—is not to reflect history mechanically or to make itself the spokesman of a given ideology, but to voice, in opposition to systems, their functionaries and executioners, the invincible Yes of life.

It was not by accident that throughout his long life Miró wrote poems. Poetry is an element in all his works. Indeed, the whole of his paintings may be looked upon as a long poem, a fable at times, at other times a children's story, at still others a mythological and cosmological tale, and always a book of fantastic adventures in which the comic and the cosmic intertwine. A poem not to be read but to be seen; there is no need to understand it, only to contemplate it, to be struck with wonder and laugh with the universal laugh of creation. It is divided into scenes and episodes, as dreams are, and like them it is ruled by a logic irreducible to concepts. And what does this poem tell us? It tells us the story of a journey. Not in space but in time: the journey of the adult that we are toward the child that

we were, the journey of the civilized man who lives under the threat of the gulag and atomic extermination, who sallies forth all by himself to win back the innocent savage within him. The journey in search of the wonder-filled eyes of the very first day. A journey not outward but inward bound.

From the Renaissance on, the history of art became that of an apprenticeship: it was necessary to master the rules of perspective and composition. But at the dawn of the twentieth century those perfect paintings began to bore people. Modern art has been an apprenticeship in reverse: an unlearning of recipes, tricks, and clever devices so as to regain the freshness of humanity's pristine gaze. One of the high points of this process of unlearning has been Miró's work. His work is admittedly uneven. He painted a lot, and a lot of his work will be discarded tomorrow by our descendants. His case is not the only one. Although more varied and more inventive, Picasso's oeuvre too will be subjected to severe scrutiny, and for the same reasons: indiscriminate abundance, complacent facility, the gratuitous gesture, the initial sharp break become a habit, the confusion between legerdemain and creation. The artist may be a magician; he is not a prestidigitator. But the core of Miró's work will continue to amaze by virtue of its fantasy, impudence, spontaneity, and humor. Wordsworth said that the child is father to the man; Miró's art confirms this. I must add that Miró's painted like a child five thousand years old. An art such as his is the fruit of many centuries of civilization and appears when human beings, weary of circling endlessly round and round the same idols, decide to go back to the beginning.

Two Centuries of
American Painting
(1776–1971)

American literature gained universal recognition more
than a century ago. Today there is no doubt: among the
great literary works of the nineteenth and twentieth cen-
turies, some are American. It has taken much longer for
American painting to become known and recognized. The
majority of critics agree, however, that since 1950 the art
of the United States has possessed a vitality, an originality,
and a diversity not found elsewhere in the world. It would
be stupid to claim that American painters and sculptors are
today's best; it is not stupid to think that the art of this
country is the liveliest of all and the one exerting the great-
est influence on comtemporary art. The exhibition that
opened in November 1980 at the Palacio de Bellas Artes
in Mexico City is a good initiation into the history of

American painting: the first painting exhibited dates from 1776 and the last from 1971.

The history of American painting offers great analogies to (as well as notable differences from) that of Mexico. In the two countries plastic art begins as a mere reflection of European developments, though Americans have nothing that can be compared to the great Baroque and Mannerist works of the seventeenth century and the first half of the eighteenth in Mexico. From the early nineteenth century on, Mexican and American artists began to express the reality of our continent—both the physical reality, the landscape, and the human one: those who peopled it, especially the aborigines. In 1846 Baudelaire wrote enthusiastic and acutely perceptive pages on George Catlin, the painter of American Indians. Baudelaire's commentary was prophetic and even today, on seeing Catlin's painting, I am astonished by his exactitude: the American painter's colors—reds, ochers, greens—have an indefinable quality, at once impassioned and restrained, barbarous and refined, that brings to mind the adjective *heroic*. His paintings evoke the emotion of wide open spaces good for hunting and war, but also for contemplation. Catlin's savages, Baudelaire says, "make us understand the sculpture of antiquity." We owe to this artist and adventurer more than six hundred paintings of the Far West, produced between 1830 and 1840; many of them are portraits of Indian chiefs, like the superb one of *Old Bear*. Before posing for Catlin, Old Bear naturally painted, decorated, and tattooed himself, as though his body and face were also a painting. He thus turned himself into a living emblem.

Side by side with the fascination for the Indian world was the love of nature. Beginning in the early nineteenth century there suddenly appeared a series of remarkable

landscape painters. Almost all of them belonged to the so-called Hudson River School. A revealing contrast: whereas the American artists of this era chose as subjects the great rivers, forests, and bays of their country, the Mexicans showed a decided preference for the valleys, above all the Central Valley of Mexico, the site of old civilizations. In the one case, the spirit of the nomad and the colonizer; in the other, peoples who have been sedentary since the pre-Columbian era. Like our Velasco, the American painters combined a predilection for visual, almost photographic exactitude and an affection for the vast open spaces of earth, sea, and sky. There is a constant note in nineteenth-century landscape painting, in Europe as well as America, that disappears with Impressionism: the attraction of the infinite. In these painters the precision of detail is allied to a sublime vision of nature. Among them there is one, John Frederick Kensett, who fascinates me by the way in which he resolves the opposition of a dual space—sea and sky seen as two plane surfaces—thanks to the intervention of the invisible element, light (*Rock Cliff at Newport*).

Toward the end of the last century, American painting ceased to be a provincial reflection of European tendencies and, through two extraordinary personalities, a man and a woman, Whistler and Mary Cassatt, participated directly in world painting. The United States and Europe can lay equal claim to these two artists. Whistler was a disciple of Courbet, although his work, admirably defined by Mallarmé, who knew him well, as "belligerent, exciting, precious, worldly," does not possess the immense scope and fecundity of the French painter. But the comparison is unfair: Courbet is one of the great artists of the nineteenth century; his peers and rivals are Goya and Turner. Whistler's painting has a certain affinity with that of his friend

Manet. Both learned the lesson of Velázquez and his expert combinations: very few colors, woven together by multiple reflections. An example of this subtle mastery is the portrait *La Andaluza*, done in gold, gray, and pearl tones. Mallarmé found just the right image for it: "a whirlwind of muslin." In this case, a motionless but scintillating whirlwind. This is Whistler's magic—and his limitation.

Mary Cassatt's cosmopolitanism is not that of the great international world of Whistler, with his endless shuttling between London, Paris, and Venice. She lived almost all her life in France, and though she showed her paintings with the Impressionists and was a friend of Degas and Renoir, she never gained real fame. The portrait *Susanne and Her Dog* is an excellent example of her talent, less brilliant than Whistler's but solider. Between Susanne and the dog there is a sort of harmony: health. The same simple harmony rules the lines, colors, and forms of her paintings. In Mary Cassatt's Impressionism there is a freshness, a common sense, and an aesthetic honesty that are profoundly Yankee. And there is something more, something that saves her from Impressionist vagueness: in her own way, she is an architect, and each of her paintings is a genuine construction.

Thomas Eakins never journeyed very far afield: he was born and died in the same house in Philadelphia. In the delightful poem that Charles Tomlinson dedicated to him, he gives its exact address: 1729 Mount Vernon Street. He was not a society painter as Sargent was, nor was he a friend of celebrated artists and writers as Whistler was. Nor did he undergo the influence of the Impressionists as Cassatt did. His painting is severe and uncompromising. This realism, steeped in French classicism and British puritanism, must have irritated his wealthy contemporaries.

It was the era of the great tycoons of industry, and every one of those potentates wanted to be an aristocrat. As Tomlinson says:

> *The figures of perception*
> *as against*
> *the figures of elocution.*
> *What they wanted*
> *was to be Medici*
> *and they survive*
> *as Philadelphians.*

It should be added that they have survived thanks to Eakins. The story is told that one day, on meeting an old lady, he said to her: "What beautiful skin you have, with all those wrinkles!" In the portrait *Miss Van Buren*, perhaps showing a spinster, Eakins painted not only a body, a face, and a social class, but melancholy itself.

This article is not a catalogue or even a chronological account. So I have not dwelt on certain artists who deserve comment, like some representatives of the Hudson River School (Cole, Durand, Church, Bierstadt), or Peto, a curious precursor of the modern collage—but a collage painted with the ultraacademic technique of trompe-l'oeil—or Albert Pinkham Ryder, an extraordinarily modern painter. Nor, in the period that followed, have I dwelt on the Cubist Weber; Marin, the painter of violent seascapes; or Dove, the abstractionist. Although all of them are something more than forerunners, their art blends in with that of their time: they do not constitute a style, but rather variations—often felicitous—of modern styles.

Art does not proceed by gradual evolutions but by sudden leaps. Georgia O'Keeffe's painting has something unexpected and deeply spontaneous about it that calls to mind a sudden gust of wind on a calm day. With her we have definitely entered the twentieth century. Her painting is yet another example of the dialogue—sometimes a violent argument and at other times a duet—that photography and painting have had with each other from the beginning. The camera lens is an abstract and timeless eye, but Georgia O'Keeffe uses this lens to transfigure plant and animal forms into emblems animated by a diffuse sexuality. Her art is not exquisite or delicate, but sweeping and powerful: the art of an Amazon.

Edward Hopper's landscape is not forest or plain but the great modern city: cafeterias, offices, motels, gas stations. Anonymous places peopled by men and women who are also anonymous, a world of loners, everywhere strangers, above all to themselves. To Hopper the city is not crowds but the isolated individual: each painting is a cage or a cell. He is the painter of time passing—an empty time. His realism is mental and reticent: he disturbs us not by what he says but by what he leaves unsaid. A poetry of loss, of what is lost and makes us losers: time.

It is said that Hopper is a great realist. I shall add: he is not great because of his realism but because he was the painter of an intensely modern vision of the human individual and of time. There are other realists represented, more violent but less profound: Benton, Levine, Ben Shahn. Almost all of them were influenced by Expressionism. At times they call to mind the Orozco of the earliest period (perhaps his best), and at other times Soutine and Rouault. They had a strong bent toward socialist realism, a genre that borders on propaganda at one extreme and on

sentimentalism at the other. Shahn was an assistant to Diego Rivera when the latter painted the murals, subsequently censored, in Rockefeller Center. Shahn's painting was a contribution to the art of his time, not groundwork for the art to come.

The last section of the Bellas Artes exhibition is the one richest in works and talents. After World War II the magnetic center of painting and sculpture shifted from Paris to New York. In the space of twenty years, after assimilating and transforming a series of influences in a very personal way, American painters succeeded in creating an art that amazes us by both its vigor and its diversity. The first influence was that of Mexican mural painting. One of the most original U.S. painters, Jackson Pollock, profited from many an idea about the use of new materials garnered from Siqueiros and his work. Other painters were influenced by Orozco, especially Tobey in his first experimental works. The second, and decisive, influence made itself felt during World War II, when many of the great European artists came as refugees to New York: Léger, Miró, Chagall, Mondrian, Max Ernst, Tanguy. The majority of U.S. painters adopted the nonfigurative aesthetic of the Abstractionists; at the same time, they used the automatic techniques of the Surrealists. Three Surrealist painters had a major influence on the Americans: the Catalan Miró, the Chilean Matta, and the Frenchman Masson. Great art is always an invention that begins as an imitation.

Milton Avery understood admirably the lesson of Matisse and, less well, that of Bonnard. He transmitted these teachings, assimilated in a personal and sensitive way, to younger painters, above all to Mark Rothko and Helen Frankenthaler. In Mark Tobey we find the union of painting and Oriental meditation, Chinese calligraphy and the

feeling of the infinite—the one within, not without. His was a temperament akin in certain respects to Michaux's, though more purely plastic. Pollock profited from Tobey's example, as Dubuffet was later to do in his *Sols et Textures*. Another poet is Morris Graves. His flowers speak. His birds do not fly but write magic signs in space. At the opposite pole is the explosive Stuart Davis, who practices in painting what Apollinaire preached about language: poetry is in the street, in advertisements and posters.

It is not possible to describe a painting by Gorky: it has to be seen. But seen as one hears music, with one's eyes alternately open and closed. Gorky was a great colorist, and an inventor of fantastic forms as well: his imagination adds new territories to visual reality. He never entirely freed himself, however, of European influences, that of Matta and Miró in particular. A painter of great sensibility, he never managed to fuse all his extraordinary gifts. Next, the impetuous Pollock: whirlwind painting. I feel the same reservations about Pollock as about Gorky, though for very different reasons. A great painter? Rather, a powerful temperament. The most painterly of this group, in the strict sense of the word, is Willem de Kooning. A wild, sensual, fierce artist. Something about his women brings to mind great goddesses on the first day of creation, and at the same time huge animals with martyred flesh: myth and butchery.

Kline learned, like so many others, the lesson of Chinese and Japanese calligraphy, except that he transformed these signs into great, compact black and white masses: signs that have become landscapes of crags and mountains. Rothko discovered the secret of the melody that fascinated Baudelaire: a patch of paint as a space that evokes sea, sky, desert, metaphors of the infinite. In his monochrome

compositions, blocks of a single color broken here and there by fringes of a complementary color, the monotony turns into an extraordinary wealth of vibrations, reflections, nuances. Rothko's painting invites us to contemplation, but the mania of sublimity—a frequent defect of modern U.S. painting—eventually overwhelms us. Another notable painter is Gottblieb, a colorist who knows how to combine his lyric gifts with rigorous geometries (in Gottblieb's first paintings, the liberating presence of a great Latin American, Torres García, is visible). In contrast to the paintings of Clyfford Still—great, quiet patches of color, like gleaming marshes—the somber masses of Robert Motherwell: blue, black, white, and ocher condensations that simultaneously evoke clouds before a storm and rugged mountains. But Motherwell can also transform the dense, ponderous energy of his great oils into magical compositions that defy the law of gravitation: his collages.

For all these artists, art was above all sensibility, passion, enthusiasm. The painters who come after them seek a more objective painting, in which the forms are reduced to simple lines—circles, triangles, ovals, rectangles—and the colors are pure and unshaded. This is an art suitable for decorating airports and other great spaces, with nothing intimate or subjective about it. The painting of Morris Louis, Noland, Kelly, and Stella—that of the last in particular—merits the adjective that Ortega y Gasset used in an effort to define modern art: *dehumanized*. This term is neither complimentary nor derogatory; it is merely descriptive. This is painting dehumanized in a very precise sense of the word: rocks, infusoria, and atoms are ahuman; machines, the human creation par excellence, are dehuman. The origins of this manner are to be found in Mondrian, but Mondrian, inspired by occultist hermeticism, was endeavoring to reduce

the innumerable forms of the universe to a few arche-
types—in other words, to ideas. I find nothing similar in
Stella or the others: their art seems to me to be not so
much an intellectual speculation as a manipulation of typ-
ical forms and flat colors. I neither know nor understand
what their intention is, but I do understand that there is
very little to understand in their paintings. To suppress
subjectivity is to cut the heart out of art. Stella's paintings,
like automata, move but do not breathe, walk but are not
alive. Yet even though it doesn't move us, this an art that
we cannot deny: it is there in front of us, visible, palpable,
and indifferent to our criticism and praise.

Confronting this art reduced to quantitative and imper-
sonal relations of lines, volumes, and colors, is the emi-
nently subjective, ironic, and intelligent painting of Jasper
Johns. In the Bellas Artes exhibition is a painting of his,
in reds, whites, and blues, combining circles and ellipses
with straight lines and diagonals. The protagonists of this
painting are neither human figures nor abstract forms but
numbers, from 0 to 9. It is a pictorial charade in which
numbers, by losing their numerical value and meaning,
suggest a question. At the other extreme is Rauschenberg,
who—like Duchamp—does not scruple to place two real
watches and a tin can in his painting. Rauschenberg does
not modify the object, as Picasso and the Surrealists did,
but instead disorients the spectator by wrenching it out of
its context. Rauschenberg says that he works at the bor-
derlines between art and life; these borderlines, as we all
know, are ever shifting. At times, like quicksand, they
swallow Rauschenberg.

After more than half a century of formal experiments,
there was bound to be a return to realism, as can be seen
in Pearlstein's painting, *Male and Female Nudes*. Is it really

a return? Perhaps we are not witnessing a retreat to the past but a search for another realism, very different from Hopper's or that of the painters of the last century. Whatever our opinion of contemporary art may be, it is clear that a cycle that began around 1910 in Europe (Paris, Berlin, Milan, Saint Petersburg) is now ending in America (New York). In a 1967 essay ("Baudelaire, crítico de arte") and later in *Children of the Mire* (1974), I pointed out that the very notion of "modern art" was disappearing and that the avant-garde had degenerated into a series of movements at once spasmodic and repetitive. Precisely because of its radicalism, the painting of the last thirty years in the United States poses the question in even more peremptory terms: is it not the most extreme consequence of the adventure begun almost a century ago by the Cubists and Futurists?

In its most perishable though most eloquent expression, the contemporary painting of the United States has been an amplification and a simplification of European painting prior to World War II, from Fauvism to Surrealism and Abstractionism. But at its best moments it has been an intensification of European art. In both cases it has been *a going beyond*. Hence it has also been the discovery of *another* space, not only in the physical sense but in the aesthetic. With certain American painters the sensibility and the imagination of our century rediscover the infinite. Not the infinite of the Romantics, associated with landscape and the concept of the sublime, nor that of Baudelaire and his descendants, which is essentially mental and reached by a *dépassement* of the senses, but precisely the contrary: the tactile dimension, so to speak, of senses capable of extending throughout the entire universe and *touching it*. Not seeing with one's hands but touching with one's eyes—

that has been the great discovery of the Pollocks, the Klines, and the de Koonings. A more appropriate term than *infinite*, in their case, is an expression used in modern physics: *transfinite*.

The infinite has fascinated great poets: Blake and Hugo, to name two. To paint it—or rather, to evoke it—is heroic and demoniacal: the infinite is not coterminous with Buddhist emptiness but with Romantic vertigo. Dante's universe is not infinite; Hugo's is. Teeming abundance or emptiness; or rather, teeming abundance that ends in emptiness. The space of these painters is an empty space: how and with what or whom can these endless—and in essence boundless—expanses be peopled? Despite the immensity that their paintings evoke—or rather, an immensity that evokes itself—we are confronted with a *deserted* painting that cruelly lacks presence. A solipsism without end and without limits, since it is the *other* that constitutes the limit. Beyond this space that repeats itself and opens out without end there is, literally, nothing. And on this side there are only grandiloquent gestures, the rhetoric of the monumental, that fatal flaw of American art. Thus the painting and the sculpture of the United States—deformed, moreover, by an art market that inflates them with unlimited publicity and vampirizes them—are confronted by a question, the same one that European art was unable to answer fifty years ago: *now what?* The situation of American painting today—and with it that of the entire world—is perhaps merely the end result of something that began with Romanticism: the erosion of the limits of art. For more than two hundred years now, artists have forgotten the old Greek maxim: perfection is finite.

Mexico City, November 22, 1980

The Tree of Life

The other night, on closing the book, my eyes red with insomnia, my brain boiling with warring ideas, as I looked without looking through the window at the black landscape crisscrossed by the swift beams of automobile headlamps, I heard myself murmur: *theory is gray, green the tree of life*. Green or golden? No matter. Perhaps green *and* golden. As I repeated them mentally, the two words suddenly lit up like the flaming leaves of the maples on these autumn days, floated in my memory for an instant, then vanished completely. They disappeared as they had appeared—silently, without warning, through one of those sudden breaches that fatigue or distraction sometimes opens

Apropos of *La Logique du vivant (Une histoire de l'hérédité)* by François Jacob, 1970.

up within us. In those empty spaces, times intersect and our relation with things is reversed: rather than remembering the past, we feel the past remembers us. Unexpected rewards: the past becomes present, an impalpable yet real presence. Amid the rustling of the branches and the murmur of the syllables, someone is looking at me—the someone I was before, long ago, the youngster who walked about the courtyards of the National Preparatory School repeating, enthralled, the recently read phrase: *theory is gray, green the tree.* . . .

Who today could repeat that phrase with the same innocence? Life no longer presents itself to us as a green and/or golden tree but as a physicochemical relation between molecules. Its graphic representation is a capricious configuration of irregular polygons that evokes, if anything at all, not the world we call natural but those mental landscapes by Yves Tanguy consisting of an abstract beach littered with a population of pebble-bubbles. The word *life* has ceased to be not only an image but an idea as well: it is an empty noun. The concept *life* once designated a unique reality, possessed of properties that also were unique; there was a moment (which one, where, how?) when matter changed and was transformed into life—that is, into matter qualitatively different from the rest of matter. In the cells was an element irreducible to the other elements, substances, or combinations of substances—an ungraspable element, hence identified as the "mystery of life." This element animated matter as though it were an equivalent of the ancient *pneuma*. Spirit, banished from the kingdom of incorruptible essences, became once again what it had been at the beginning: the breath that brings clay to life. This metaphor led to another: if man could isolate this element, the modern divine breath, he would become a

veritable god. A curious reversal of the Bible story: the same knowledge that had caused the fall of Adam and Eve would now be the means for deifying humanity. Modern genetics disabuses us: it is not possible to isolate this qualitatively different element because it doesn't exist. The secret is that there is no secret. The mystery vanishes because the very concept of *life* breaks down: it is a process, and within it there is no element different from and irreducible to other processes. Life is not an exception save in the sense of being, probably, an unusual combination, a chance case in nature.

When the "mystery of life" disappeared, our pretension to divinity and immortality disappeared with it: the word *death* is written into the genetic program, Jacob says. One of the conditions for the reduplication of cells—the sine qua non—is that they be mortal; therefore the series of physicochemical combinations that we call life necessarily includes the combination we call death. On the level of molecular biology the words *life* and *death* have no existence of their own: life resolves (dissolves) into a physicochemical relation we call death, and death dissolves (resolves) into the life process. But the difference between the two doesn't disappear; or, to put it more exactly, it disappears only to reappear at another level. If the physicochemical absorbs the biological, the distinction between life and death shifts from the cells to consciousness. From the point of view of the physicochemical process, the difference between what we call life and what we call death is illusory: they are two inseparable and complementary phases of the same operation. From the human point of view, the realities of life and death, although inseparable, are not complementary but contradictory; I know I am going to die, and knowing it keeps me awake nights. Sci-

ence had shown that the eternities and immortalities of religions were foolish fancies; at the same time it led us to believe that it might one day give us wisdom and perhaps immortality. Wisdom: the courage to look death in the face and make our peace with it; immortality: the power to overcome it. Genetics today repeats, in a different yet no less categorical language than that of Christianity, the Biblical "dust thou art and unto dust shalt thou return." Neither immortality nor wisdom.

In the depths of modern materialisms there lay hidden, until recently, the seed of the hope of resurrection. The reason is not hard to understand: our materialisms are steeped in evolutionism and therefore, unlike the pessimism of the materialisms of antiquity, they are optimistic. This is what distinguishes Epicurus and Lucretius from Marx and Darwin. Thus Engels was persuaded that, even if human individuals are not immortal, the species would be: someday humanity would discover the secret of overcoming the second law of thermodynamics that dooms our world to extinction. Mayakovski believed that, in the future, scientists would be able to bring the dead back to life; in one of his great love poems, with rhetorical flourishes that waver between the ridiculous and the magnificent, he seeks from his comrades of the future the resurrection of the poet Mayakovski and his beloved. But the most impressive example is that of César Vallejo. In his poem "Masa" it is not the science of the future but the will of all humanity that brings the fallen combatant back to life. This is a miracle no less prodigious than the resurrection of Lazarus, and one that depends on another miracle: the universal love of human beings for one another. Communism will vanquish death.

Science dispels the illusions of Mayakovski and Vallejo

as it once dispelled religious illusions. It does not do away with the contradiction, however; it simply displaces it. If we were like cells, our one desire would be to die in order to duplicate ourselves; but we are human beings and the idea of duplication is as terrifying to us as the idea of death. In all societies man fears his double: it is his enemy, his ghost, the present image of his future death. Our shadow warns us of our mortality and therefore it is hateful; to kill my double is to kill my death, hence in many myths one of the pair of twins must be sacrificed. Each human being believes himself or herself to be unique—and is, to himself or herself. Even if reflection makes me discover that the self is a bundle of sensations, desires, and thoughts that have no substance and no independent reality, as the Buddhists and Hume tell us, only I can make this discovery within my inner self. Criticism of the self is necessarily self-criticism. Thus, between the program of the cells and the program of the human there is a radical disparity: cells are destined to die by duplicating themselves—or, put another way, they seek immortality in their double—whereas we kill our double and (vainly) seek immortality within ourselves. They carry out their program and we fail. Do we really fail? Perhaps the word *failure* is written into our program the way the word *death* is written into the cells' program. And there is something even more disturbing: we are that phase of evolution in which cells criticize themselves and deny their own reality. Our contradiction is constitutional and therefore, perhaps, insoluble.

The advances of science are, in a way, like the acts of prestidigitators; when the performance is over, the magician shows his empty hands to tell us that his wonders were made of thin air: there was nothing behind them. Physics revealed to us that matter was neither a substance

nor a thing but a relation: matter as we once knew it vanished, as if through a conjuror's trick. Genetics is now doing the same with life. *Matter* and *life* have become words no less insubstantial than *soul* and *spirit*. What we call life is a system of signals and responses, a communications network that is also a transformation circuit. In the communications process the signals sent out are transformed, and this transformation is analogous to what we call translation. Every transformation is, in a manner of speaking, equivalent to a translation provoking a response that in turn must be translated. The system may be thought of as a circuit of translations/transformations—a chain of metaphors that becomes a series of equivalents. The analogy with language is perfect—and with language at its extreme of perfection, the poem. As in a poem of poems, each thing is consonant with every other; each thing—while not ceasing to be itself—is other, and all of them, though different, are the same thing. The system is a world of equivalents and correspondences. But there is a moment at which the spiral of signal/transformation/response is interrupted: death and life are correlative terms at the level of the cells, but not in my consciousness. For me, death is death and life is life. Rupture, dissonance, noncommunication, irony: the universe appeared to us to be a solar system of correspondences, then suddenly, in the very center, the sun blacks out. The text becomes illegible and there is a gap: human beings. The only beings who hear (or think they hear) the poem of the universe do not hear themselves in this poem—except as silence.

Cambridge, Mass., October 1971